The **196**

BRITAIN IN PICTURES

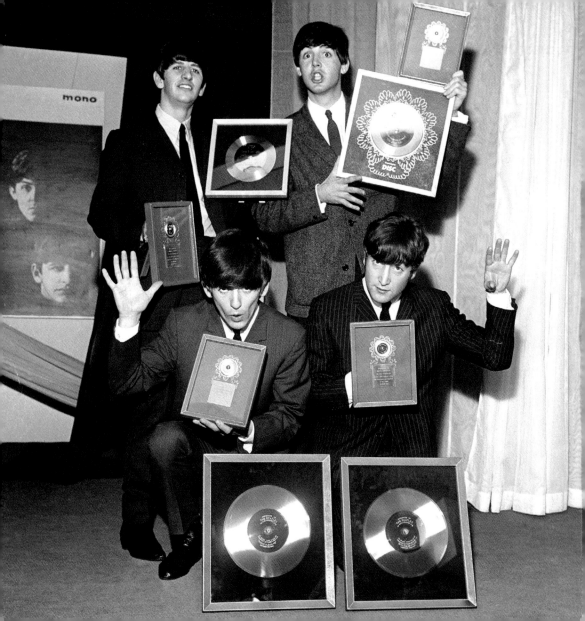

The 1960s

BRITAIN IN PICTURES

AMMONITE PRESS

PRESS
ASSOCIATION
Images

First Published 2012 by
Ammonite Press
an imprint of AE Publications Ltd,
166 High Street, Lewes, East Sussex,
BN7 1XU, United Kingdom

This title has been created using material first published in
Britain in Pictures: The 1960s (2008).

Text © AE Publications Ltd, 2012
Images © Press Association Images, 2012
Copyright © in the work AE Publications Ltd, 2012

ISBN 978-1-90770-865-7

British Cataloguing in Publication Data. A catalogue
record of this book is available from the British Library.

Editor: Neil Kelly
Series Editor: Richard Wiles
Picture research: Press Association Images
Design: Gravemaker + Scott

Colour reproduction by GMC Reprographics
Printed and bound in China by C&C Offset Printing Co. Ltd

Page 2: The Beatles, pictured at EMI House, Manchester Square, London. They were presented with two Silver LPs to mark the quarter-million plus sales of their first LP *Please Please Me* and their new *With the Beatles*, as well as for their *Twist & Shout* EP and the single *She Loves You*.
28th November, 1963

Page 5: The Millinery Institute of Great Britain display part of their Autumn Collection at the Mayfair hotel. Here, a trio of trouser suits are worn by (L–R) June Fry, Jill Wright and Jenny Wilson. The hats are from the Tomboy range.
8th September, 1964

Page 6: Fans waiting in Hyde Park, London, hours before a concert by the Rolling Stones.
5th July, 1969

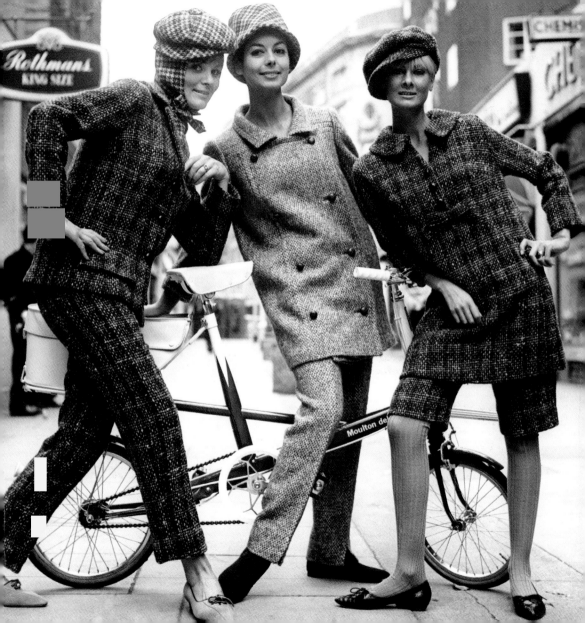

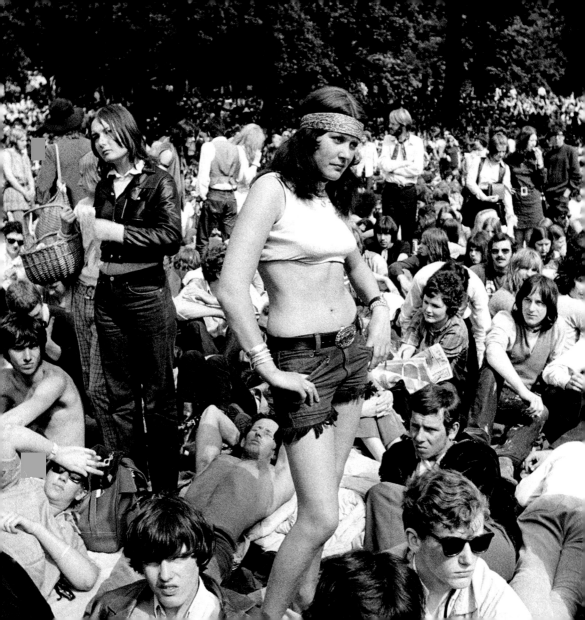

Introduction

The archives of PA Photos yield a unique insight into Britain's recent past. Thanks to the science of photography we can view the 20th Century more accurately than any that came before, but it is thanks to news photography, and in particular the great news agency that is The Press Association, that we are able now to witness the events that made up life in Britain, not so long ago.

It is easy, looking back, to imagine a past neatly partitioned into clearly defined periods and dominated by landmarks: wars, political upheaval and economic trends. But the archive tells a different story: alongside the major events that constitute formal history are found the smaller things that had equal – if not greater – significance for ordinary people at the time. And while the photographers were working for that moment's news rather than posterity, the camera is an undiscriminating eye that records everything in its view: to modern eyes it is often the backgrounds of these pictures, not their intended subjects, that provide the greatest fascination. Likewise it is revealed that Britain does not pass neatly from one period to another.

The decade between 1st January, 1960 and the 31st December, 1969 was unquestionably the most iconic of the 20th Century. The fashions, music, arts and personalities that emerged then continue to influence Britain more strongly than those of any other period. Given this, photographs of the era portray a world that is more drab than we might imagine, but below the surface everything was changing. This can be seen most clearly in the faces of the young people – and young people come to dominate the news of the time – which wear expressions of challenge and confidence not seen before. This was a generation born after the War, who were experiencing greater affluence and leisure than either their parents' or grandparents' generations: perhaps this explains the decade's explosion of creativity and individualism that fuels Britain still.

Just as Profumo fell before Christine Keeler and Mandy Rice-Davies, so the old order fell before the advance of the new. On the beaches of the South Coast; in Hyde Park; in the universities; on the Isle of Wight, the future had already arrived.

A ladder helps a man and a young girl keep their feet dry along North Parade in the badly flooded town of Worcester. The deluge occurred when the River Severn burst its banks, with the water rising to 16 feet above its normal level.

25th January, 1960

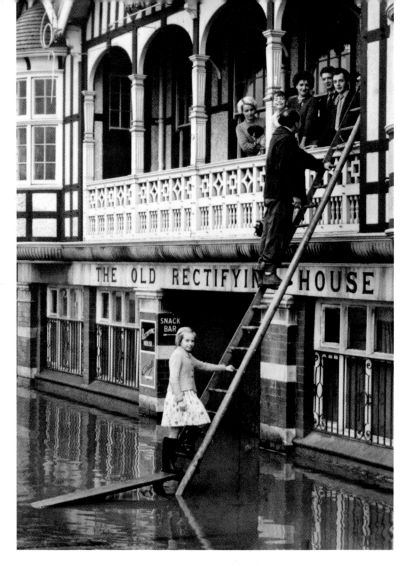

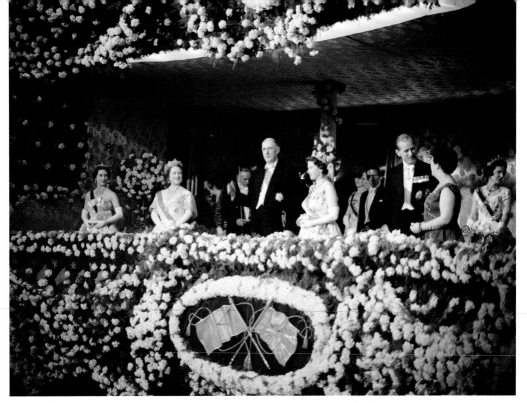

With the Queen at his side, President Charles de Gaulle of France (C) attends a gala ballet given for him and Madame de Gaulle – seen here talking to the Duke of Edinburgh (R), at the Royal Opera House, Covent Garden, London. Also pictured are Princess Margaret (far L) and the Queen Mother (second L).
7th April, 1960

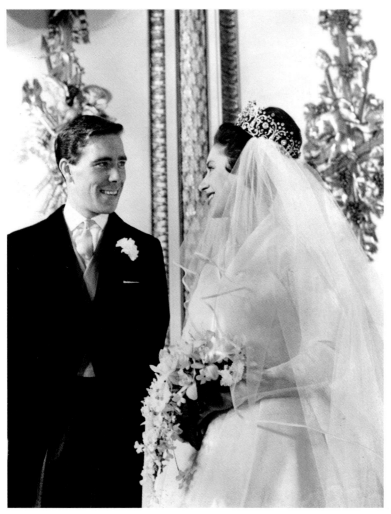

Princess Margaret and her bridegroom, the photographer Anthony Armstrong-Jones, after the Royal Wedding ceremony at Westminster Abbey. The couple later had two children, David, Viscount Linley (born 1961) and Lady Sarah (born 1964). The marriage ended in divorce in 1978.
6th May, 1960

Facing page: Members of the ship's company remove the tampions on the after guns of X and Y turrets on board HMS *Vanguard* at Portsmouth, Hampshire, in preparation for removing her to the breaker's yard after a 14-year career.
31st May, 1960

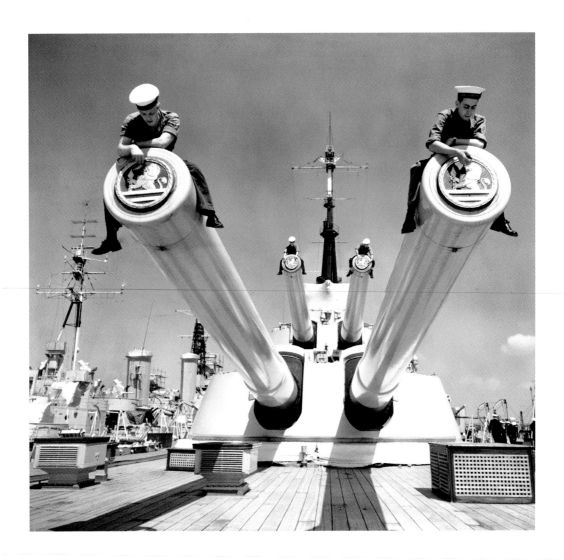

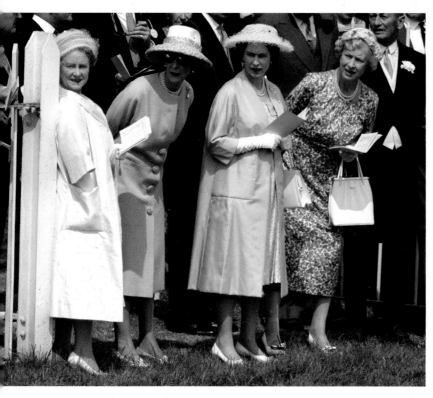

The Royal ladies crane forward to view the runners in the paddock before the Derby at Epsom in 1960. Left to right: the Queen Mother; the Duchess of Kent; the Queen and the Princess Royal.
1st June, 1960

Facing page: Inside the studios of the British Broadcasting Corporation's brand-new £12m Television Centre in Wood Lane, London. This iconic building became the backdrop for decades of first-class television that informed, educated and entertained the nation. Opened officially on 29th June, 1960, it also became one of the largest television headquarters in Europe.
16th June, 1960

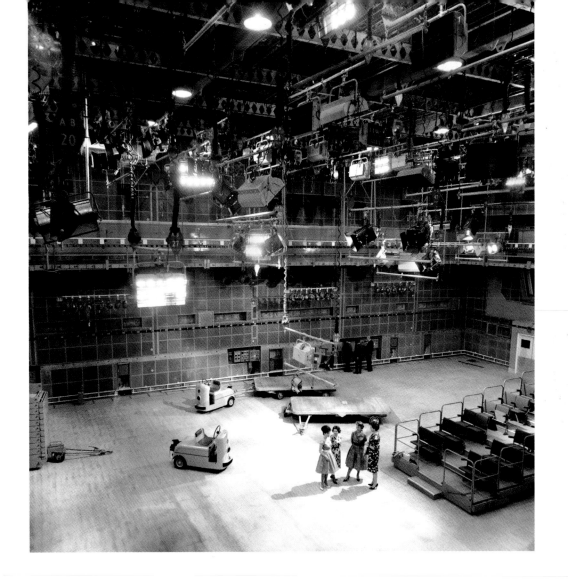

This snapshot of British life in the 1960s shows Mr Douglas Hoare and his 20-year-old daughter Patricia Ann painting a telephone box at the seaside town of Swanage, Dorset. The pair worked together for the GPO (General Post Office – the forerunner of British Telecom) in Hampshire and Dorset, maintaining postal boxes, telephone booths and police boxes.

20th June, 1960

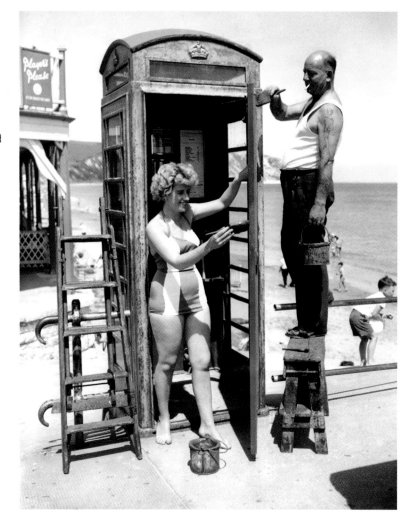

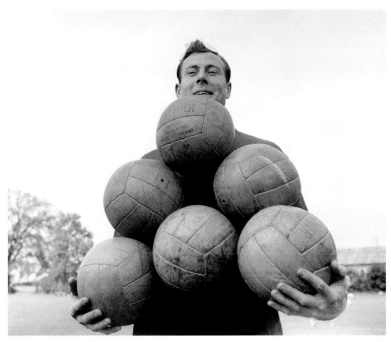

Arsenal goalkeeper Jack Kelsey stops an incredible six shots simultaneously during pre-season training for the Division One club in 1960. Kelsey is regarded as one of Arsenal's greatest-ever goalkeepers, making 327 appearances for the team between 1949 and 1963. He was also a highly celebrated Welsh international goalkeeper, with 41 caps awarded between 1954 and 1962.

16th August, 1960

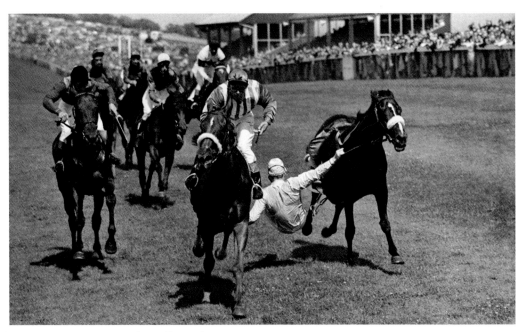

Lester Piggott tries desperately to hang on to his horse, Barbary Pirate, as he is unseated on the final straight at Brighton. Known as 'the Long Fellow' due to his short stature, Piggott is one of the best-known English racing jockeys of all time, with a total of 4,493 career wins, including nine Epsom Derby victories.
18th August, 1960

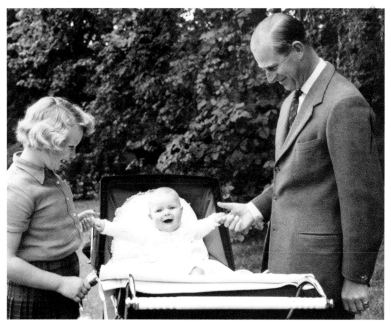

With one hand for his father, the Duke of Edinburgh, and the other for big sister Princess Anne, a laughing Prince Andrew sits up in his pram in the grounds of Balmoral. The second son, and third child of Queen Elizabeth and Prince Philip, he was second in line to the throne until the birth of his elder brother Charles' sons William (born 1982) and Harry (born 1984).

8th September, 1960

After being banned for over 30 years, D.H. Lawrence's controversial book, *Lady Chatterley's Lover*, sells out hours after being released in November 1960. An Old Bailey jury decided that Penguin Books were not guilty of publishing an obscene novel, allowing it to be published as it was written by the author without any edits or amendments.

2nd November, 1960

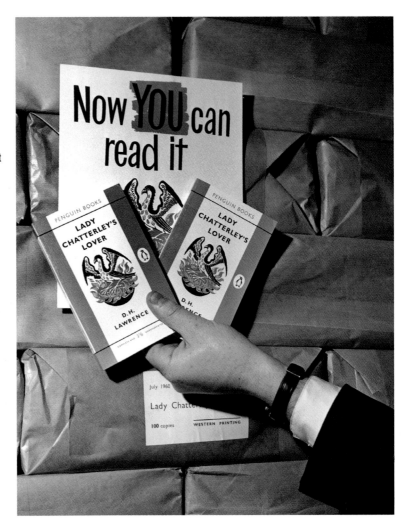

A double-decker bus ploughs its way through rising floodwaters on the main Newport-Cardiff road in the suburbs of the Welsh capital, following gale-force winds and torrential rain in December. The River Taff burst its banks during the deluge, which also led to the pitch of the Cardiff Arms Park stadium being completely submerged under floodwater.

4th December, 1960

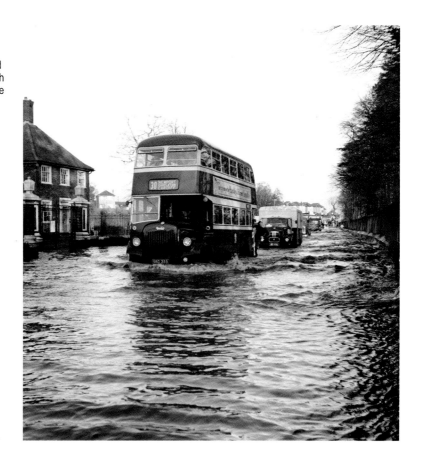

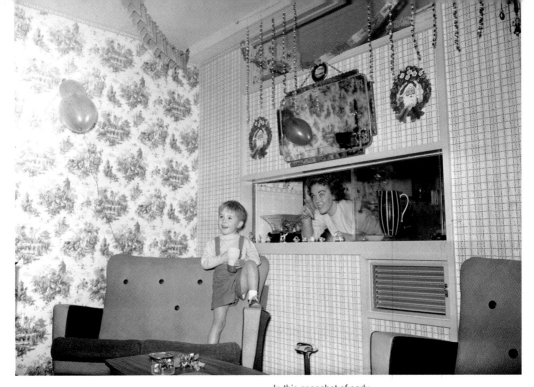

In this snapshot of early 1960s family life, Mrs Crockwell and her son David enjoy the Christmas decorations in their living room as they prepare for the annual Yuletide festivities.

17th December, 1960

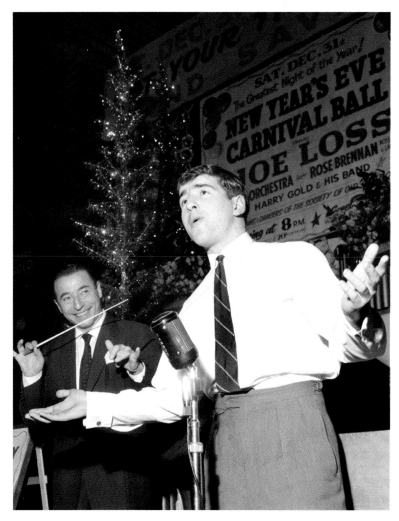

Chelsea's 17-year-old half-back Terry Venables with band leader Joe Loss, rehearsing at the Hammersmith Palais for his debut as a singer. Nearly 50 years later, after a career as a football player, manager and media pundit, Venables recorded a cover of the Elvis Presley song *If I Can Dream*, in association with the British newspaper *The Sun*. It featured the Royal Philharmonic Orchestra and was filmed at Wembley Stadium. The song reached number 23 in the UK charts on 13th June, 2010.

23rd December, 1960

Arsenal physiotherapist Bertie Mee, shown here using revolutionary new techniques to treat an injured patient in 1961. As well as being a trained physiotherapist, Mee was also a football player who made appearances for Derby County and Mansfield Town during the 1930s. In 1966 he became Arsenal's manager, holding the position until 1972. He became a noted figure in the club's history, managing Arsenal to their first Double Win in 1971.

14th April, 1961

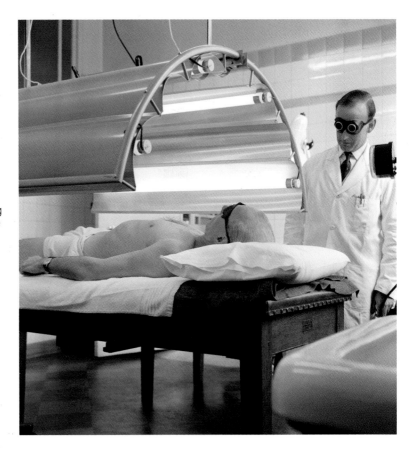

After winning the League Division One championship following a 2–1 victory over Sheffield Wednesday at White Hart Lane, members of Tottenham Hotspur take a warm bath. From left to right: Les Allen, Cliff Jones, John White, Dave Mackay, Peter Baker (rear); Terry Dyson, Bill Brown, Ron Henry and Bobby Smith (rear, waving). The two absent members were captain Danny Blanchflower, who took a shower, and Maurice Norman who was having a cut head stitched.

17th April, 1961

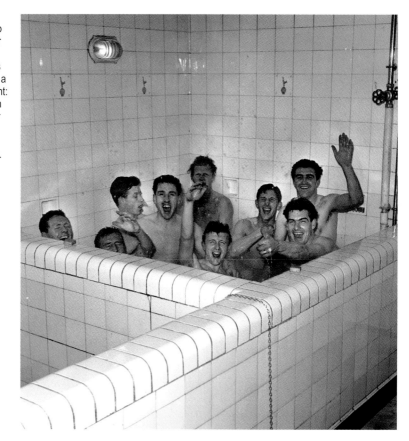

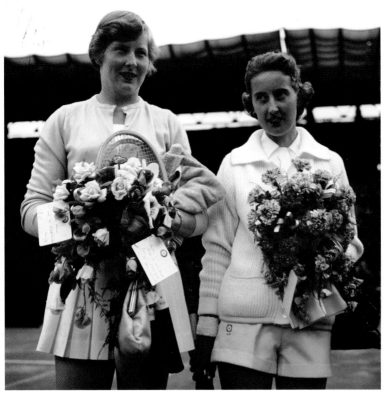

Christine Truman (L) and Angela Mortimer (R) before their Wimbledon Ladies Final. The tennis match was the first final between two English players since 1914. In an exciting match, Mortimer came from behind to win 4–6, 6–4, 7–5. She was later named British Sportswoman of the Year. Angela – who married BBC sports commentator John Barrett – was inducted into the International Tennis Hall of Fame in 1993.
21st April, 1961

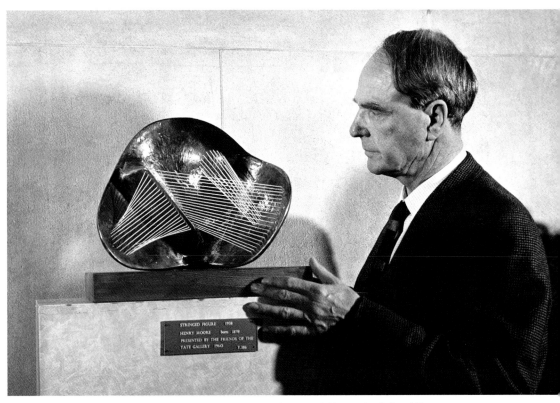

Modernist sculptor and artist Henry Moore, with his creation *Stringed Figure, 1938*, at the Tate Gallery in London during a viewing of six sculptures to be presented to the gallery by the Friends of the Tate Gallery. Born in Castleford, the son of a coal miner, Moore became well-known through his abstract carved-marble and cast-bronze sculptures. His commissions made him very wealthy, but most of his money went to the Henry Moore Foundation, which continues to support education and promotion of the arts.

28th April, 1961

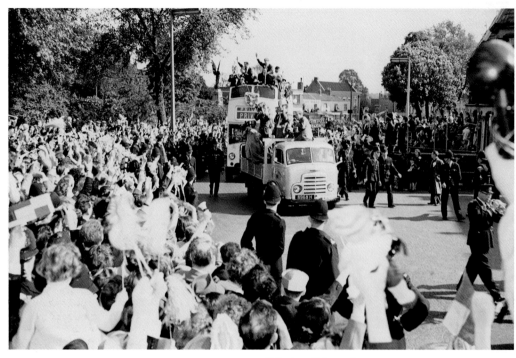

Tottenham Hotspur players parade the FA Cup and Division One League Championship trophies through London on an open-topped bus, after wrapping up the Double by beating Leicester City 2–0 at the Empire Stadium, Wembley.
6th May, 1961

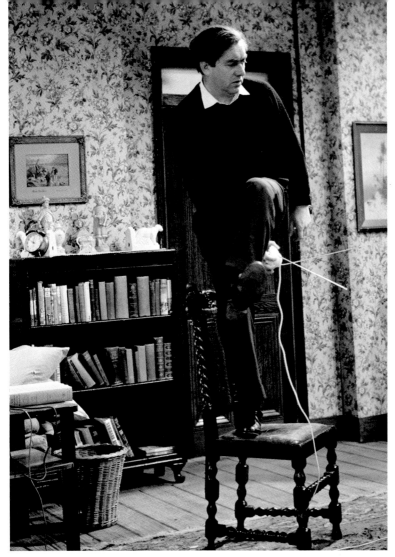

Comedian Tony Hancock stands stork-like on a chair while manoeuvring his indoor aerial into a good receiving position, in preparation for his new BBC Television series, *Hancock*. He had enjoyed television success from 1956 with his previous show *Hancock's Half Hour*, which also featured the talents of actor-comedian Sidney James. Hancock's concerns that they were becoming a double act led to the new series featuring Hancock without James. It became his last BBC Television series. Hancock suffered from depression for many years, a condition that eventually led to his suicide in Sydney, Australia on 24th June, 1968.

8th May, 1961

Stirling Moss with the trophy after his victory in the 200-mile Silver City Trophy race in the United States, during which he lapped all but the next two finishers. Moss, who raced from 1948 to 1962, won 212 of the 529 races he entered, including 16 Formula One Grand Prix. Despite his success in a variety of racing categories he is often called 'the greatest driver never to win the World Championship'. Moss retired in 1962 after recovering from a crash that left him in a coma for a month. On 21st March, 2000 he was knighted by Prince Charles, standing in for the Queen who was on an official visit to Australia.

3rd June, 1961

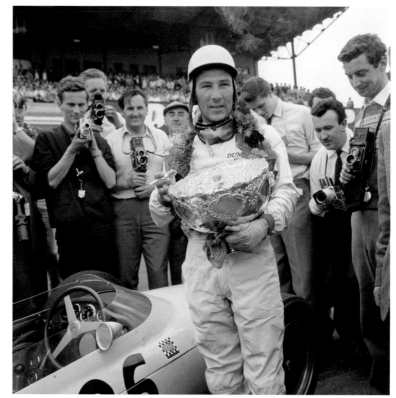

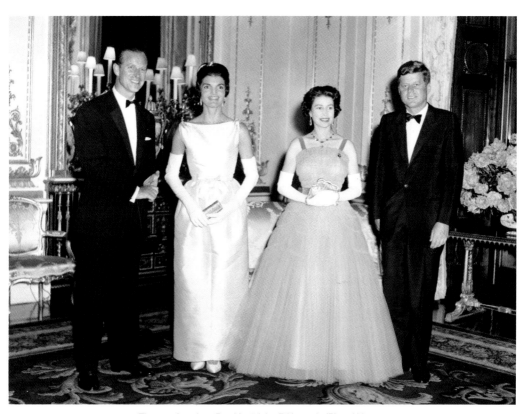

The new American President John F. Kennedy (R) and his
wife Jacqueline (second L) pictured with Queen Elizabeth II
(second R) and the Duke of Edinburgh at Buckingham Palace,
in London. Kennedy – the 44th President of the United States
of America – was elected on 8th November, 1960 and began
his official term of office of 20th January, 1961.
5th June, 1961

Major Yuri Gagarin, the first man in space, waves to bystanders on his departure from Admiralty House, London. Pictured with the Russian cosmonaut are the British Prime Minister Harold Macmillan (R) and Aleksander Soldatov (glasses), the Soviet Ambassador in London. Gagarin completed one orbit of the Earth on 12th April, 1961 in his spacecraft *Vostok 1*, and was awarded many honours, including Hero of the Soviet Union. He never flew into space again, but later became deputy training director of the Cosmonaut Training Centre outside Moscow, He died in 1968 when a MiG 15 training jet he was piloting crashed.

13th July, 1961

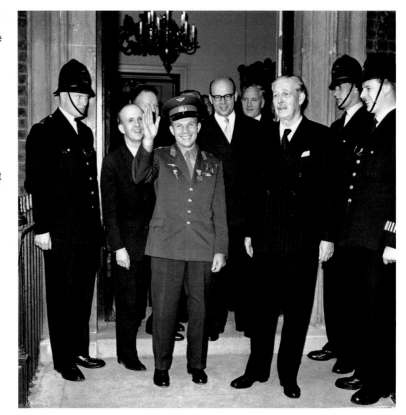

American golfer Arnold Palmer with the British Open Golf Championship trophy at the Royal Birkdale course, Southport, Lancashire. Palmer is regarded as one of the greatest players in the history of men's professional golf. He is part of 'The Big Three', along with Jack Nicklaus and Gary Player, who are credited with popularising and commercialising the sport around the world. Palmer was inducted into the World Golf Hall of Fame in 1974 and won the Professional Golfers' Association (PGA) Tour Lifetime Achievement Award in 1998.

15th July, 1961

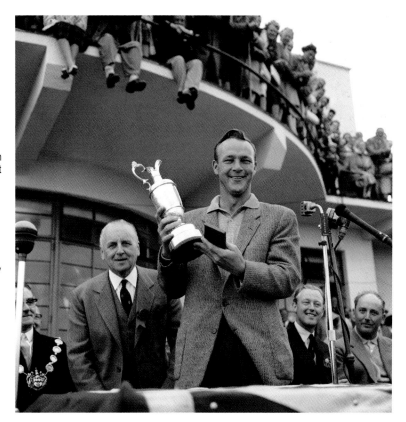

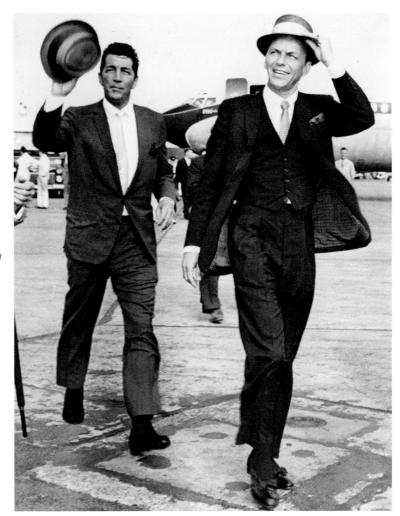

Dean Martin (L) and Frank Sinatra (R) make their way across the London Heathrow Airport tarmac before travelling to Shepperton Studios to film a two-minute cameo in Bing Crosby and Bob Hope's comedy, *Road To Hong Kong*. Nicknamed the 'King of Cool', Martin was a major recording artist, nightclub performer and a successful film and TV star. Sinatra enjoyed a singing career that lasted for more than 50 years. As well as being one of world's most acclaimed, best-selling recording artists, he also won an Oscar for his acting perfomance in the 1953 film *From Here To Eternity*.

4th August, 1961

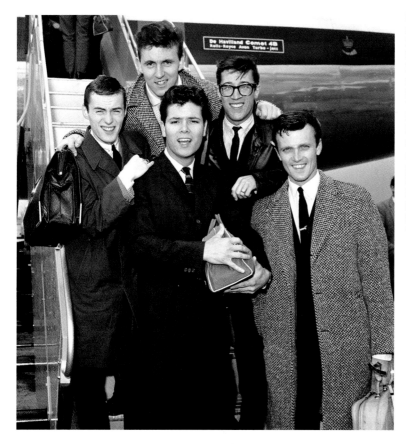

Cliff Richard and members of his supporting instrumental band The Shadows, at London's Heathrow Airport as they are about to fly off for a Scandinavian tour in 1961. Both Cliff and his bespectacled guitarist Hank Marvin (second R) would go on to enjoy successful solo careers that continue to the present-day. In 2009 and 2010, Cliff and The Shadows reunited to play a series of successful concerts around the world.

15th August, 1961

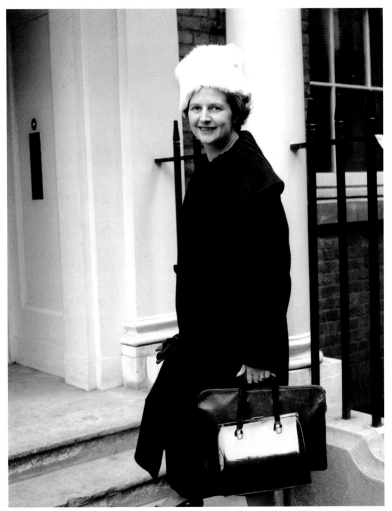

Margaret Thatcher takes up her new appointment as Joint Parliamentary Secretary, Minister of Pensions and National Insurance. A grocer's daughter from Grantham in Lincolnshire, the ambitious young minister would go on to become one of the most important and controversial figures in modern British politics. The future leader of the Conservative Party, she held the position of British Prime Minister from 1979 to 1990.
12th October, 1961

Facing page: An old horse bus passes the latest London Transport Routemaster in Fleet Street on a drive from Hyde Park Corner to Ludgate Circus for an ITV televison programme. The run was made to compare the time taken by horse-drawn transport to the duration of the journey by motor-bus.
20th October, 1961

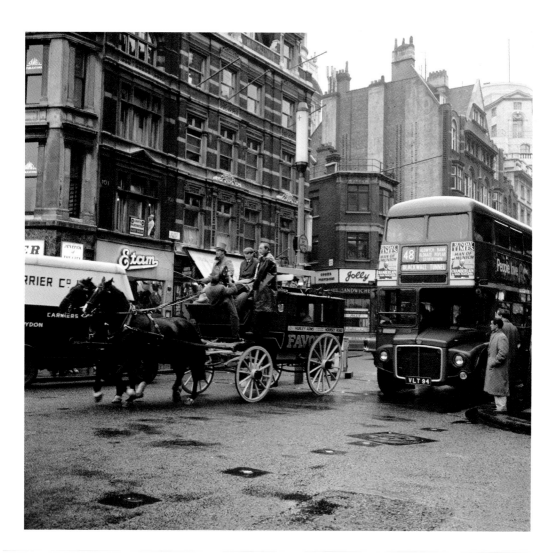

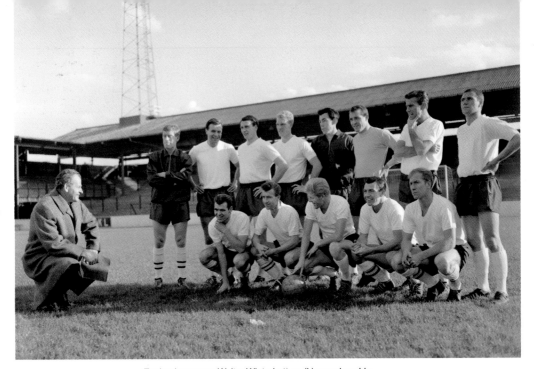

England manager Walter Winterbottom (L) examines his team selection: (back row, L–R) Tony Kay, Jimmy Armfield, Bobby Robson, Ron Flowers, Gordon Banks, Ron Springett, Peter Swan, Ray Wilson; (front row, L–R) John Connelly, Bryan Douglas, Ray Pointer, Johnny Haynes, Bobby Charlton. Many of the members of this squad would go on to take part in the 1966 World Cup, a event that will be forever remembered in the history of English football.

23rd October, 1961

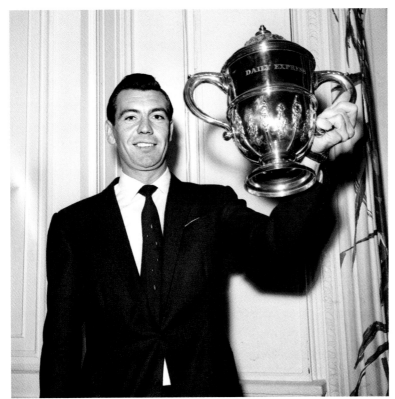

Fulham and England captain Johnny Haynes holds aloft the cup after receiving the Sportsman of the Year trophy at the Savoy Hotel, London. Haynes led the national squad to an outstanding 9–3 victory over Scotland in 1961. An inside forward, Haynes is regarded by many to be the greatest footballer ever to play for Fulham. He made 56 appearances for his country, including 22 as captain. He also became the first player to be paid £100 a week, following the abolition of the £20 maximum wage in 1961.

10th November, 1961

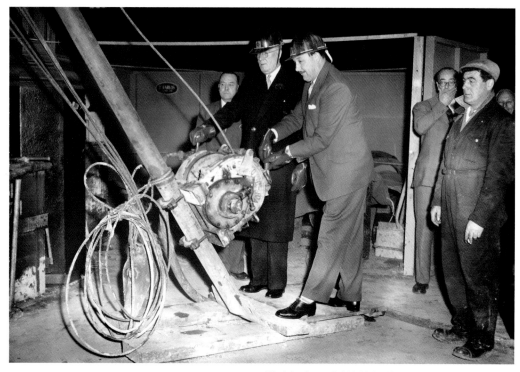

Work begins on British United Airways' new passenger terminal at London's Victoria Station. W.T. Fearne (L), station master at Victoria, and F.A. Laker, executive director of British United Airways, operate the boring machinery at a ceremony to initiate the foundation work. The check-in facility opened in late April 1962. This enabled BUA's scheduled passengers to complete all check-in formalities, including dropping off their hold luggage, before boarding their train to Gatwick Airport.
13th November, 1961

Bystanders near the gates of Bedford Prison on the day of James Hanratty's execution by hanging as the 'A6 Killer'. He was convicted of the murder of Michael Gregsten at Deadman's Hill on the A6, near the village of Clophill, Bedfordshire, on 23rd August, 1961. The identification leading to his conviction remained controversial until 2001, when DNA evidence from his exhumed body was provided to the Court of Appeal. The Court concluded it proved his guilt, but his family continued to press for a review of the conviction.
4th April, 1962

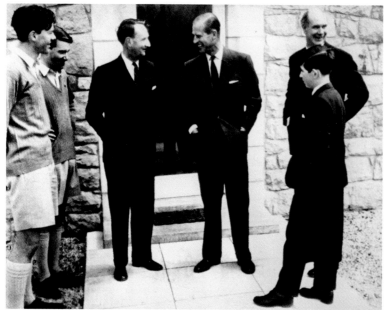

The Prince of Wales with his father, the Duke of Edinburgh, on his first day at school – Gordonstoun in Scotland. He was greeted by Head Boy Peter Paice (L), Senior Boy Dougal McKenzie with Housemaster R. Whitby (third L), and Headmaster F.R.G. Chew. The Prince did not enjoy the austere approach of the school, later choosing to send his own sons to Eton College.
1st May, 1962

Facing page: A new dance, the Apple Twist, demonstrated by Colin and Sidney Wilson at a London party. The Apple Twist is danced to a beat rhythm while the dancers have to keep the apple between their foreheads.
2nd May, 1962

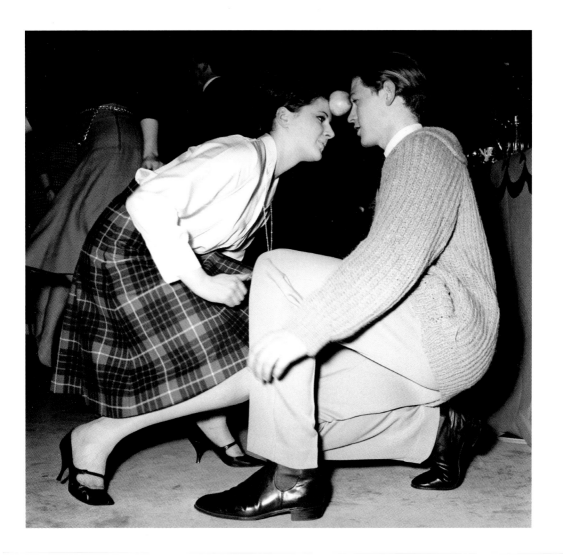

On the far bank of the River Avon stands the Royal Shakespeare Theatre. Renamed in 1961, it was formerly called the Shakespeare Memorial Theatre. The architect was Elisabeth Scott – the theatre was the first important work erected in the United Kingdom from the designs of a woman architect. The building was opened in 1932 by the Duke of Windsor. In November 2010, the Royal Shakespeare Company opened the newly renovated theatre, part of a £112.8m transformation project that included the creation of a new 1,040-plus seater thrust stage auditorium.

29th May, 1962

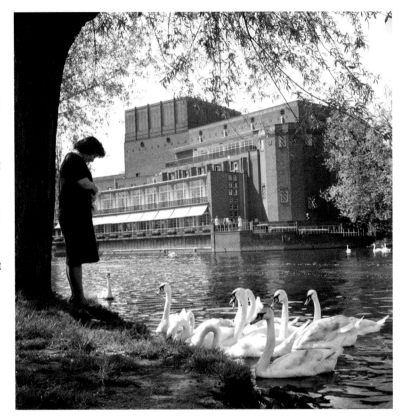

Comic actor, film prducer and composer Charles Chaplin, wearing an academic gown, signs the book at the Encaenia held at Oxford Town Hall upon receiving his honourary degree of Doctor of Letters. Chaplin made his name in Hollywood, USA but was born in Walworth, London in 1889. One of the most influential talents of the silent-film era, Chaplin co-founded United Artists film studios with fellow stars Mary Pickford, Douglas Fairbanks and D.W. Griffith in 1919.

27th June, 1962

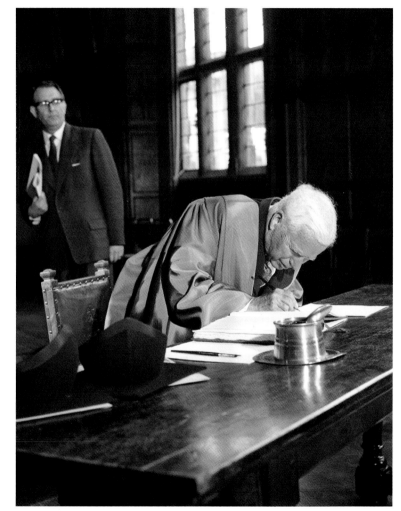

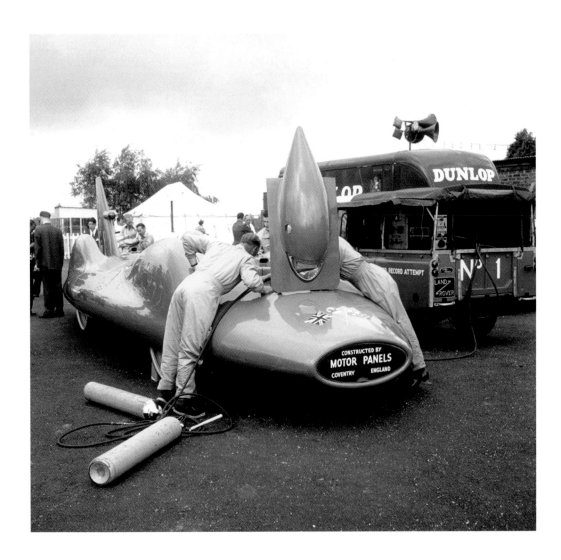

A scientist operates a reactor control console inside the new nuclear power station at Bradwell-on-Sea, Essex, which was one of the country's first two Magnox reactors. It started operations in 1962 and was shut down 40 years later on 28th March, 2002.
29th August, 1962

Facing page: Engineers work on the *Bluebird*, a wheel-driven land speed record-breaking car, driven by Donald Campbell. After a disastrous crash in 1960, the car was completely rebuilt and was fitted with a vertical fin to aid stability. On 17th July, 1964, at Lake Eyre, Australia, it smashed the World Land Speed Record for a four-wheeled vehicle, reaching a speed of 403.10 mph (648.73 km/h)
1st August, 1962

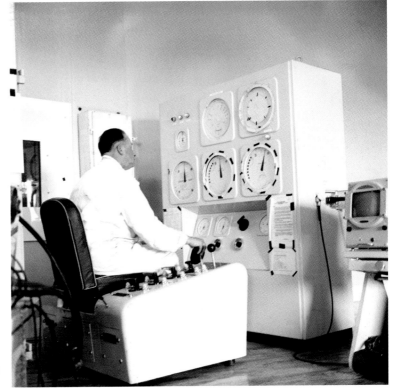

The Hover Rover, an air-cushioned, long wheelbase Land Rover. Converted by the Vickers company, the vehicle used two engines to drive it along. Unfortunately, the hover cushion hindered the car's road operations. It was trialled for use as a crop-spraying vehicle, but the air from the cushion scattered the spray, making it inefficient. The vehicle was never developed any further, but was briefly used as a promotional tool for Vickers' bigger hovercraft.

27th September, 1962

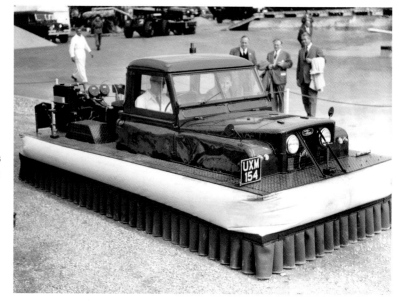

Earl Bertrand Russell, whose telegram appeal to the Soviet premier Mr Krushchev in 1962 brought a hint of conciliation in the Cuban Missile Crisis, reads in the study of his North Wales home. The discovery by the United States that the Soviet Union was constructing nuclear missile bases on Cuba brought the world close to the edge of a nuclear war. Russell's appeal led to the Soviet leader's public assertion that he would not behave recklessly in the stand-off with the United States.

25th October, 1962

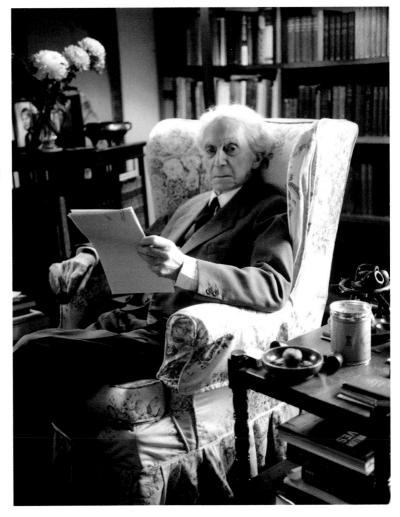

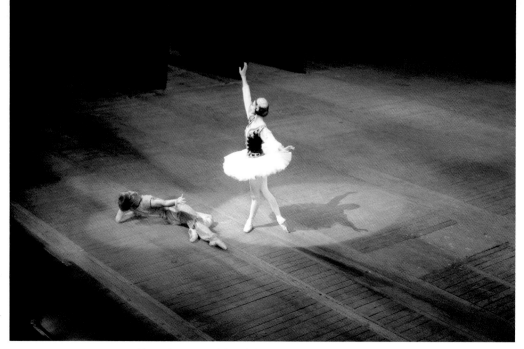

Margot Fonteyn and Rudolf Nureyev rehearse *Le Corsaire* Pas De Deux at Covent Garden in London. Nureyev had defected to the West from the Soviet Union the previous year. Their dance partnership was one of the greatest in the history of ballet. Despite many differences, and a 19-year age gap, Fonteyn and Nureyev became intensely loyal life-long friends. Rumours abounded of a physical relationship between the pair, but the truth remains unclear.
1st November, 1962

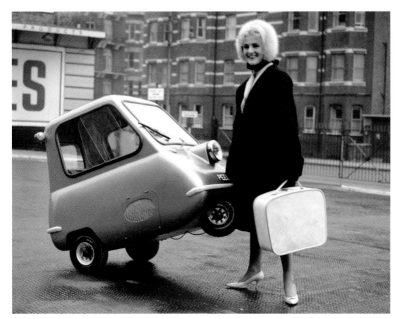

Karen Birch lifts the world's smallest car, the Peel P50, off the ground. It weighs a mere 59kg (132lb). The three-wheeled microcar was originally manufactured in 1962 and 1965 by the Peel Engineering Company on the Isle of Man. In 2011, production began on an updated version, featuring a 49cc four-stroke engine, improved suspension, continuously variable transmission and a reverse gear.

8th November, 1962

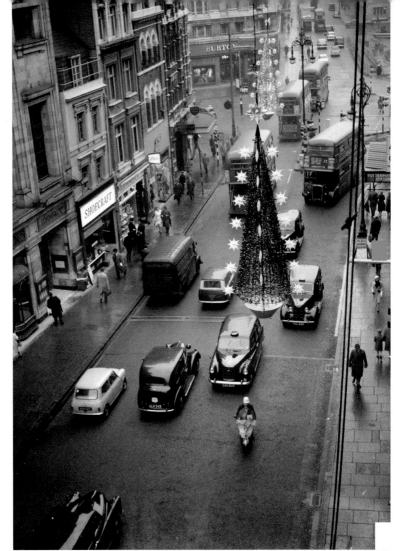

Christmas decorations going up on Oxford Street. A giant tree defies gravity as it is suspended above the busy thoroughfare. The tradition of putting up lights in Oxford Street continues to the present day, with the display becoming ever more spectacular. The switching-on ceremony, often by a famous celebrity, has become a much-anticipated annual event.
16th November, 1962

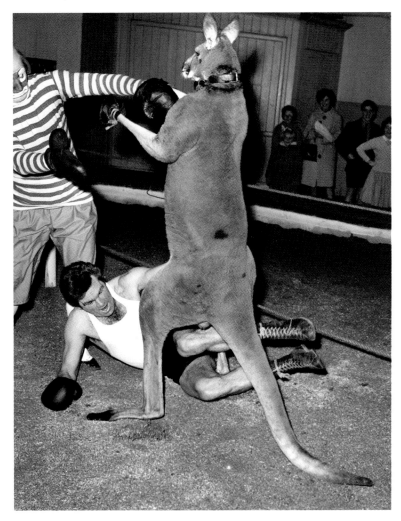

Freddie Mills, a former British Light-Heavyweight Boxing Champion, is outclassed by George the kangaroo, of the Bertram Mills Circus. The fight took place at Ascot in Berkshire in preparation for the opening of the Bertram Mills Circus Christmas season at Olympia, London.

25th November, 1962

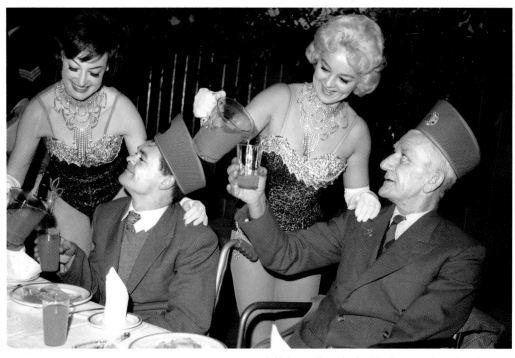

A Christmas Party for the 'Not Forgotten Association': 400 ex-servicemen from hospitals and homes were invited to the event in 1962. Established in 1920, the organization provides entertainment and recreation for the serving wounded and also for the ex-service community with disabilities. Two dancers from the cabaret show, Connie Reid (rear, L) and Mandy Mather (rear, R), serve drinks to two of the guests, Bob Struthers (front, L) and Paddy McCarthy (front, R).
13th December, 1962

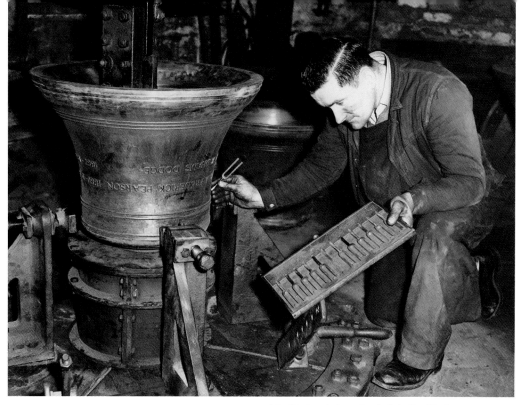

John Mackenzie tunes in a bell destined for the new Cathedral in Washington D.C., USA, at the Whitechapel Bell Foundry in London. The foundry is listed by the *Guinness Book of Records* as the oldest manufacturing company in Great Britain, dating back to at least 1570. The bell for Big Ben, which tolls the hour at the Palace of Westminster, was cast at the foundry in 1858 and at 13½ tons is the largest bell the company has ever created.

19th December, 1962

A security guard guards the office of the Pools Selection Board, as Chairman Lord Brabazon (L), with Board members Ted Drake (C) and Tom Finney (R), work out predictions for the Football League matches cancelled due to the 'Big Freeze'. The winter of 1962–63 was one of the coldest ever recorded in the United Kingdom. The freezing conditions began in December 1962 and continued until March the following year.

26th January, 1963

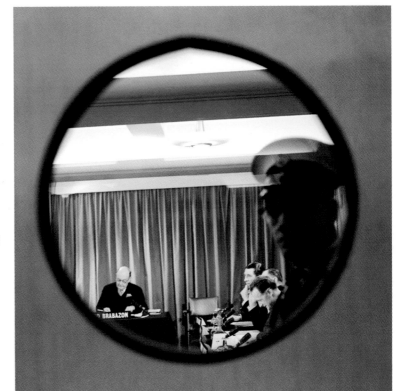

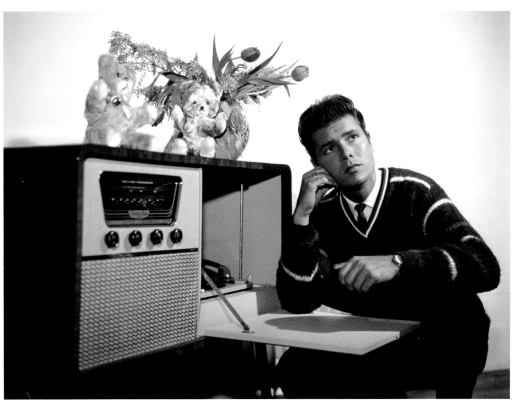

Singer Cliff Richard listens carefully to a record on his radiogram at home. He is pictured here during a break from rehearsals wth his backing band, the Shadows. By 1963, Cliff had also become a film star, and was one of Britain's major cinema box-office attractions.
20th February, 1963

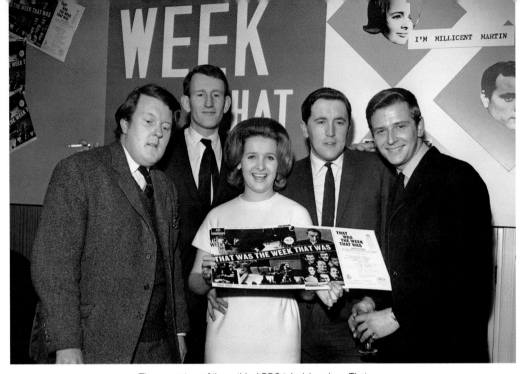

The presenters of the satirical BBC television show *That Was The Week That Was*, displaying the record sleeve of a Parlophone long-playing record featuring items from the show. They are shown here at a reception at Durrant's Hotel in London to mark the release of the album: (L–R) Willie Rushton, Lance Percival, Millicent Martin, David Frost and David Kernan.

21st February, 1963

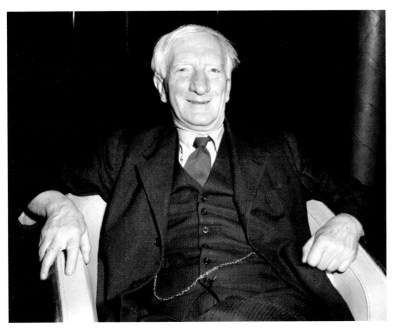

Lord Beveridge, author of the 1942 Beveridge Report for social security, who died at the age of 84 on 16th March, 1963 at his Oxford home. Born in Bengal, the son of a civil servant, Lord Beveridge was immensely influential in socio-economic matters. The Beveridge Report provided the basis for the post-World War II welfare state put in place by the Labour government elected in 1945.

17th March, 1963

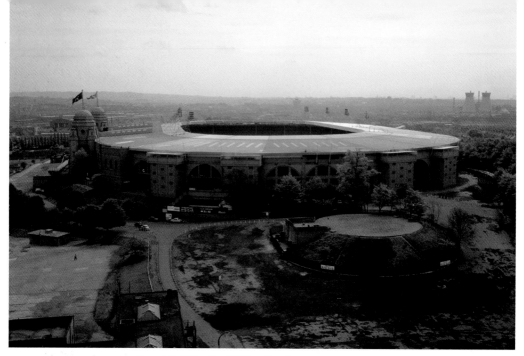

The original Wembley Stadium. New improvements were added in 1963, including an electric scoreboard and the all-encircling roof. Officially known as the Empire Stadium, it was built in 1924. The architects were Sir John Simpson and Maxwell Ayrton, and the Head Engineer Sir Owen Williams. The 82,000-capacity building hosted FA Cup Finals, five European Cup finals, the 1948 Olympics, the 1966 World Cup Final, Summerslam '92, the Final of Euro '96 and the Live Aid concert of 1985 before its closure in 2000 and demoltion in 2003. A new, 90,000-capacity Wembley Stadium was opened in 2007.

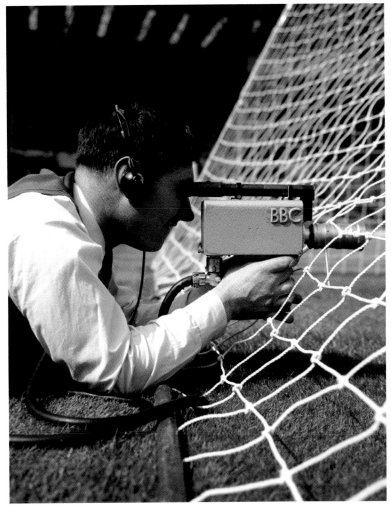

A BBC camera man films through the goal in the European Champions Clubs' Cup Final between Benfica and AC Milan at Wembley Stadium. The Portuguese club Benfica were holders of the cup, but the Italian team AC Milan beat their rivals in a 2–1 victory. The BBC's very first televised football match – a specially-arranged friendly between Arsenal and Arsenal Reserves at Highbury – was screened on 16th September, 1937. This was followed by the first international match, between England and Scotland on 9th April, 1938. The first televised FA Cup final followed soon after, on 30th April the same year, between Huddersfield Town and Preston North End.

22nd May, 1963

Manchester United captain Noel Cantwell clowns with the FA Cup, watched by teammate Maurice Setters, as the triumphant United team begin their journey back to Manchester after beating Leicester City 3–1 in the FA Cup Final in 1963.

26th May, 1963

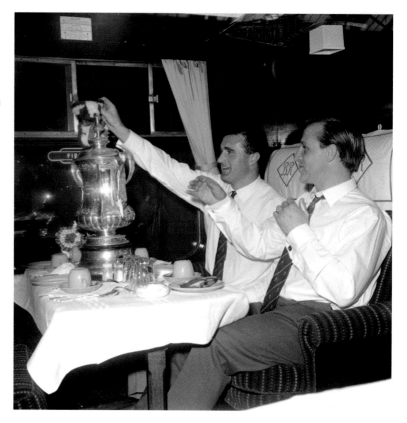

Cassius Clay (later known as Muhammad Ali) takes a breather during an early morning run through Hyde Park, in training for his non-title Heavyweight bout with Henry Cooper, scheduled for 18th June, 1963. The boxing legends fought against each on two occasions – the second clash was in 1966 in Highbury, London, by which time Clay (now Ali) had become World Heavyweight Champion.

28th May, 1963

War Minister John Profumo. His affair with Christine Keeler, the reputed mistress of an alleged Russian spy, followed by lying in the House of Commons when he was questioned about it, forced his resignation. In his letter of resignation he writes that his *"statement in the House of Commons on 22nd March regarding relations with Miss Christine Keeler, was not true, and misled the Prime Minister and the House of Commons"*. Profumo also damaged the reputation of Prime Minister Harold Macmillan's government. Macmillan himself resigned a few months later due to ill health.

5th June, 1963

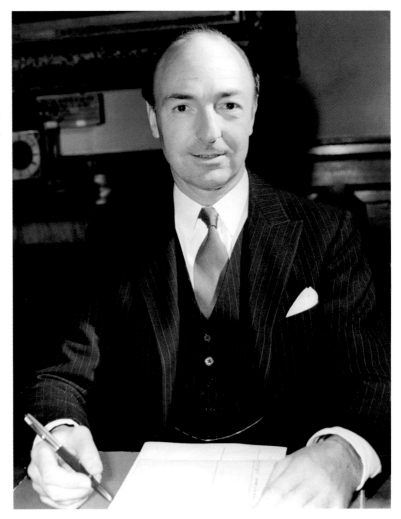

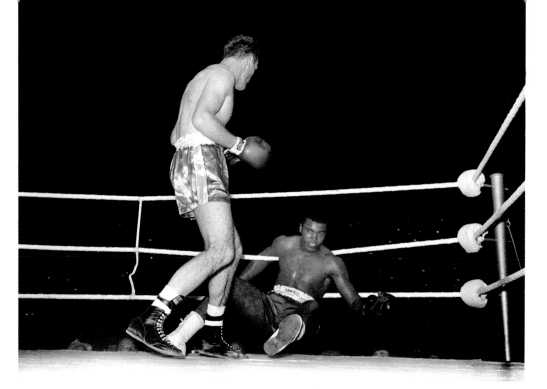

Henry Cooper knocks down Cassius Clay during the fourth round of their Heavyweight bout. The result of the clash was a technical knockout – although Cooper was ahead on the scorecards. Clay opened a wound under his opponent's eye in the fifth round that led to the referee stopping the fight and declaring Clay the winner.

18th June, 1963

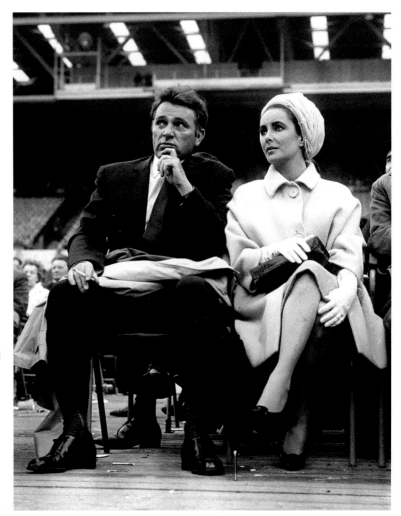

Elizabeth Taylor and Richard Burton, stars of the film *Cleopatra*, at the ring side at Wembley, London for the Heavyweight match between Henry Cooper and Cassius Clay in 1963. Burton and Taylor fell in love while working together on the set of *Cleopatra* and were married – for the first time – in 1964.
18th June, 1963

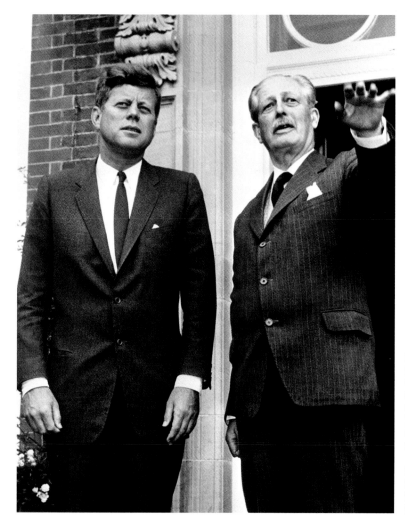

Prime Minister Harold
Macmillan (R) points out
the lie of the land at Birch
Grove, his Sussex home, to
the visiting President John
F. Kennedy of the United
States, during a break in
their informal talks in June,
1963. By the end of October,
Macmillan had resigned
from office in the wake of
the Profumo scandal.
30th June, 1963

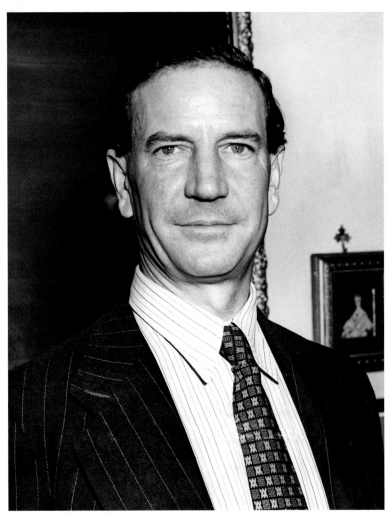

Kim Philby, KGB and NKVD spy. In 1963, Philby was revealed to be a member of the spy ring now known as the Cambridge Five, the other members of which were Donald Maclean, Guy Burgess, Anthony Blunt and John Cairncross. Philby is believed to have been the most successful member of the ring in providing secret information to the Soviet Union. He defected to Moscow, where he was granted political asylum and Soviet citizenship. He died in 1988 and was awarded a hero's funeral by the USSR.
1st July, 1963

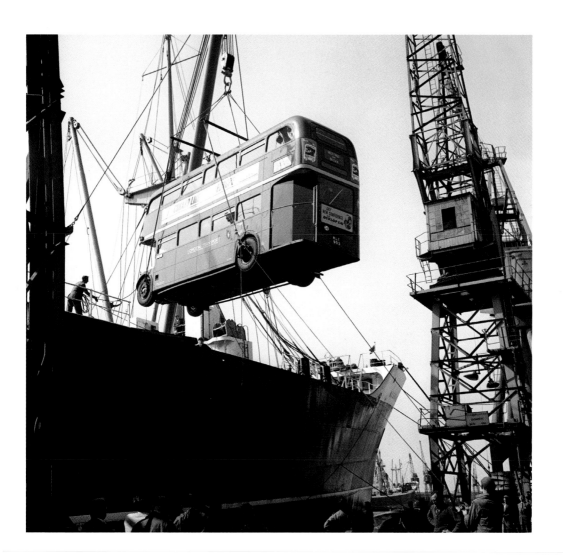

Sightseers surround French actress Brigitte Bardot as she sits on the back of a bench at Hampstead, London, during a break from the filming of *An Adorable Idiot*. The film, which also starred Anthony Perkins, was a light-hearted Cold War romp in which Bardot played Penelope Lightfeather, a glamorous Soviet intelligence agent.
25th October, 1963

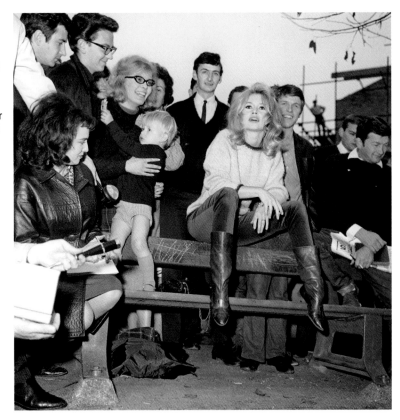

Bystanders look on during the Tar Barrel Burning Ceremony in Ottery St Mary, Devon. On the 5th November each year, the local residents celebrate Bonfire Night by carrying flaming tar barrels through the streets, a practice that's continued for hundreds of years and was originally connected with the ritual burning of witches.

5th November, 1963

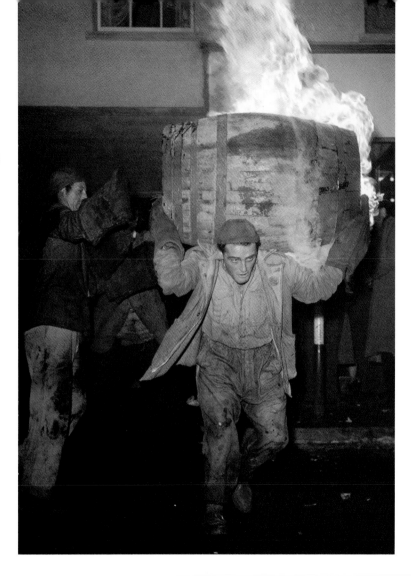

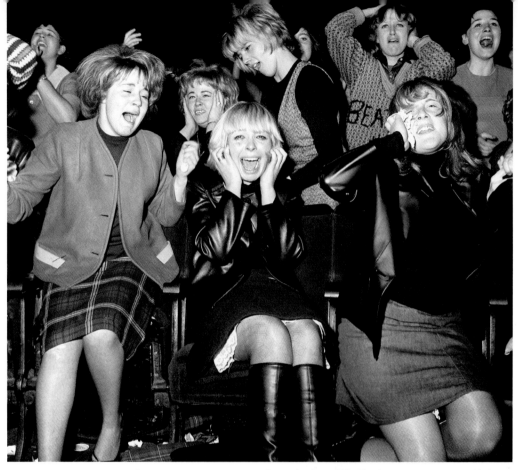

Screaming fans of The Beatles pop group, at one of their concerts in Manchester. The group's first album *Please Please Me* was released on 22nd March, 1963. The No. 1 record was hugely successful, and led to the birth of of the phenomenon known as 'Beatlemania'.

21st November, 1963

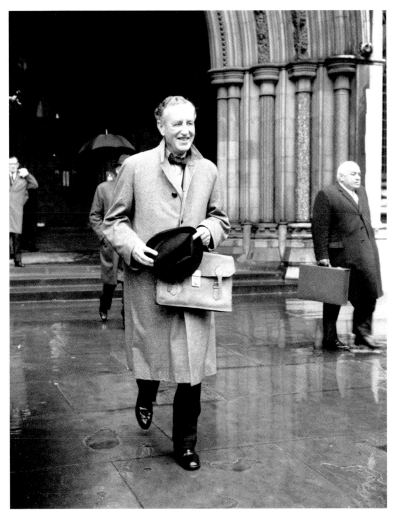

Ian Fleming, creator of secret service agent James Bond, during the lunch adjournment of the High Court hearing in which he is being sued for alleged infringement of copyright. Fleming, producer Kevin McClory and scriptwriter Jack Whittingham had worked together on a potential film script. Fleming later turned this into the novel *Thunderball* and did not credit them. McClory took Fleming to the High Court, with the resolution that all future copies of the novel should carry the statement *"based on a screen treatment by Kevin McClory, Jack Whittingham, and Ian Fleming"*.

21st November, 1963

Daleks board a London bus, but are unlikely to travel on the upper deck due to their inability to climb stairs. The metallic alien menaces made their first appearance in December 1963 in the second story of the new BBC Television series *Doctor Who*. They were a huge success, spawning a merchandising phenomenon and terrifying small children across the nation.

23rd December, 1963

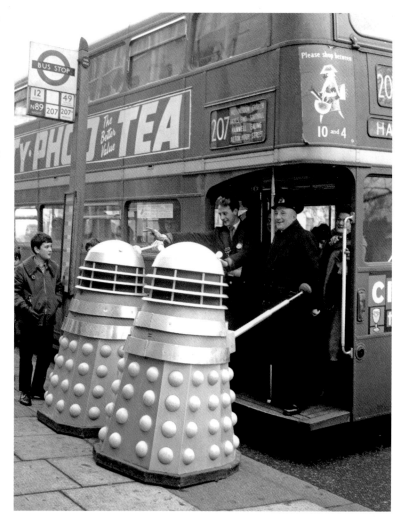

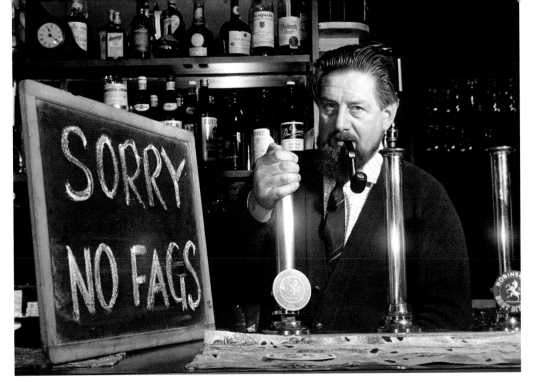

In a move that anticipated future health concerns and legislation over smoking, forward-thinking landlord Arthur Slater is seen here in 1964 behind the bar of the Red Bull Hotel, Stockport, Cheshire, where he has decided to stop selling cigarettes – while refusing to part with his pipe.

27th January, 1964

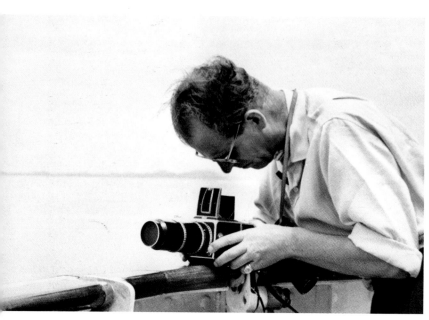

Prince Philip, the Duke of Edinburgh, takes a
photograph with his Hasselblad camera aboard
the Royal Yacht *Britannia*. A keen bird-watcher
and nature lover, Prince Philip published a book
of his photographs entitled *Birds From Britannia*
for Longmans Publishers in 1962. It consisted
of photographs of seabirds – some of them rare
and unusual – that he had taken on previous
expeditions around the world aboard the yacht.
1st February, 1964

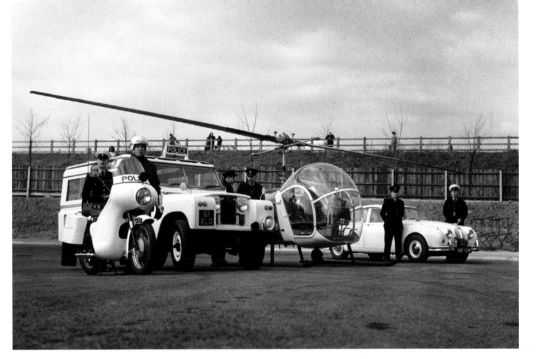

A selection of state-of-the-art police vehicles, used by officers in the 1960s in the fight against crime. L–R: a Norton motorcycle, Land Rover, Westland Sioux helicopter and Jaguar pursuit vehicle.
9th March, 1964

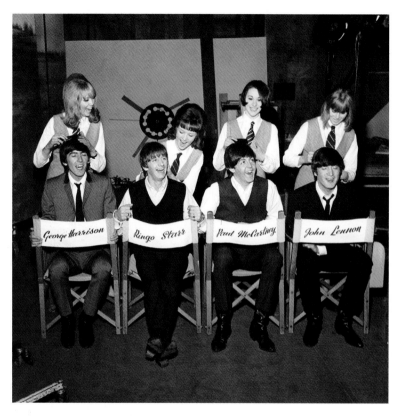

The Beatles, seated on chairs bearing their names, have their hair worked on by (L–R) Pattie Boyd (later Pattie Harrison, then Clapton), Tina Williams, Pru Berry and Susan Whiteman. They are pictured here on the set of *A Hard Day's Night* at Twickenham in London. The highly acclaimed movie was the first of five Beatles films.
16th March, 1964

Facing page: In the 1960s, the range of food products available to British consumers expanded greatly, as convenience foods and new imported goods filled the shelves and racks of the new supermarkets. By 1969, there were around 3,400 supermarkets throughout Great Britain.
19th March, 1964

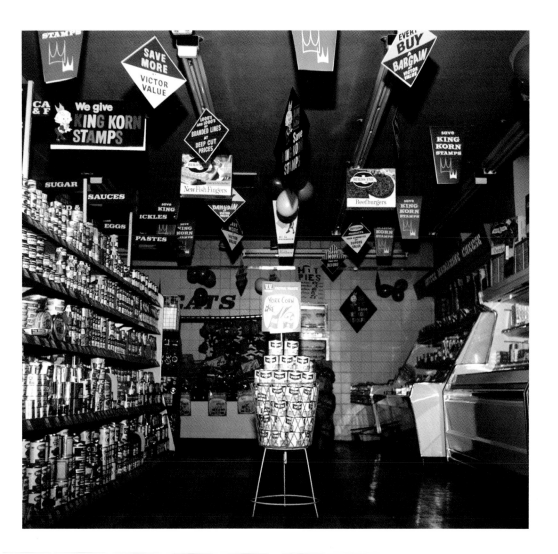

Honor Blackman (Pussy Galore) meets Sean Connery (James Bond) during a press conference at Pinewood Studios for the third Bond film, *Goldfinger*. The film was a huge financial success, recouping its $3 million budget in just two weeks at the box office. It was also critically acclaimed and is considered to be one of the best-ever Bond films. Widely regarded as the definitive James Bond, Connery portrayed the super-spy in seven Bond films between 1962 and 1983 (six 'official' Eon Productions films and the non-official *Thunderball* remake, *Never Say Never Again*). In 1988, Connery won the Academy Award for Best Supporting Actor for his role in *The Untouchables*. He was knighted in July 2000.

25th March, 1964

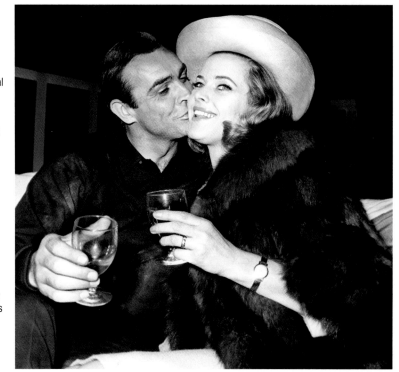

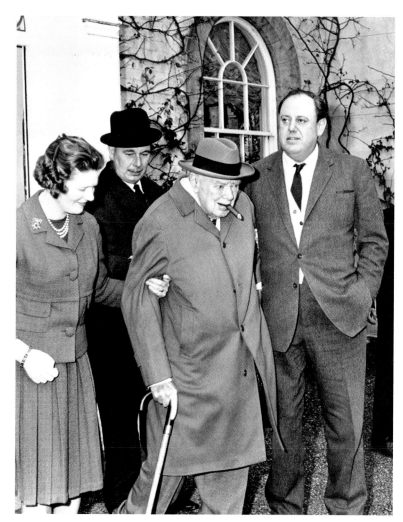

Sir Winston Churchill gets an affectionate helping hand from his daughter, Mary and son-in-law Christopher Soames, as he leaves their home near Tunbridge Wells to return to his house, Chartwell. With Lady Churchill, he had been a guest at a family luncheon party to celebrate her 79th birthday.

1st April, 1964

A 15-year-old singer from Scotland, Lulu made her debut in 1964 with the hugely popular *Shout*, a cover version of a song written by the Isley Brothers. Born Marie McDonald McLaughlin Lawrie on 3rd November, 1948 in Lennoxtown, Stirlingshire, Lulu's success as a singer, actress and television personality continues to the present-day.

14th April, 1964

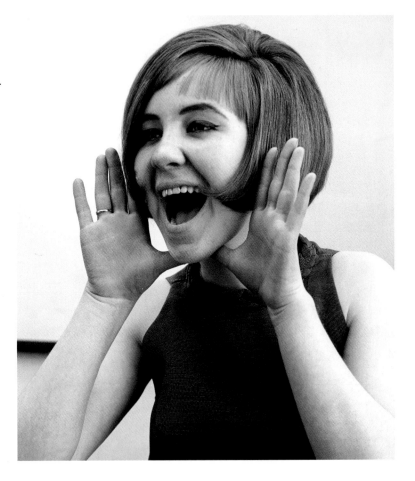

Ronald Biggs, sentenced to 30 years in prison for his role in the Great Train Robbery. He escaped from London's Wandsworth prison after 15 months and went on the run for more than 30 years, living in Australia and Brazil. He returned to the UK voluntarily in 2001 in search of medical treatment. In 2009, he was released from prison to a care home on compassionate grounds after suffering from ill health.
15th April, 1964

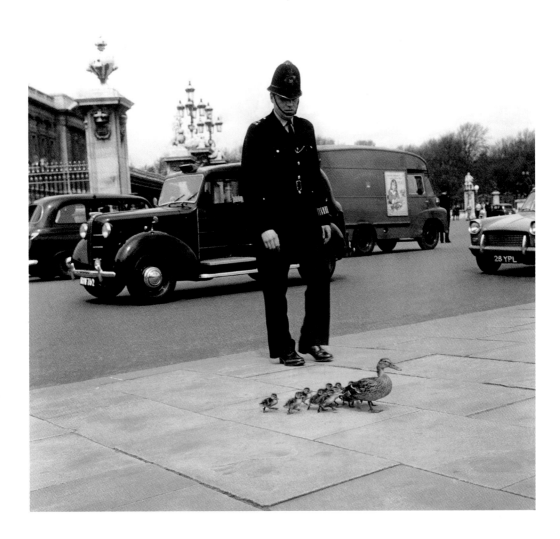

Concert pianist, Joseph Cooper, who is to play at the Bath Festival, poses for an ironic photograph with a dummy keyboard while taking a bath at his home in Surrey. Cooper later became a familiar face on British television as the chairman of the BBC's long-running TV panel game *Face the Music*. which ran from 1964 to 1979.
11th May, 1964

Facing page: Safely through the traffic outside Buckingham Palace, mother duck and the ducklings march on – under police escort – to St James Park and the peace of the lake. The 58-acre park in the City of Westminster, central London is the oldest of the Royal Parks of London. It lies at the southernmost tip of the St James's area, which was named after a leper hospital dedicated to St James the Less.
4th May, 1964

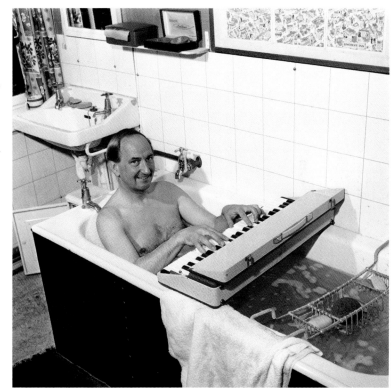

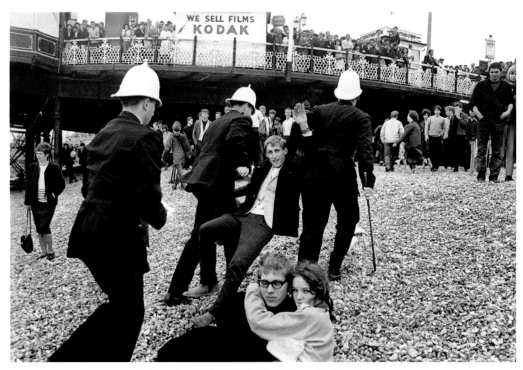

Police make arrests during fighting between Mods and Rockers on the beach at Brighton, Sussex. There were many clashes between the two British youth sub-cultures in the early to mid-1960s. Rockers wore leather jackets and rode heavy motorcycles, while the Mods often wore suits and rode scooters. The Rockers considered Mods to be effeminate snobs, and Mods saw rockers as out of touch, oafish and scruffy.

18th May, 1964

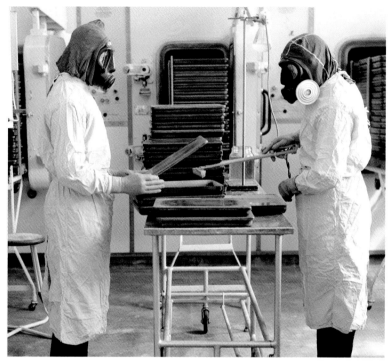

Protected by masks, gloves, overalls and rubber boots, scientists carry out experimental work on an improved anthrax vaccine at the Microbiological Research Establishment at Porton Down, near Salisbury, Wiltshire. Porton Down was set up in March 1916 to provide a scientific research facility for the British use of chemical warfare, in response to the earlier German deployment of chemical weapons in 1915.

23rd May, 1964

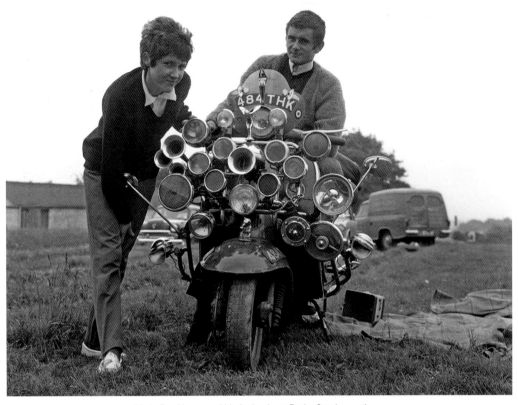

Mods Roy Young and Linda Jarvis on Derby Sunday on the Epsom Downs, with their fully-dressed motor scooter. Mod (from the term 'modernist') is a subculture that originated in London and peaked in the early-to-mid 1960s. Elements of the subculture include fashion (tailor-made suits and oversized parkas), scooters, soul music, Jamaican ska, British beat music (bands such as the Small Faces, the Kinks and The Who) and R&B (rhythm and blues).

31st May, 1964

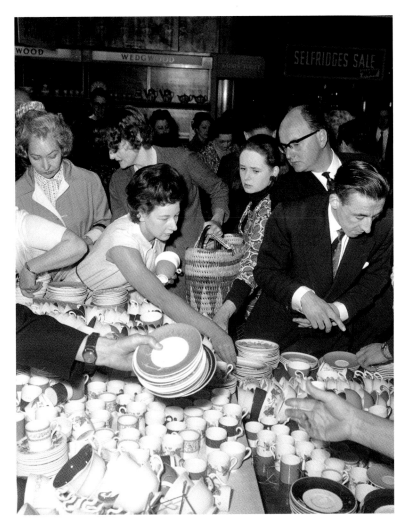

Shoppers in the China department of Selfridges store in Oxford Street, London, during the first day of the middle-of-the-year sale in June 1964. The United Kingdom's relative economic prosperity during the 1960s led to an increase in consumer spending after the austere years of the 1950s.

25th June, 1964

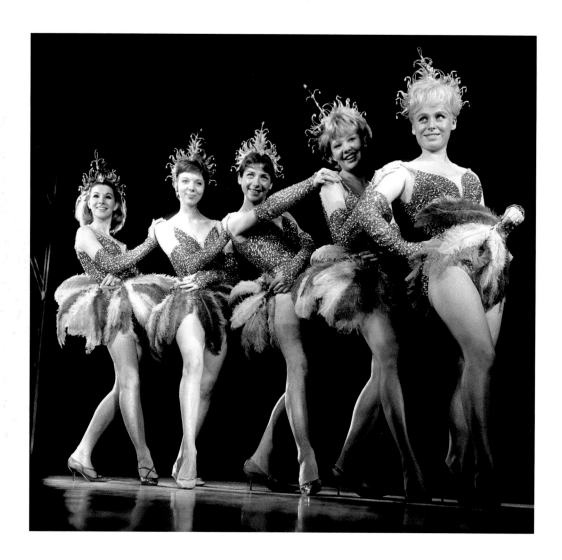

Future Liberal Democrats leader Menzies 'Ming' Campbell as a 23-year-old Glasgow University law student, crossing the finishing tape to win the 220-yards Final at the Amateur Athletics Association (AAA) athletics Championships in London. Campbell held the British record for the 100 metres sprint from 1967 to 1974, having run the distance in 10.2 seconds. He also captained the Great Britain's national athletics team in 1965 and 1966.
23rd July, 1964

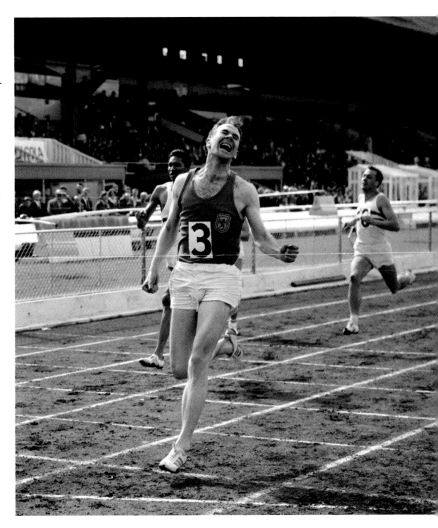

Facing page: Top names of British showbusiness at the London Palladium in the *Night Of 100 Stars*. From left: Susan Hampshire, Anna Massey, Miriam Karlin, Hayley Mills and Barbara Windsor.
5th July, 1964

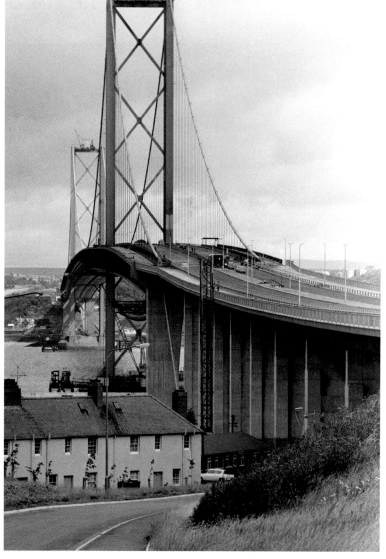

The Forth Road Bridge opens in Scotland, spanning the Firth of Forth – an estuary, or firth, of the River Forth, where it flows into the North Sea – to connect Edinburgh and Fife. The new bridge replaced a centuries-old ferry service. The Firth is geologically a fjord, formed thousands of years ago in the last glacial period. In Roman times, the Firth was known as 'Bodotria'.
17th August, 1964

Facing page: Teenagers listen to the latest tunes on the jukebox in the Freight Train Coffee Bar in Soho, London. The bar was owned by Chas McDevitt, a star of the US-influenced 'Skiffle' music scene, which encouraged young people to make their own rhythmic music using improvised instruments such as home-made guitars, washboards and kazoos.
1st September, 1964

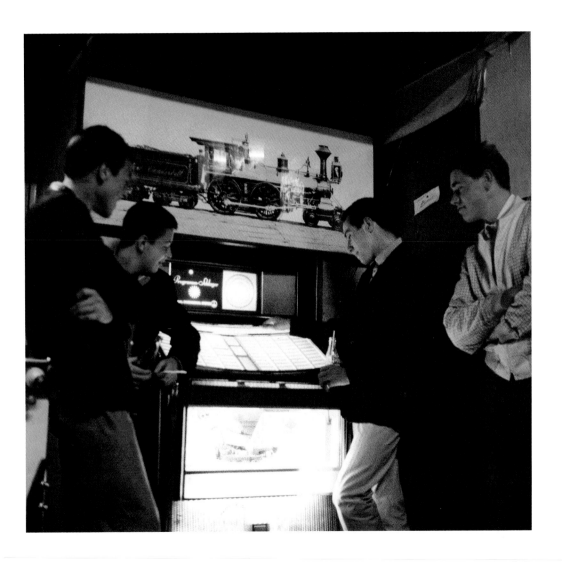

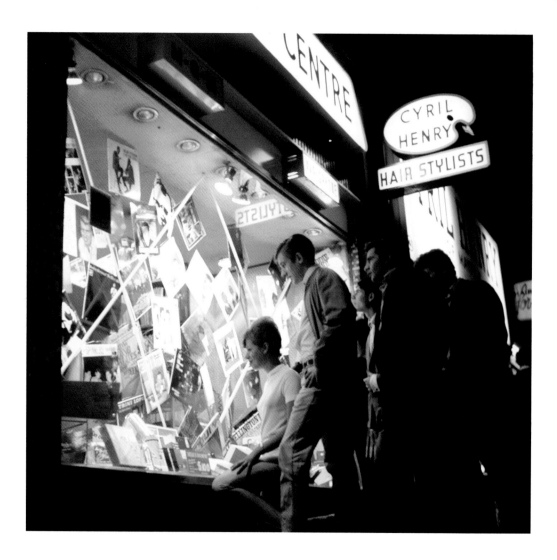

Robert Maxwell, elected as a Labour MP for Buckingham in 1964. He was re-elected in 1966, but lost in 1970 to the Conservative William Benyon. Czechoslovakian-born Maxwell built up a media empire in Britain, acquiring Mirror Group Newspapers from Reed International plc in 1984. He died in 1991, after falling overboard from his luxury yacht, *Lady Ghislaine*. After his death, his empire collapsed amidst the revelations that he had used hundreds of millions of pounds from his companies' pension funds to save his businesses from bankruptcy.
1st September, 1964

Facing page: Teenagers window-shop for records in Coventry Street, London. The 1960s was a boom time for record shops in the UK, with thousands of outlets throughout the country. Music-hungry teenagers would pore over the record racks in search of the latest home-grown or imported sounds.
1st September, 1964

Blues and Northern Soul singer Joe Cocker (R) buys a copy of his first single, a cover version of The Beatles' song, *I'll Cry Instead*. Despite major promotion from his record company, Decca, the record flopped and his recording contract lapsed at the end of 1964. Four years later, Cocker's arrangement of another Beatles' song, *A Little Help From My Friends*, finally made him a international star, reaching No. 1 in the British charts on 9th November, 1968.

1st September, 1964

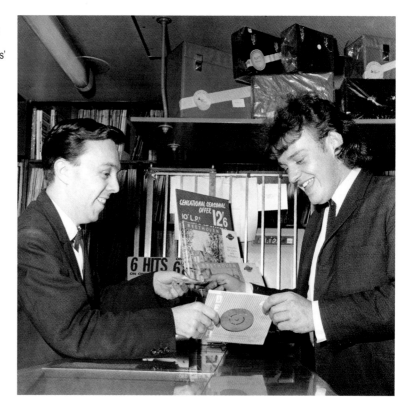

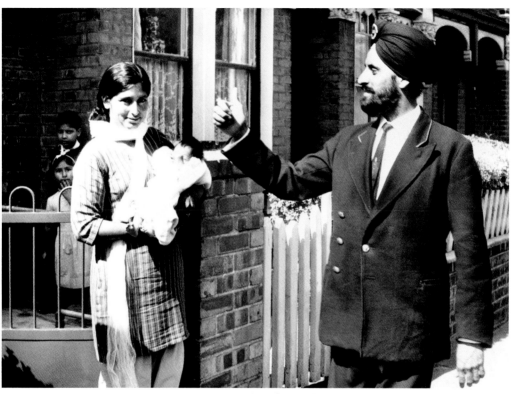

Amar Singh, a Sikh train guard who has been given permission to wear his turban while on duty on London's Underground, with his wife, Amrid, and their 13-day-old daughter, at their Southall, Middlesex home. As increasing numbers of migrant workers arrived in Britain from India and the Commonwealth, British society had to adapt to the cultural differences, religious beliefs and customs of its new citizens.

2nd September, 1964

The Rolling Stones, banned from the BBC in 1964 for showing up late for radio shows. Deliberately marketed by their manager Andrew Loog Oldham as rebellious 'bad boys' in contrast to the clean-cut image of The Beatles, the ban only added to the Stones' rock 'n' roll reputation. L–R: Mick Jagger, Bill Wyman, Brian Jones, Keith Richards and Charlie Watts.

12th September, 1964

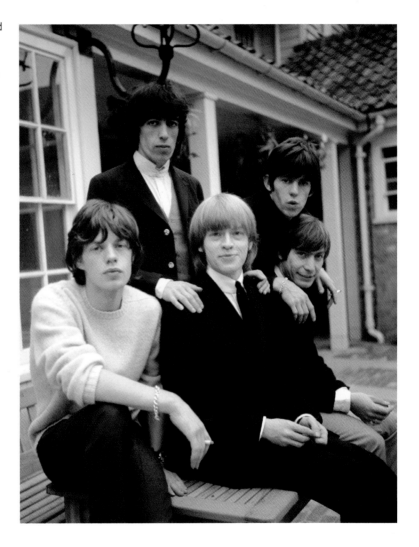

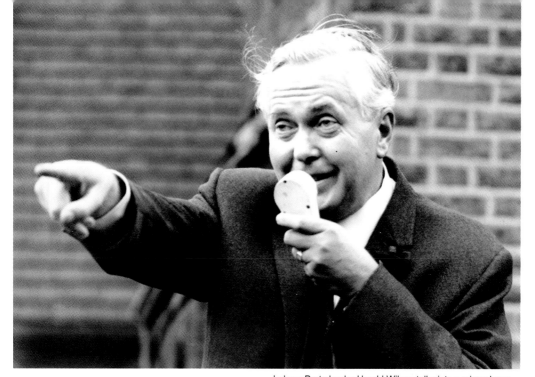

Labour Party leader Harold Wilson talks into a microphone during a campaign tour of London constituencies. On 16th October, 1964, he became Prime Minister of the United Kingdom, a position he held until 1970. In 1974, he led a minority government after the General Election in February resulted in a hung parliament. Wilson is the most recent British Prime Minister to have served non-consecutive terms.

1st October, 1964

American singing group The Supremes outside EMI House in London during a visit to Britain. L–R: Diana Ross, Mary Wilson and Florence Ballard. Originally named The Primettes in Detroit, Michigan, in 1959, The Supremes were the most commercially successful of the Motown record label's acts with 12 number one singles. Most of these hits were written and produced by Motown's main songwriting and production team, Holland-Dozier-Holland.

8th October, 1964

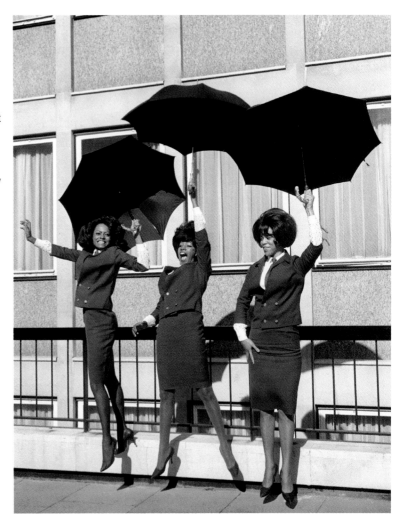

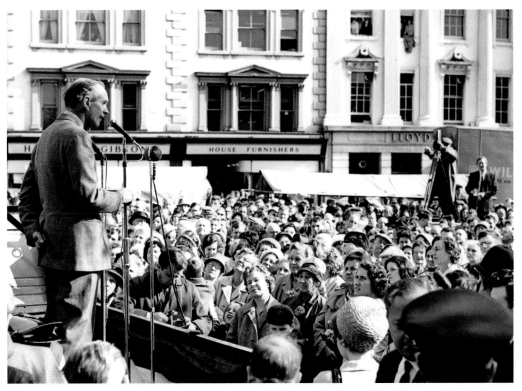

Sir Alec Douglas-Home, Prime Minister and Leader of the Conservative Party, addressing a lunchtime meeting, mainly composed of women, in Bedford. The meeting was part of the Conservatives' 1964 General Election campaign, which ended in defeat for Douglas-Home and his party as the electorate voted Labour into power.
8th October, 1964

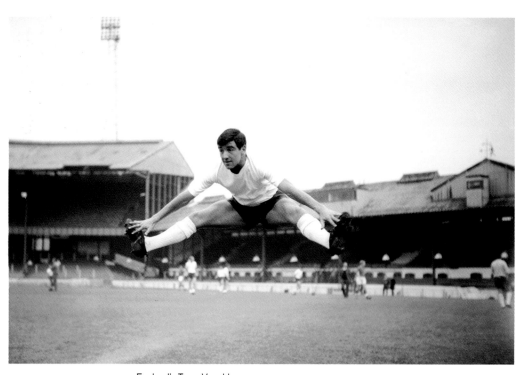

England's Terry Venables
practises his splits at
Chelsea Football Club's
Stamford Bridge ground in
preparation for a friendly
international match against
Belgium. The game resulted
in a 2–2 draw.
19th October, 1964

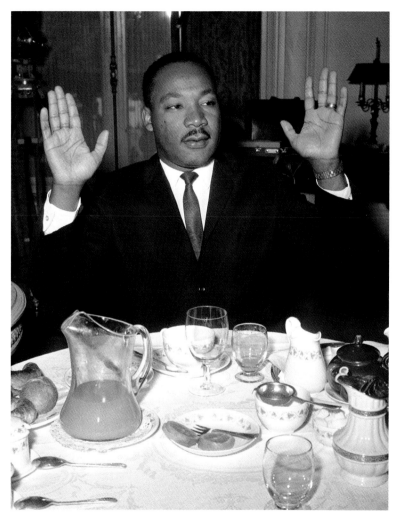

Dr Martin Luther King at the Ritz Hotel in London on a one-day visit to launch the British publication of his book *Why We Can't Wait*. King was a major figure in the African-American civil rights movement in the United States, basing his approach on the non-violent methods of India's Mahatma Gandhi. In 1964, he received the Nobel Peace Prize for his work. King was assassinated on 4th April, 1968, in Memphis, Tennessee. He was posthumously awarded the Presidential Medal of Freedom in 1977 and Congressional Gold Medal in 2004. Martin Luther King, Jr Day was established as a US Federal holiday in 1986.

21st October, 1964

The Ford Cortina was voted the International Car of the Year, with a top speed of over 80 mph, at the Earls Court Motor Show in 1964. The Cortina was Ford's first British mass-market mid-sized car. It was a great success, and it became a common sight on British roads. Five generations of the car were produced from 1962 until 1982, when it was replaced by the Ford Sierra.

21st October, 1964

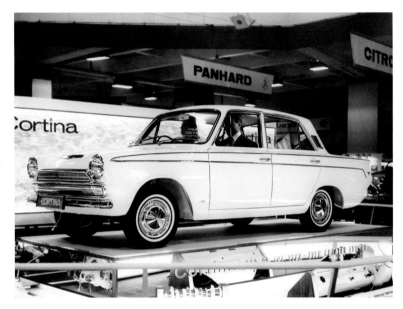

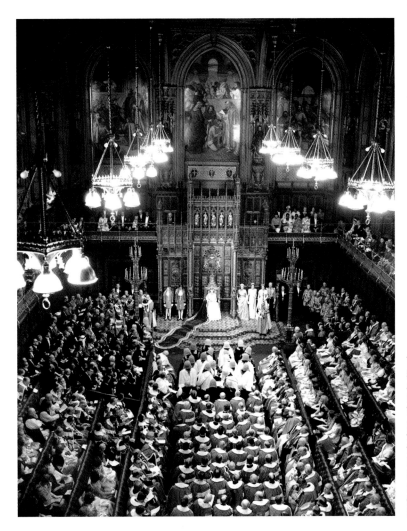

The Queen reads her speech from the throne at the State Opening of Parliament as Harold Wilson's Labour Party prepare to take power following their success at the 1964 General Election. It was the first time the Queen had opened Parliament with a Labour government.

3rd November, 1964

Carole Ann Ford, who plays the Doctor's grand-daughter Susan in BBC Television's *Doctor Who*, autographs a copy of the *Dalek Book*. She is also demonstrating a child-powered Dalek toy. The Daleks were a huge hit with children across the nation in the 1960s and Dalek toys were on every child's Christmas present list in 1964.

28th November, 1964

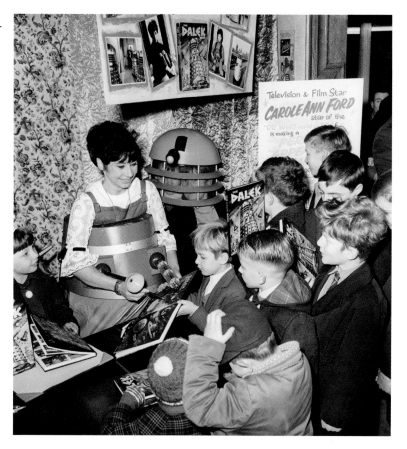

Manchester United manager Matt Busby, the first recipient of the Football Sword of Honour, presented to him in Manchester for 'distinguished service to British and international football'. In 1958, after a European Cup tie against Red Star Belgrade, the Manchester United team's plane crashed on the runway at Munich Airport. Many players died and Busby himself was seriously injured. He went on to rebuild the team, leading Manchester United to a 3–1 victory over Leicester City in the 1963 FA Cup Final.
2nd December, 1964

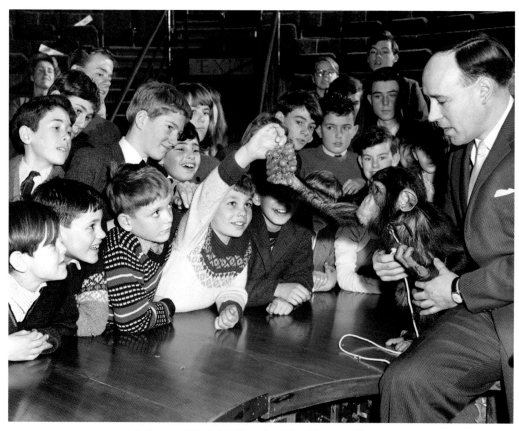

Dr Desmond Morris introduces Butch the chimpanzee, from London Zoo, to children at the Royal Institute Christmas Lectures. Morris, a renowned zoologist and anthropologist, was also a children's television presenter, hosting *Zoo Time* for ITV from 1956 to 1968.

12th December, 1964

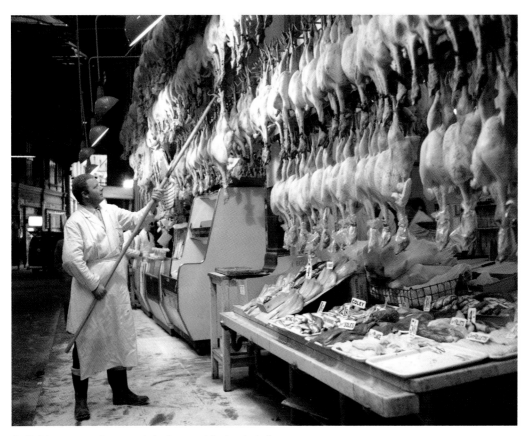

As Christmas approaches, a market salesman at the Leadenhall Market in the heart of the City of London takes a turkey off the line. Leadenhall dates back to the 14th century, and primarily sells fresh food. Originally a meat, game and poultry market, it stands on land that was once the centre of Roman London.

21st December, 1964

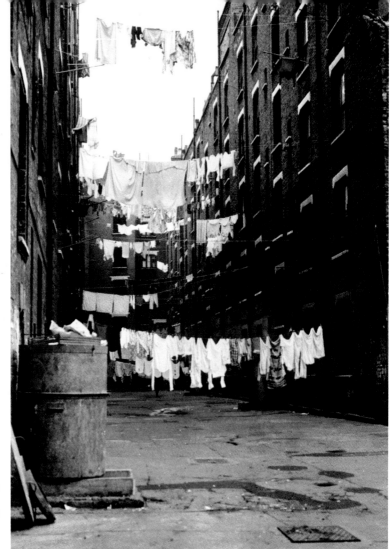

Washing hangs over a courtyard between slum tenements in Southwark, South London. Much of Southwark was run-down, war-damaged and neglected in the 1960s. Since the 1980s, regeneration of the area has led to it becoming a prosperous part of the city. It now contains many desirable and expensive commercial and private properties.
January, 1965

Mick Jagger of the Rolling Stones during filming for *Ready, Steady, Go*. The programme was one of the first British rock and pop TV shows. To begin with, artists mimed to records but the show switched to all-live performances in April 1965. The ITV programme was broadcast from August 1963 until December 1966. As lead singer of the Rolling Stones, Jagger has enjoyed five decades of success with the group. His distinctive voice and performance style, along with Keith Richards' guitar riffs, have been the trademark of the Rolling Stones throughout their career. Knighted in 2003, Jagger is one of the most influential performers in the history of rock 'n' roll music.
January, 1965

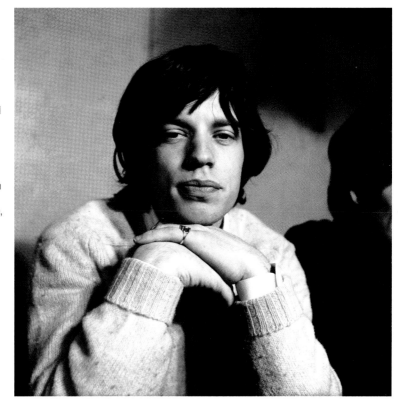

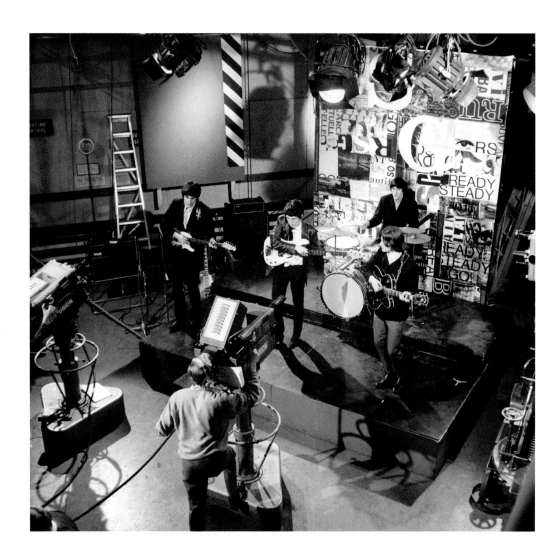

The Duke of Edinburgh and his son, Prince Andrew, alight from their railway carriage at Liverpool Street Station, London. They are returning to the capital from the Royal country retreat at Sandringham with the Queen and Prince Edward.
27th January, 1965

Facing page: The Kinks perform for the cameras of *Ready, Steady, Go*. Formed in 1964 by brothers Ray and Dave Davies, the Kinks were a highly influential British band who achieved great success in the United States as well as the UK. Their music featured rhythm and blues, country, folk and British music hall influences LR: Ray Davies, Pete Quaife, Mick Avery (drums), Dave Davies.
5th January, 1965

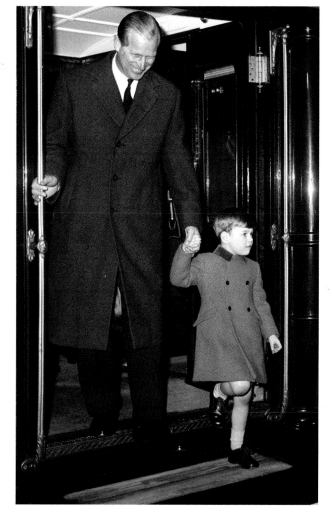

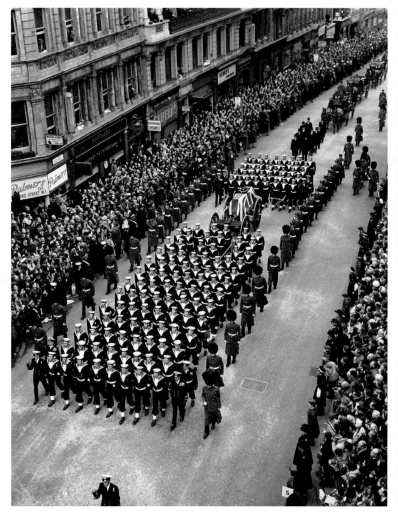

Crowds cram the pavements of London in silent farewell as the gun carriage bearing the coffin of Sir Winston Churchill is drawn by naval ratings up Ludgate Hill to St Paul's Cathedral. A politician and statesman who led the United Kingdom to victory during the dark days of World War Two (1939–45), Churchill was also an historian, a writer, an artist and a military officer. The only British Prime Minister to have received the Nobel Prize in Literature, he was also the first person to be made an Honorary Citizen of the United States.
30th January, 1965

Facing page: The flag-draped coffin of Sir Winston Churchill is carried to the Port of London Authority launch *Havengore* at Tower Pier. It was taken to Waterloo station and loaded onto a special carriage as part of the funeral train for its rail journey to Handborough, near Oxford.
30th January, 1965

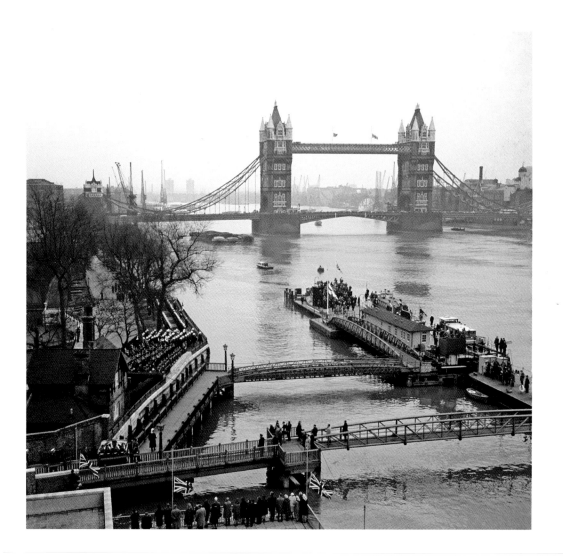

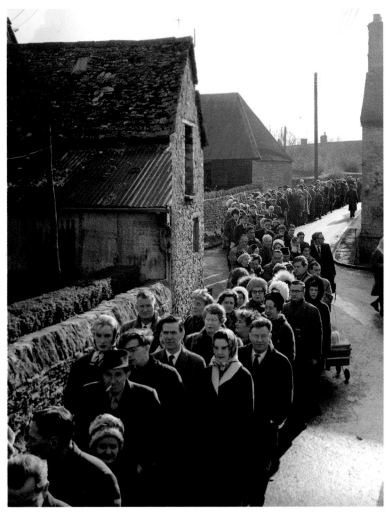

A queue winds its way through the buildings of the village of Bladon, Oxfordshire, where thousands arrived by car to file silently past the grave of Sir Winston Churchill in the churchyard. It was Churchill's request that he was buried in the family plot at St Martin's Church in Bladon, not far from his birthplace at Blenheim Palace.
31st January, 1965

Facing page: Alec Issigonis, creator of the British Motor Corporation's 'Mini' car range, drives the 1,000,000th Mini off the production line at the Longbridge, Birmingham, works in 1965. In 1999 the Mini was voted the second most influential car of the 20th century, behind the Henry Ford's Model T.
2nd February, 1965

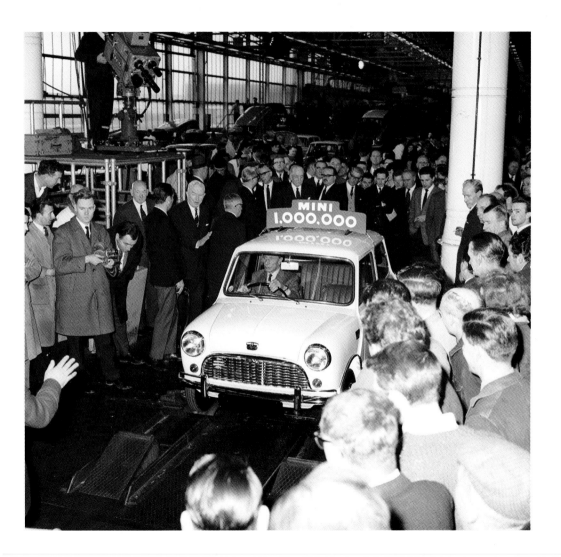

Malcolm X, leader of the American Black Muslim Sect, after flying back to London. He had been barred from entering France because it was believed his presence might cause demonstrations and trouble. Malcom X spoke out against white America's treatment of black Americans, but he was also accused of preaching racism, black supremacy, antisemitism and violence. He was shot dead at the age of 39 while addressing an Organization of Afro-American Unity rally on 21st February, 1965.

9th February, 1965

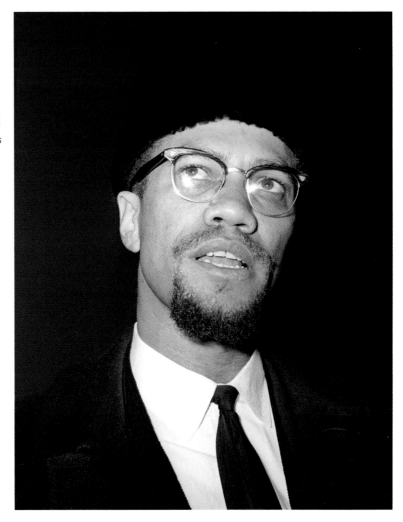

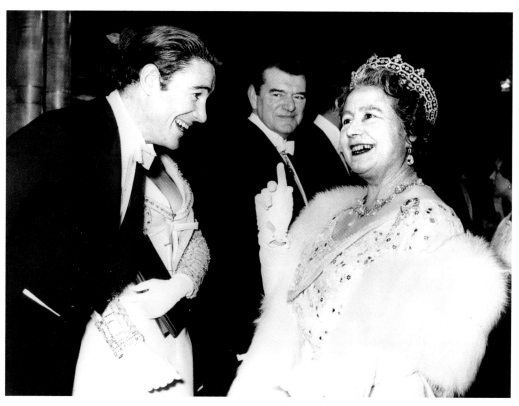

The Queen Mother wags her finger at
British actor Peter O'Toole, during a joke in
the foyer of the Odeon Cinema in Leicester
Square, London, where she was attending
the Royal Film Performance of O'Toole's
new film *Lord Jim*.
16th February, 1965

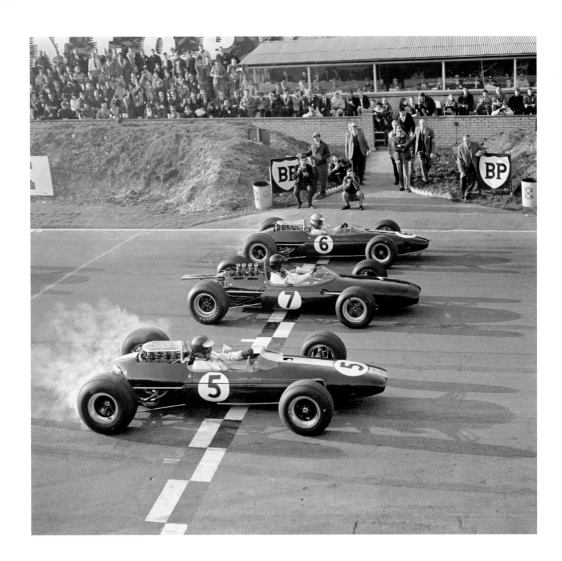

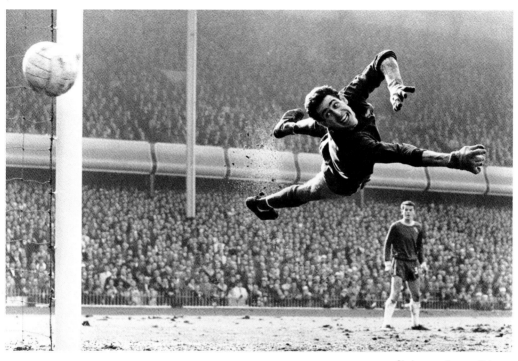

Chelsea goalkeeper Peter Bonetti makes a desperate flying save in the 1965 semi-final FA Cup football match against Liverpool at Wembley Stadium. The result was a resounding 2–0 victory for Liverpool.
29th March, 1965

Facing page: The second heat of the Race of Champions gets underway, as Jim Clark (5), Dan Gurney (7) and Mike Spence (6) move off from the start. This non-Championship motor race, run to Formula One rules, was held at Brands Hatch circuit in Kent. It was run over two heats of 40 laps, and was won overall by Mike Spence, who drove a Lotus 33.
13th March, 1965

Carrying banners, West Country farmers march from Waterloo Station, London, to lobby MPs at the House of Commons before the debate on the farm prices review. 1,200 farmers from Devon, Dorset, Gloucestershire, Somerset and Wiltshire were expected to attend the rally. Farmers were demanding a fair deal from the government through grants and subsidies as the farming industry was under increasing pressure to boost production and reduce reliance on imported beef.
31st March, 1965

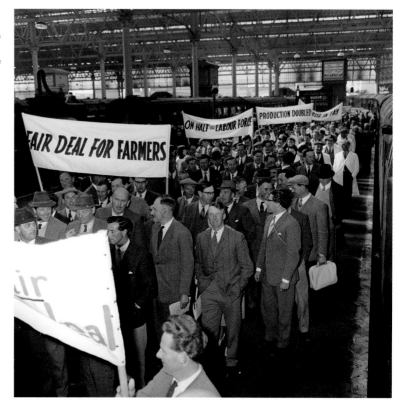

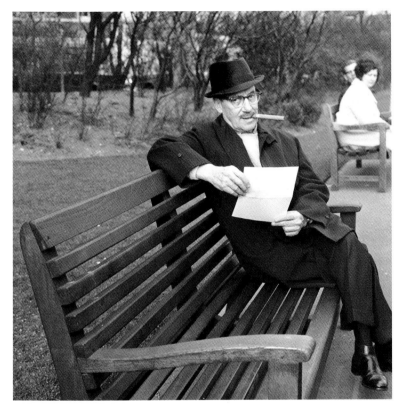

Groucho Marx enjoys the late evening sun in the Embankment Gardens, London. An American comedian and film star renowned for his wit, he made 13 films with his siblings, Chico and Harpo, as the Marx Brothers. In 1965, he featured in a weekly show for British TV titled *Groucho*. Unfortunately, it was unsuccessful and received poor reviews, lasting only 11 weeks before it was cancelled.

31st March, 1965

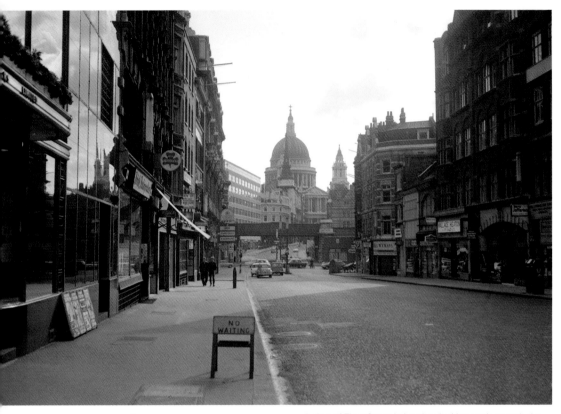

A view of Fleet Street in London, looking north towards the *Daily Telegraph* building. The street was named after the River Fleet, a stream that now flows underground. Up until the 1980s it was the home of the British press, with the last major news office, Reuters, relocating in 2005.
1st April, 1965

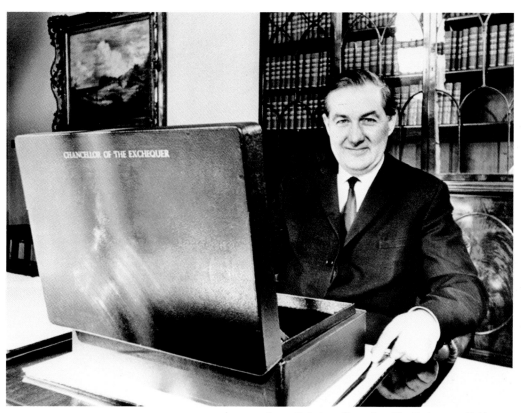

James Callaghan, Chancellor of the Exchequer, with his brown leather despatch box which, he said, symbolised a 'new era'. Callaghan's second budget for Harold Wilson's Labour government was announced on 6th April, 1965, in which he attempted to deflate the economy and reduce home import demand by £250 million to stabilise the British economy and British financial markets.
1st April, 1965

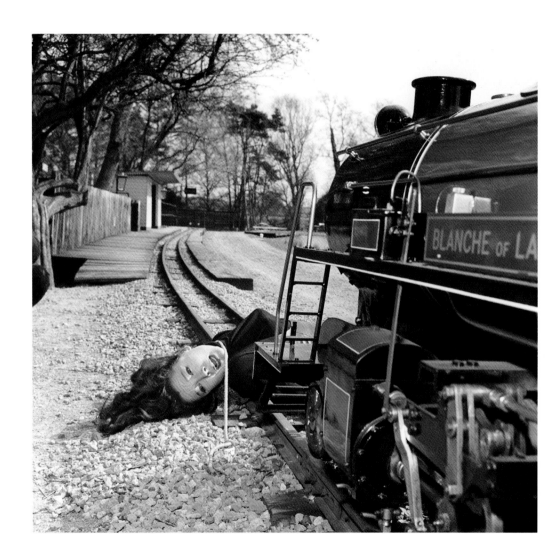

A BEA Sikorsky S-61 helicopter operating from Battersea Heliport in London made 25 journeys across the Thames to Fulham Power Station, carrying materials needed to replace a gas flue duct on the roof. First used in the early 1960s, the Sikorsky S-61 is one of the world's most widely used airliner and oil-rig support helicopters.
5th April, 1965

Facing page: Actress Diana Rigg on a location shoot for a new series of the popular 1960s spy fantasy action drama *The Avengers*. Captured by her enemies, Rigg's character, Emma Peel, is seen here strapped to the rails of a miniature railway near Melton Mowbray, Leicestershire, in an episode entitled *The Gravediggers*.
4th April, 1965

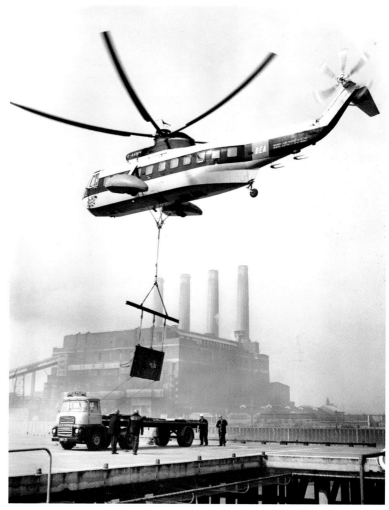

The Beatles (L–R): Paul McCartney, George Harrison, John Lennon and Ringo Starr in an appearance on ABC Television programme *The Eamonn Andrews Show* at Teddington Studios, London. The Fab Four lip-synched to their songs *Ticket To Ride* and *Yes It Is*, and joined Eamonn (rear, holding umbrella) for an extended live television interview.
12th April, 1965

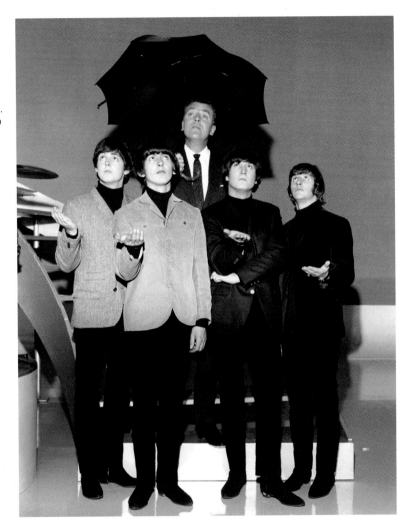

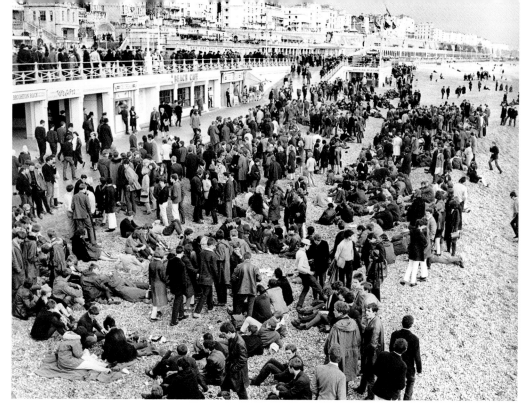

Bank Holiday riots in Brighton. A large crowd of Mods gathers near the Palace Pier on the beach, a scene repeated a number of times at the Sussex resort, where gangs of stylish Mods and their arch-rivals, the leather-clad, motorcycle-riding Rockers, clashed during holiday periods.
17th April, 1965

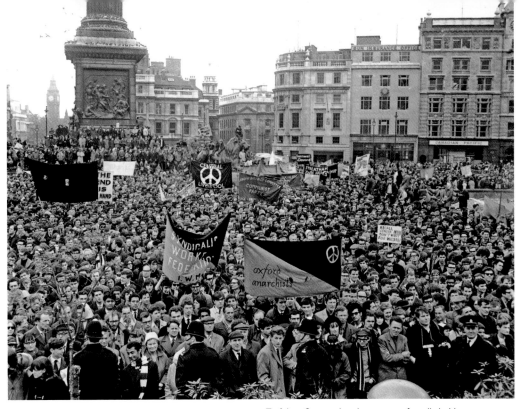

Trafalgar Square, London, scene of a rally held
by the Campaign for Nuclear Disarmament (CND)
after a three-day march from High Wycombe,
Buckinghamshire. CND was formed in 1957 and
advocates unilateral nuclear disarmament by the
United Kingdom, international nuclear disarmament
and more stringent international arms regulation.
20th April, 1965

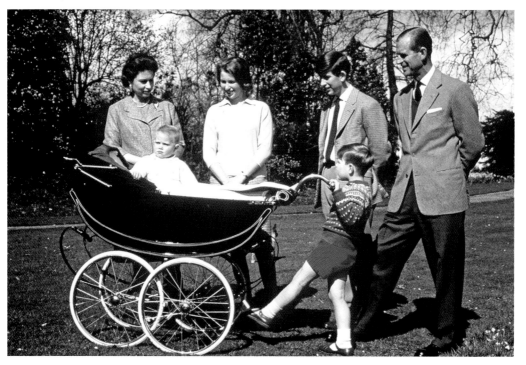

The Queen and her family
relax in the beautiful, leafy
grounds of their Royal retreat
at Frogmore House, Windsor
on her 39th birthday. L–R:
The Queen, Prince Edward
(in pram), Princess Anne,
Prince Charles, Prince Andrew
(pushing pram), Prince Philip.
21st April, 1965

Stoke City's Stanley Matthews walks out onto the pitch before the Stanley Mathews Testimonial Match, Stoke City v World Stars XI. Often regarded as one of the greatest-ever English footballers, he is the only player to have been knighted while still playing. He was also the first winner of both the European Footballer of the Year and the Football Writers' Association Footballer of the Year awards. He was still fit enough to play both for his country and in the First Divsion of English football at the age of 50 – the oldest player ever to do so.
28th April, 1965

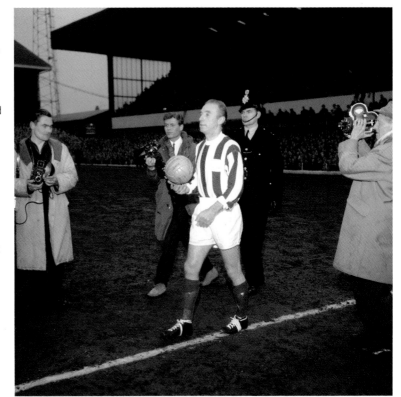

The *Flying Scotsman* locomotive leaves Paddington Station, London, at the head of a special train to commemorate the 20th anniversary of VE Day – the day in which the Second World War Allies formally accepted the unconditional surrender of Nazi Germany's forces. The train is making a round trip to Gobowen, Shropshire. The *Flying Scotsman* earned its name from its usual role as a high-speed express train between London and Edinburgh, which began in 1862 and continues to the present day.
9th May, 1965

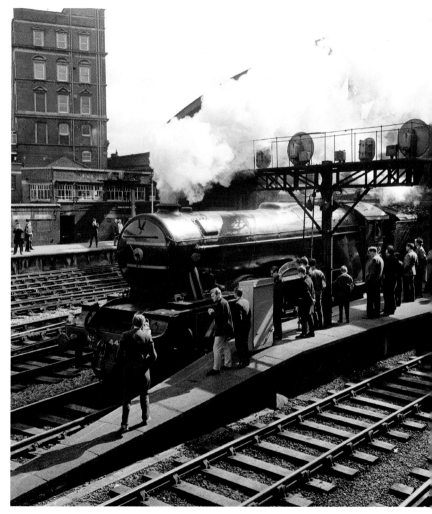

The Postmaster General, Anthony Wedgwood Benn, demonstrating the new 'Trimphone'. The deluxe telephone was to be made available to GPO (General Post Office, the predecessor to British Telecom) customers as an optional extra in strictly limited quantities in North West London. The name is an acronym standing for Tone Ring Illuminator Model, referring to the phone's electronic ringer and its illuminated dial.
10th May, 1965

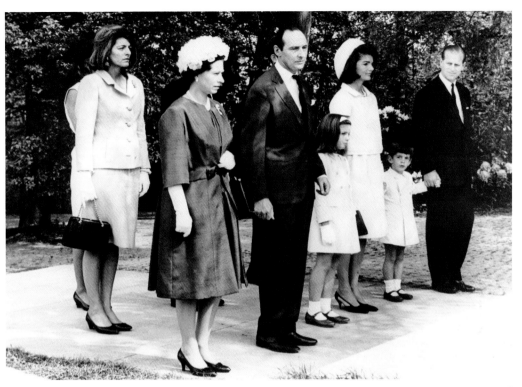

HRH Queen Elizabeth II stands at the inauguration of the John F. Kennedy Memorial in Runnymede, Surrey, with JFK's widow Jacqueline Kennedy and, to her left and right, daughter Caroline and son John Jr. President Kennedy was assassinated on 22nd November, 1963 in Dallas, Texas as he rode through the American city in a open-top motorcade. A lone gunman, Lee Harvey Oswald, was charged with the crime, but the possibility of a conspiracy involving other parties is still a matter of speculation and debate today.
15th May, 1965

West Ham United celebrate with the European Cup Winners Cup after their 2–0 win against the West German club TSV 1860 Munich. Back row, L–R: Alan Sealey, Martin Peters, Bobby Moore (with cup), Geoff Hurst, John Sissons, Ken Brown. Front row, L–R: Brian Dear, Ronnie Boyce, Jack Burkett.

19th May, 1965

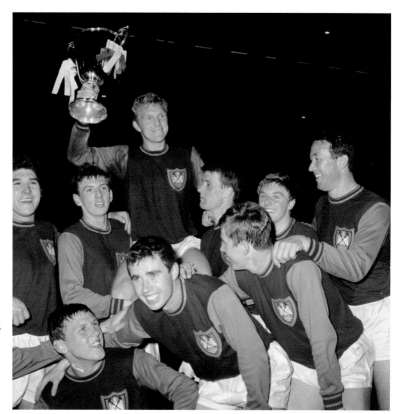

The Beatles (centre, from L) John Lennon, George Harrison, Ringo Starr and Paul McCartney, almost crowded out by interviewers at a press conference at Twickenham film studios after the public announcement that each member of the group had received the MBE in the Queen's Birthday Honours. The Fab Four were awarded the prestigious honour for their services to the British entertainment industry.

12th June, 1965

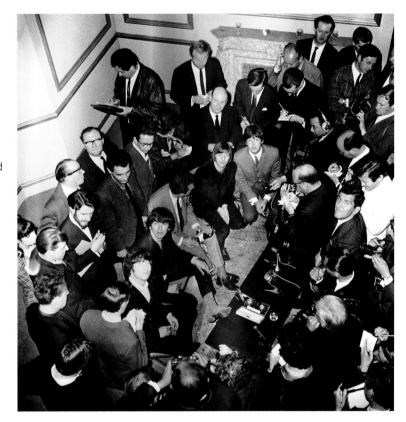

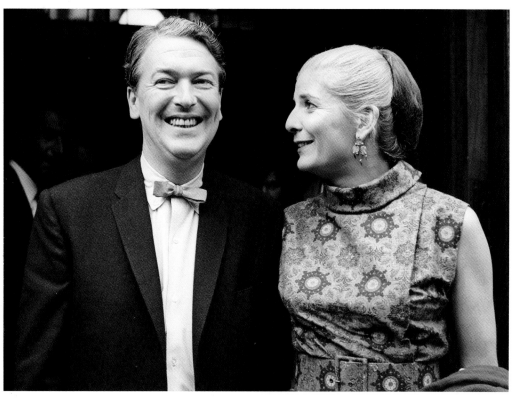

Author, poet, teacher and critic Kingsley Amis, pictured here after his marriage to fellow novelist Elizabeth Jane Howard at Marylebone Register Office, London. Best known as a comedic writer, Amis divorced his first wife, Hilary, so that he could marry Howard, with whom he had been having an affair. This second marriage lasted 18 years, but ended in divorce in 1983.
29th June, 1965

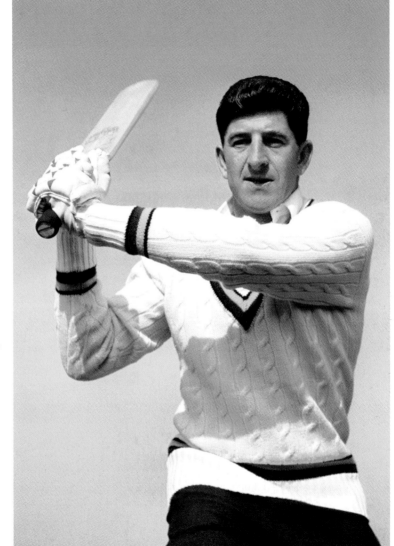

Surrey and England batsman Ken Barrington. A right-handed batsman and occasional leg-spin bowler, Barrington was well known for his jovial nature and long, defensive innings. He has the highest Test average of any post-war England batsman. Barrington twice made centuries in four successive Tests and was the first England batsman to make a hundred on all six traditional Test grounds; Old Trafford, Edgbaston, Headingley, Lords, Trent Bridge and the Oval. In 1965, he was named the South African Annual Cricketer of the Year.

2nd July, 1965

Actor Michael Caine as Alfie, with the cast of the movie of the same name. L–R: Vivien Merchant, Jane Asher, Julia Foster and Shelley Winters. The story of a promiscuous young man, the consequences of Alfie's actions eventually lead him to rethink his approach to life. Alfie breaks the 'fourth wall' convention of drama by speaking to the camera to narrate his thoughts, which often contrast with or contradict his actions.
4th July, 1965

Movie star Peter O'Toole hands Prime Minister Harold Wilson a cup of tea with actor Harry H. Corbett (C) at the United Nations Association's garden party at 10 Downing Street. The United Nations Associations are non-governmental bodies that exist in various countries to enhance the relationship between the people of a member state and the United Nations (UN) organization. They are not a part of the UN itself. The United Nations Associations raise public awareness of the UN and its work, promote its general goals and act as an advisory body to governments and the news media. Their concerns include peace, security and human rights and humanitarian issues.

6th July, 1965

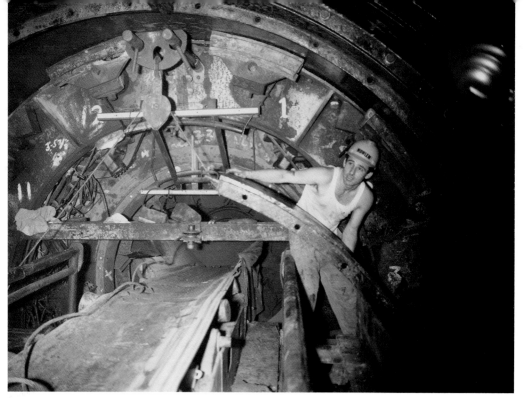

Work continues on the construction of the new Victoria Line for the London Underground. Construction began in 1962 on the Walthamstow–Victoria section and continued until 1972, when Pimlico station was opened. The name 'Victoria line' dates back to 1955; other suggestions were 'Walvic line' (Walthamstow – Victoria) and 'Viking line' (Victoria – King's Cross). During the planning stages, it was known as Route C, finally being named the Victoria line after Victoria Station.

27th July, 1965

Facing page: Edward Heath leaving his flat in Albany, Piccadilly, London. In 1965, Heath won the leadership of the Conservative Party in a victory over fellow candidates Reginald Maudling and Enoch Powell. In opposition during the 1960s, Heath became the British Prime Minister after winning the 1970 general election.

28th July, 1965

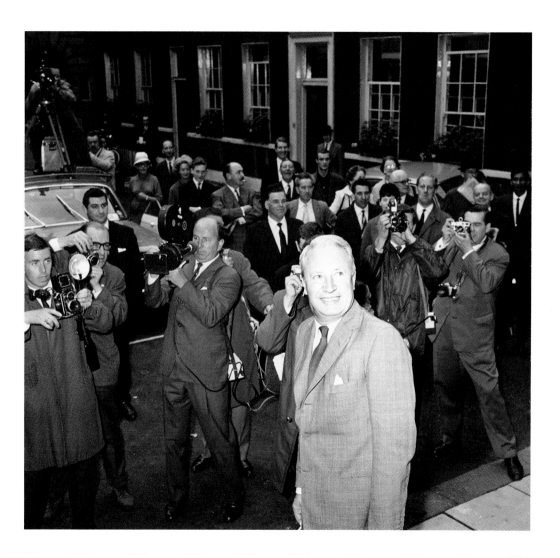

Photographer David Bailey and French actress Catherine Deneuve, at St Pancras Town Hall Registry Office after their marriage ceremony. Along with Terence Donovan and Brian Duffy, Bailey captured and helped create the 'Swinging London' of the 1960s: a culture of high fashion and celebrity chic. The three photographers socialised with actors, musicians and royalty, and were elevated to celebrity status. The first real celebrity photographers, they were nicknamed 'The Black Trinity'. Bailey's marriage to Deneueve was not to last; the couple divorced in 1972 after seven years of marriage.

18th August, 1965

Wilfrid Brambell (R), who plays Steptoe in the television show *Steptoe and Son*, watches Harry H. Corbett (L), who plays Harold, kiss the bride, played by Karol Hagar, during filming at St Luke's Church, Shepherd's Bush. A British sitcom written by Ray Galton and Alan Simpson, *Steptoe and Son* focused on the inter-generational conflict between two rag-and-bone men. The father, Albert Steptoe, is set in his grimy and grasping ways. By contrast his 40-year-old son Harold is filled with social aspirations and pretensions but is continually prevented from achieving his ambitions. In this episode, Harold finally gets to the altar with Albert as his best man, but at the last moment his bride changes her mind.

2nd September, 1965

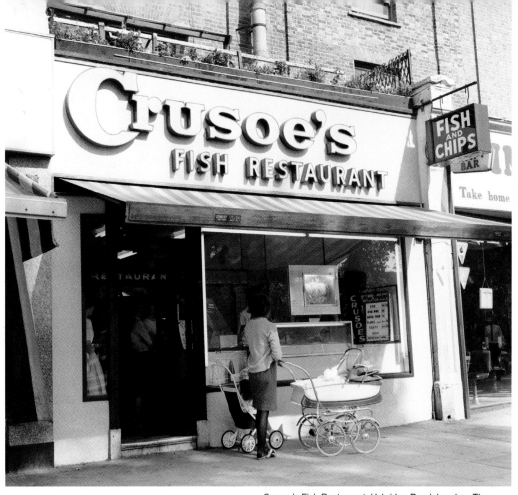

Crusoe's Fish Restaurant, Uxbridge Road, London. The favourite take-away food of British consumers, fish-and-chip shops flourished throughout the country in the 1960s.
9th September, 1965

Lancashire comedian-singer Ken Dodd leaps for joy at the news that his single *Tears* is top of the New Musical Express Hit Parade. He has just flown in to London Aiport from Liverpool. Famous for his frizzy hair, buck teeth, and feather duster 'tickling stick', Ken Dodd's unique comic style made him as big a name as the Beatles in British households during the 1960s. The song *Tears* topped the UK charts for five weeks in 1965, selling over a million copies. At the time it was the UK's biggest selling single by a solo artist, and it remains one of the UK's biggest selling singles of all time.

20th September, 1965

Members of the cast of *Z Cars*, the BBC Television police drama. L–R: James Ellis (DC Lynch), Frank Windsor (Sgt John Watt), Stratford Johns (Chief Inspector Barlow), Joseph Brady (PC Jock Weir), Colin Welland (PC Dave Graham), Robert Keegan (Sgt Blackitt) and Donald Gee (PC Walker). The series centred on the work of mobile, uniformed police in the fictional town of Newtown, based on Kirkby in the outskirts of Liverpool in Merseyside. It debuted in January 1962 and ran until September 1978. Its writers – Troy Kennedy Martin and Allan Prior – and the producer David Rose, wanted to create a more realistic portrayal of policing than had been seen on British television before.
27th September, 1965

Facing page: View from the balconies overlooking the exhibition stands at Earls Court, London, at the 50th International Motor Show. The British International Motor Show is held biennially in the United Kingdom. The first British Motor Show, organised by the Society of Motor Manufacturers and Traders (SMMT), was held at Crystal Palace, London in 1903. It subsequently moved to Olympia in London, where it was held each year for 32 years.
1st October, 1965

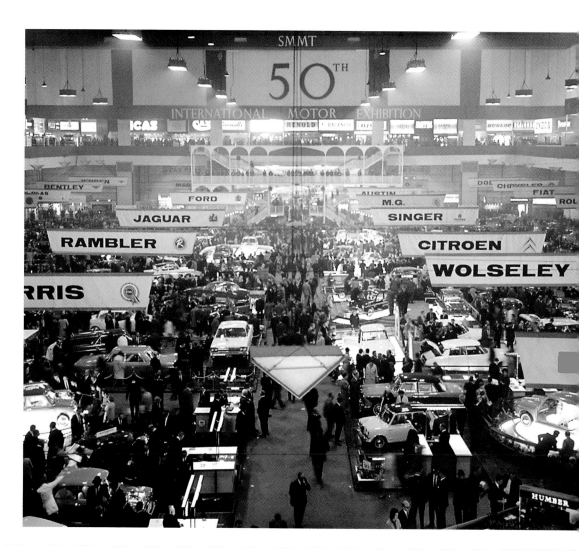

The Beatles showing their MBE insignias at Buckingham Palace after receiving them from the Queen in 1965. L–R: Ringo Starr, John Lennon, Paul McCartney and George Harrison. In 1969, Lennon rejected his award and returned the medal to the Queen. He did this as part of his peace protests, in particular for the involvement of the British Establishment in the Biafran conflict and its support of America in the Vietnam War.
26th October, 1965

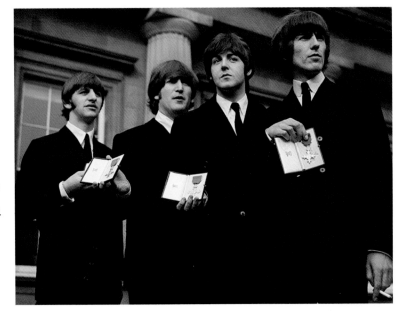

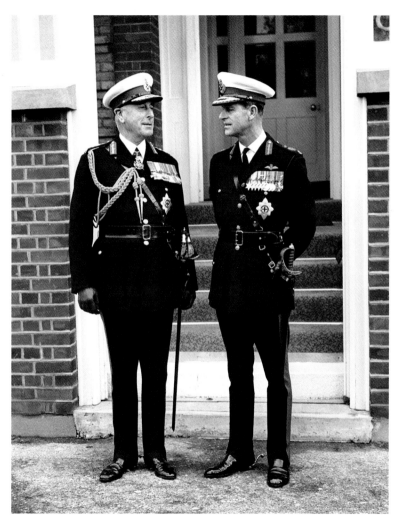

Prince Philip, The Duke of Edinburgh (R) in uniform as Captain General of the Royal Marines pictured with his uncle, Admiral of the Fleet, Earl Mountbatten of Burma (L) at the Royal Marines Barracks, Eastney near Portsmouth. Mountbatten was a British statesman and naval officer. He was the last Viceroy of India (1947) and the first Governor-General of the independent Union of India (1947–48), from which the modern Republic of India would emerge in 1950. From 1954 until 1959 he was the First Sea Lord. In 1979 Mountbatten was assassinated by the Provisional Irish Republican Army (IRA), who planted a bomb in his fishing boat, the *Shadow V*, at Mullaghmore, County Sligo in the Republic of Ireland.

27th October, 1965

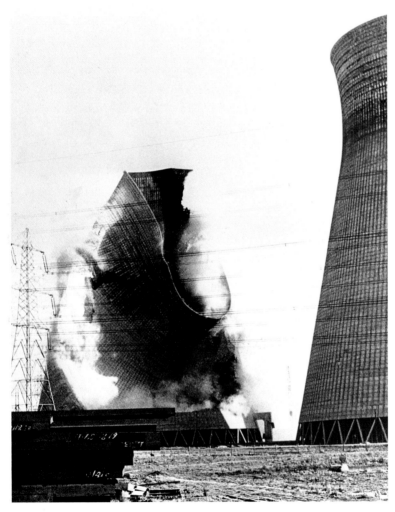

A huge concrete cooling tower crumbles under the impact of high winds at Ferrybridge C Power Station near Knottingley, Yorkshire on 1st November 1965. In total, three of the station's eight cooling towers collapsed due to vibrations created by 85-mph winds. The remaining five were severely damaged. The structures had been built to withstand higher wind speeds, but the design only considered average wind speeds over one minute and neglected shorter gusts. The towers were rebuilt and all eight cooling towers were strengthened to tolerate adverse weather conditions.

1st November, 1965

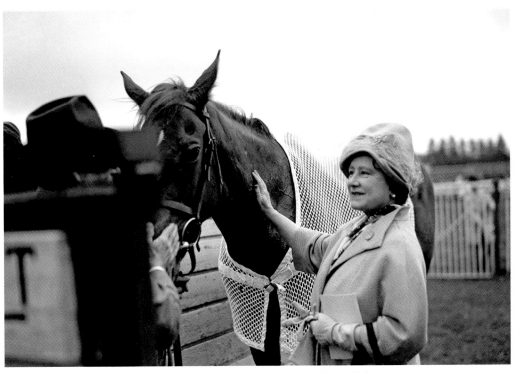

A keen equestrian and race-horse owner, the Queen Mother pats her horse Irish Rover after winning the Marden Novices Hurdle at Folkestone in 1965. When Monaveen won at Fontwell in 1949, the Queen Mother became the first Queen of England to win a horse race in Britain since Queen Anne in 1714. In a career spanning over 50 years, the Queen Mother had 449 winners, in her blue and gold colours. The season of 1964–65 was her most successful season – her horses took line honours 27 times and she was the third most successful owner of the season.

8th November, 1965

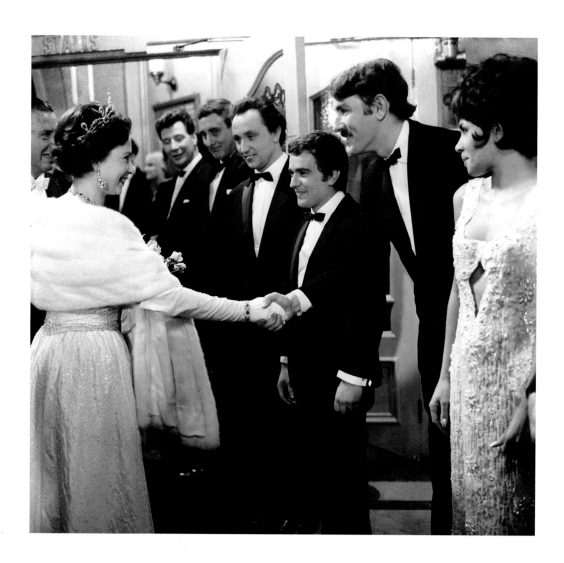

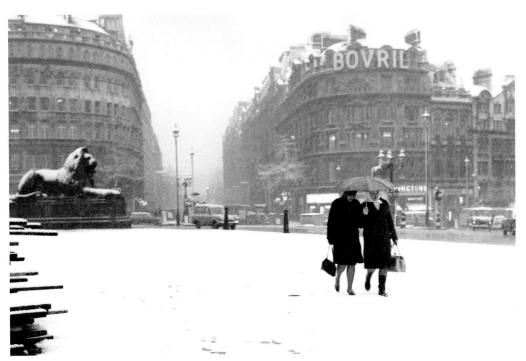

Facing page: The Queen
shakes hands with *Not
Only...But Also* star Peter
Cook at the Royal Variety
Performance at the London
Palladium. Cook's co-star,
Dudley Moore, can be seen
to Cook's right. Also in line
(L–R) are Max Bygraves,
Spike Milligan, Ken Dodd
and Shirley Bassey.
9th November, 1965

London's Trafalgar Square
during a late-November
snow storm in 1965. Despite
more snow in January, the
winter of 1965–66 was
unspectacular, although
there were surprising late
falls in April 1966. This
winter was nowhere near
as cold as the 'Big Freeze'
of 1962–63.
22nd November, 1965

The Prince of Wales acting in the dagger scene as Macbeth, in Gordonstoun School's production of the Shakespeare play. The Queen and Duke of Edinburgh joined other parents of the boys to watch the final performance. Despite enjoying his participation in theatrical pursuits at the school, the Prince was not fond of Gordonstoun, later describing it as 'Coldtiz in kilts'.
30th November, 1965

Comedian Tony Hancock and his new bride, publicity agent Freddie Ross, when they married at St Marylebone Register Office, London in 1965. Hancock became involved with Ross, who worked as his publicist, while still married to his first wife, Cicely Romanis. He divorced Romanis in 1965 and married Ross in December the same year. This union was not successful and before long Hancock began an affair Joan Le Mesurier, the wife of actor John Le Mesurier. In July 1966, Ross took a drug overdose in a suicide attempt, but survived. Hancock took his own life on 24th June, 1968.
2nd December, 1965

Opposition leader Edward Heath tries smoked eel at the International Hotel and Catering Exhibition, Olympia, London. As well enjoying fine food, Heath was a world-class yachtsman and a talented musician. Heath later held the office of Prime MInister from 19th June, 1970 to 4th March 1974. He was one of only four British Prime Ministers never to have married. Heath retired as an MP in 2001 and died in 2005.

19th January, 1966

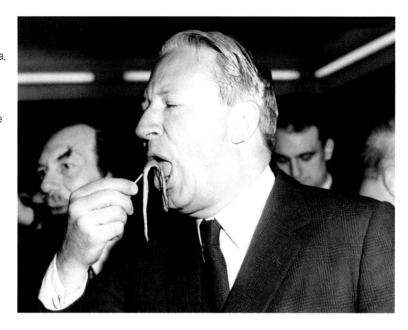

Facing page: Lionel Bart with actress Barbara Windsor, in a dress rehearsal of *Twang!* at the Shaftesbury Theatre, London. Bart was a writer and composer of British pop music and musicals, best known for creating the book, music and lyrics for *Oliver!*. His musical *Twang!* was based on the character of the legendary outlaw Robin Hood. It is most famous for its disastrous box-office failure. It opened at the Shaftesbury Theatre in London's West End on the 20th December, 1965 and closed on 29th January, 1966 after just 43 performances, playing to mostly empty houses.

15th December, 1965

The 'pirate-radio' ship *Radio Caroline*, which ran aground in rough water between Frinton and Holland-On-Sea, where she was blown by a gale during the night. Five disc jockeys, taken off by breeches buoy, were among those rescued from the vessel. Radio Caroline was an English radio station founded in 1964 by Ronan O'Rahilly to circumvent the record companies' control of popular music broadcasting in the United Kingdom and the BBC's radio broadcasting monopoly. Unlicensed by any government for the majority of its early life, it was considered to be a 'pirate' radio station.

20th January, 1966

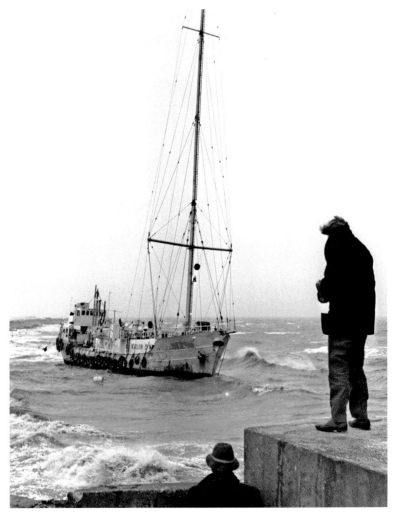

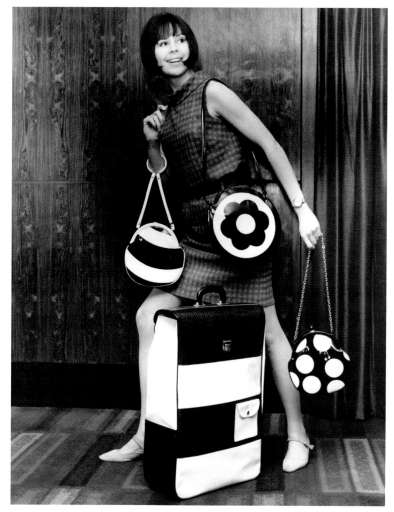

Model Dian Poore, aged 19, with a selection of Mary Quant handbags and travel bag at the The Leather Fair, Mount Royal Hotel, Marble Arch, London. Born in Blackheath, London, to Welsh parents, Quant brought fun and fantasy to fashion in the 1960s. Instrumental in the 1960s' Mod fashion movement, she was also one of the designers who took credit for inventing the miniskirt and hot pants. Her instant success made traditionally cautious designers change their attitudes and make their designs appeal to the newly important youth market.

7th February, 1966

Stewardess Maureen Galligan feeds Chi Chi as the Giant Panda is transferred from London Zoo to Moscow to meet An An, her prospective mate. Born in 1957, Chi Chi became the Zoo's star attraction and Britain's best-loved zoo animal. She was an inspiration for Sir Peter Scott's black-and-white design that was used as the logo of the World Wildlife Fund. The attempts at mating with An An were unsuccessful. She died on 22nd July, 1972 and was mourned by the nation. Her remains, now a stuffed exhibit, sit in a glass case at London's Natural History Museum.

8th March, 1966

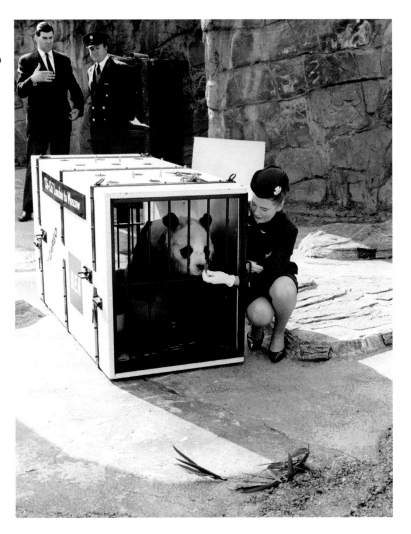

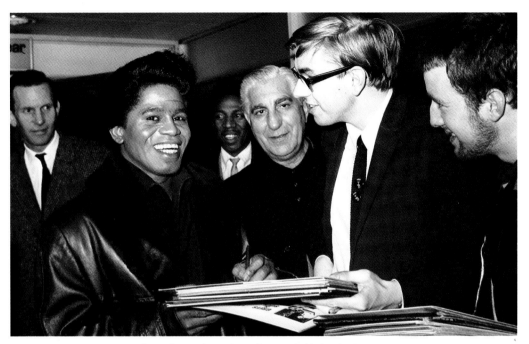

James Brown signs autographs on arrival in London to appear on the TV pop programme *Ready, Steady, Go*, before flying on to Paris. An American singer, songwriter, musician and recording artist, Brown is the originator of Funk and is recognised as a major figure in 20th-century popular music for both his vocals and dancing. Brown's talents led to him being referred to as 'The Godfather of Soul', 'The Hardest-Working Man in Show Business' and 'Mr Dynamite'.
10th March, 1966

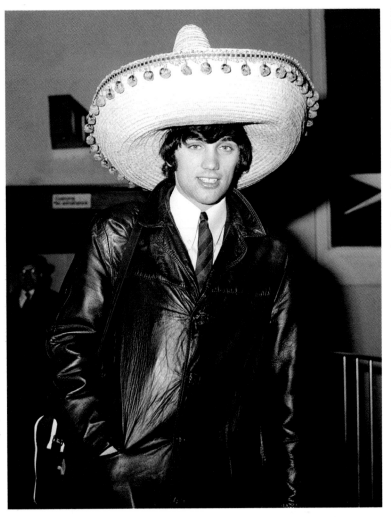

Manchester United footballer George Best wearing a souvenir sombrero on his return to London from Lisbon following United's 5–1 victory over Benfica in the second leg of the European Cup Quarter Final. Best scored United's first two goals. An enormously gifted player, he was a winger whose game combined pace, acceleration, balance, two-footedness, goalscoring and the ability to beat defenders. He was one of the first celebrity footballers, but his extravagant lifestyle led to problems with alcoholism. This curtailed his playing career and eventually led to his death in November 2005 at the age of 59.

11th March, 1966

Singer Dusty Springfield at Heathrow Airport before flying to Brussels for a visit. Born Mary Isobel Catherine Bernadette O'Brien, under her stage name she was dubbed 'The White Queen of Soul'. At her peak she was one of the most successful British female performers. A fan of American pop music, she brought little-known soul singers to a wider British audience when she created and hosted the first UK performances of the top-selling Motown artists in 1965. By 1966, she was the best-selling female singer in the world, and topped a number of popularity polls, including Melody Maker's Best International Vocalist.

22nd March, 1966

Lord Bath (Henry Tynne) raises his hat to one of the lions that will be the star attraction at Longleat Safari Park, two weeks before it opens to the public. Situated in the grounds of Longleat House, an English stately home, the park was the first of its kind anywhere in the world. It was a major breakthrough in the way in which captive animals were kept, with the animals roaming freely and the visitors in cages (cars). It was the brainchild of Jimmy Chipperfield (1912–90), former co-director of Chipperfield's Circus. Today Longleat's collection comprises over 500 animals, situated on 9,000 acres of Wiltshire countryside.

3rd April, 1966

Model and photographer
Patti Boyd in London's West
End, showing off a design
of the Quorum Autumn
Collection, designed by
Ossie Clark, an English
designer who was a major
figure in the 'Swinging
Sixties' scene in London and
the fashion industry. Along
with 1960s' fashion greats
Mary Quant and Biba, Clark
has influenced many other
designers, including Yves
Saint Laurent, Anna Sui and
Tom Ford.

21st April, 1966

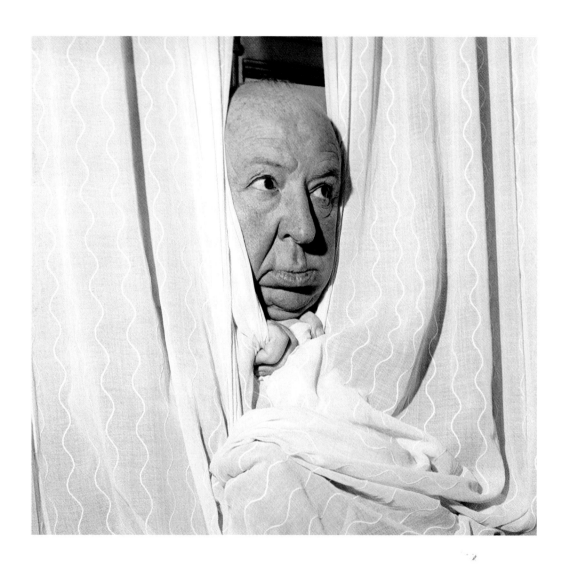

Bobby Charlton of Manchester United. After helping United to win the Football League in 1965, Charlton won a World Cup medal with England in 1966. He was named European Footballer of the Year, 1966. In January 2011, he was voted the 4th greatest Manchester United player of all time by the readers of *Inside United* and ManUtd. com, behind Ryan Giggs (1st), Eric Cantona (2nd) and George Best (3rd). Charlton was knighted in 1994.
30th April, 1966

Facing page: British film director and producer Alfred Hitchcock at Claridges Hotel in London, months in advance of the release of his latest picture, *Torn Curtain*. He pioneered many techniques in the suspense thriller genre, framing shots to create anxiety, fear, or empathy in the movie-goer. Hitchcock's films often featured twist endings and thrilling plots that centred around violence, murder and crime. He is widely regarded as one of the greatest-ever British filmmakers.
25th April, 1966

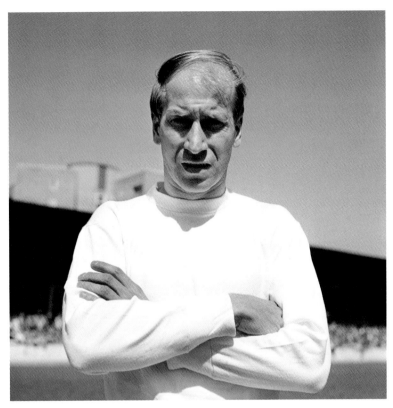

Peter Cook (L) and Dudley Moore (R) rehearsing their 'Leaping Nuns' sketch for Cook's Revue *Rustle of Spring* at the Phoenix Theatre in London. Cook was a satirist, writer and comedian. An extremely influential figure in modern British comedy, he is regarded as the leading light of the British satire boom of the 1960s. Moore – an actor, comedian, composer and musician – first came to prominence as one of the four writer-performers in the ground-breaking comedy revue *Beyond the Fringe* in the early 1960s, and then became famous as half of the highly popular television double-act he formed with Cook. He later enjoyed success in hit Hollywood movies such as *10* and *Arthur* in the late 1970s and early 1980s.
2nd May, 1966

Motor enthusiast Peter Sellers performing on the other side of the camera when he was assigned to photograph the Unipower GT Mini. A British specialist sports car first shown at the January 1966 Racing Car Show, it ceased production in early 1970, by which time only around 75 are believed to have been made. By the time he died in 1980, aged 54, Sellers was reputed to have bought almost 100 cars, mostly luxury models, including a Jaguar E-type and an Aston Martin DB4.

10th May, 1966

World Heavyweight Champion Muhammad Ali (formerly known as Cassius Clay) overtakes a horse-drawn brake during early morning training in Hyde Park, London in preparation for his title defence against Henry Cooper. Ali's training regime began with six-mile runs, pounding the streets at 5.30am in heavy army type-boots. After breakfast he would train at the gym for three hours. Ali trained six days a week with one day off to relax and ease his body and mind.

11th May, 1966

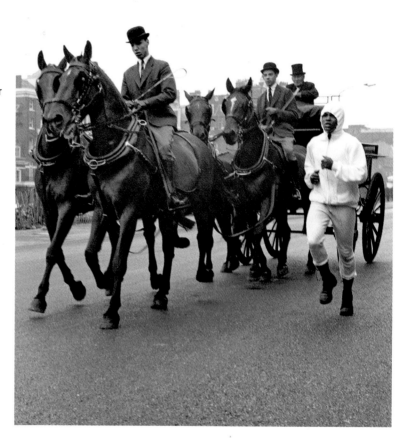

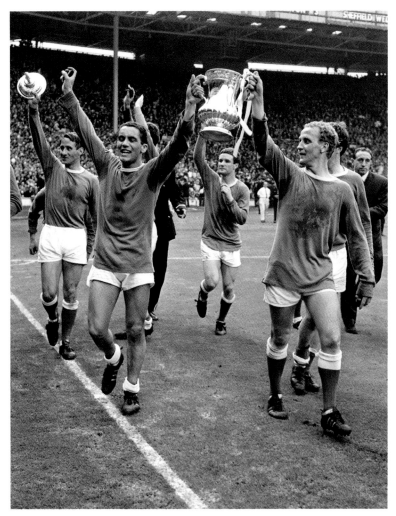

Everton players parade the FA Cup around Wembley Stadium after their 3–2 win against Sheffield Wednesday in 1966. From left: Gordon West, Derek Temple, Mike Trebilcock, Colin Harvey, Alex Young, manager Harry Catterick. Everton was the first team to reach an FA Cup Final without conceding in the preceding rounds. The FA Cup was taken back to Goodison Park for the third time – the first FA Cup win for the club in 33 years. John Lennon and Paul McCartney of The Beatles both attended the match.
4th May, 1966

Henry Cooper puts his feet up in the sunshine outside the Duchess of Edinburgh Public House in Welling, Kent. The English boxer – known for the effectiveness of his left hook, 'Enry's 'Ammer' – is seen here relaxing after finishing training for his great fight for the Heavyweight Championship of the World. He will once again take on Muhammad Ali (formerly Cassius Clay) at the Arsenal Stadium, Highbury.

20th May, 1966

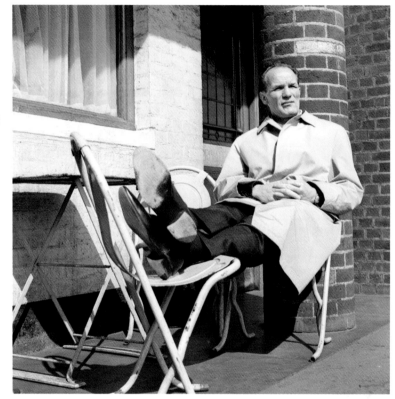

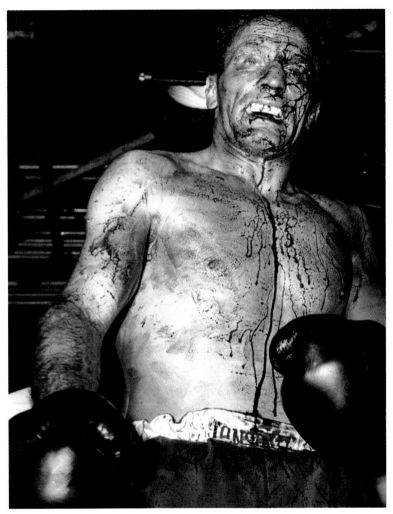

Blood pours from the face of Henry Cooper as the referee stops the World Heavyweight Championship fight in the sixth round. Accumulated scar tissue around Cooper's eyes made him even more vulnerable than in his previous meeting with Ali, who opened a serious cut that led to the re-match being stopped. Cooper again suffered a technical knockout when he was ahead on the scorecards. This meant that Muhammad Ali retained his title.

21st May, 1966

Kenneth Wolstenholme kicks off the BBC's television coverage of the 1966 World Cup. Wolstenholme was the football commentator for BBC Television in the 1950s and 1960s, including the first-ever game featured on *Match of the Day* in 1964. He is best-known for his commentary during the 1966 FIFA World Cup which included the famous phrase, *"some people are on the pitch... they think it's all over... it is now!"*, as Geoff Hurst scored England's fourth goal.
31st May, 1966

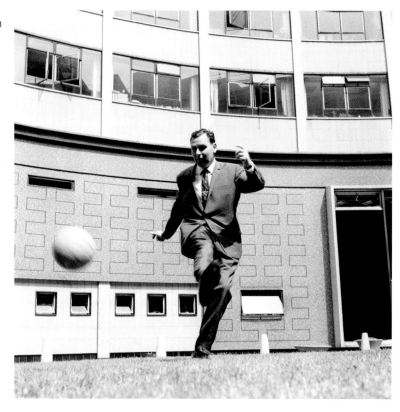

Facing page: Ascot racegoers, a race in progress and a view of the Heath – the impressive Ascot scene. One of the leading racecourses in the United Kingdom, Ascot hosts nine of the UK's 32 annual Group 1 Thoroughbred races. The course is closely associated with the British Royal Family, being approximately six miles from Windsor Castle.
1st June, 1966

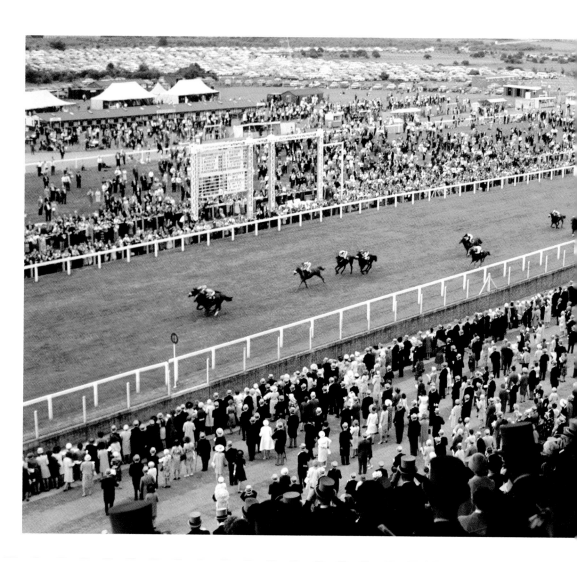

The Queen Mother talks to Boer War veterans among the Chelsea Pensioners at their Founder's Day parade at the Royal Hospital, Chelsea, London. The Hospital was founded in 1682 by King Charles II as a home for soldiers who were unfit for further duty because of injury or old age. Upon arrival at the Royal Hospital, each pensioner is given a small room and is allocated to a company. They surrender their army pension, in return receiving board, lodging, clothing and full medical care. In the Hospital, pensioners are encouraged to wear a blue uniform. If they travel any distance away, they must wear their distinctive scarlet coats. These are also worn for ceremonial occasions, accompanied by tricorne hats.

10th June, 1966

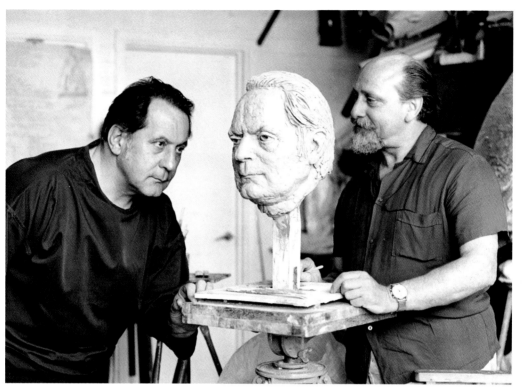

Famous portrait painter Pietro Annigoni (L) sits for portrait sculptor Anthony Gray (R) at Stamford Bridge Studios, Chelsea, London. Annigoni, an Italian portrait and fresco artist, became world famous after painting Queen Elizabeth II in 1956. His work bore the influence of Italian Renaissance portraiture, and he wrote essays challenging modern art that disregarded the basic ability to draw. He is also known for his portraits of Pope John XXIII and US Presidents John F. Kennedy and Lyndon B. Johnson.
21st June, 1966

New British Open champion Jack Nicklaus and his wife Barbara with the trophy, after Nicklaus won the title at Muirfield, East Lothian, in 1966. Nicklaus won the Open under difficult weather conditions, using his driver just 17 times, because of very heavy rough. At the age of 26 (his fifth year on the tour), this win made him the youngest player to win all four of the major championships, now known as the Career Slam. His record was eventually beaten in 2000, by 24-year-old Tiger Woods (also during his fifth year on the tour).

9th July, 1966

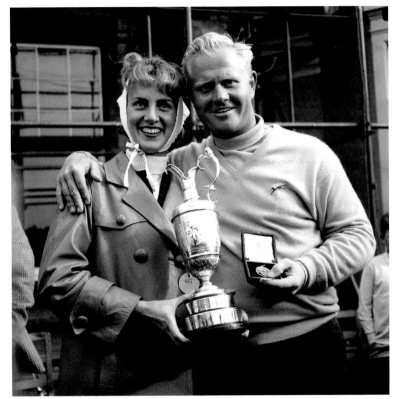

England's Jimmy Greaves (R) offers some advice to comedian Norman Wisdom (L) on heading the ball during the England World Cup squad's visit to Pinewood Studios. After a dismal 0–0 draw in the first game of the competition against Uruguay, manager Alf Ramsey decided to lift the squad's spirits by taking them to Pinewood Studios, where they met Wisdom and major movie stars such as Sean Connery and Yul Brynner.

12th July, 1966

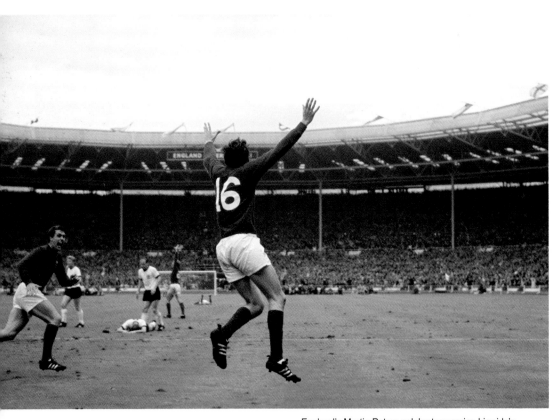

England's Martin Peters celebrates scoring his side's second goal of the World Cup Final at Wembley. England took in the lead in the 78th minute of the match and looked set to claim the title. Then, with one minute left, the referee awarded a free kick to West Germany, who levelled the score.

30th July, 1966

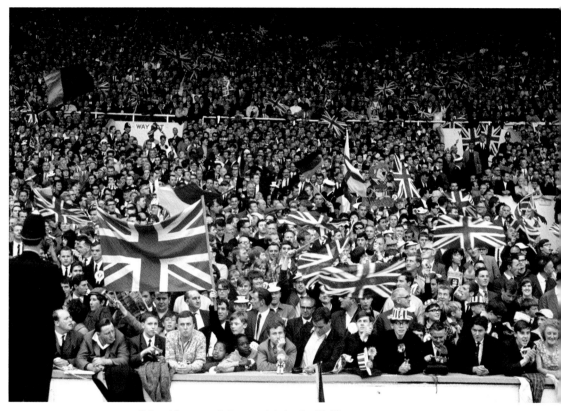

National flags wave in the crowd during the World Cup Final between England and West Germany. London's Wembley Stadium provided the venue for the final, and 98,000 people crammed inside to watch. With the score level at 2–2 at the end of 90 minutes, the game went to extra time.

30th July, 1966

England captain Bobby Moore holds the Jules Rimet Trophy, collected from the Queen, after leading his team to a 4–2 victory over West Germany in an exciting World Cup Final that went to extra time at Wembley Stadium. As well as winning the Cup for the first time, England became the first host nation to win the tournament since Italy in 1934.

30th July, 1966

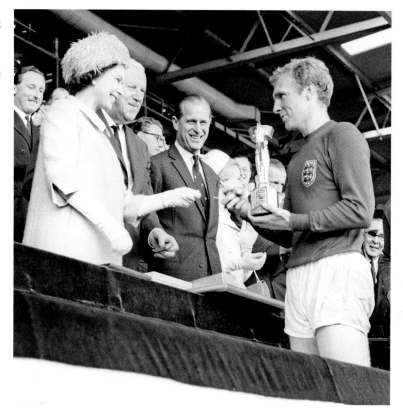

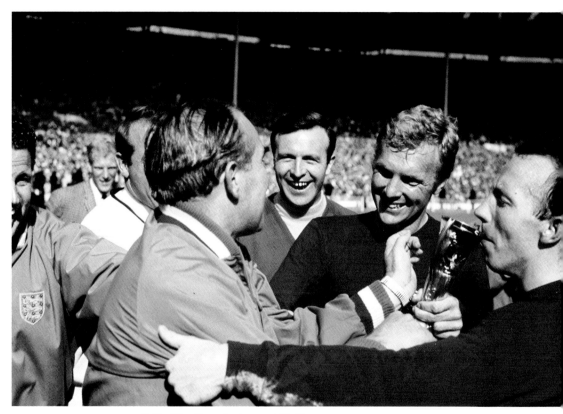

Nobby Stiles kisses the treasured World
Cup trophy as Bobby Moore (second R) is
congratulated by England manager Alf Ramsey
(in blue) at Wembley. England was chosen as
the host nation of the 1966 World Cup in Rome,
Italy on 22nd August, 1960, over opposition from
West Germany and Spain.
30th July, 1966

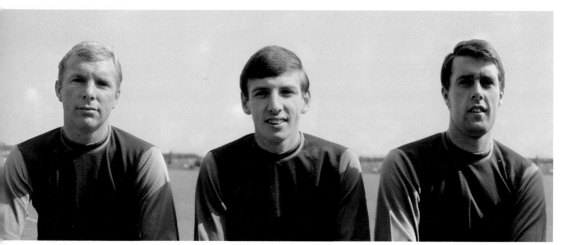

England World Cup team Captain Bobby Moore (L) and World Cup Final goal-scorers Martin Peters and Geoff Hurst (R), in their West Ham United strip. In the 98th minute of the 1966 World Cup Final, Hurst's shot hit the crossbar, bounced down and hit the ground either onto or just over West Germany's goal line. Whether the ball crossed the goal line is still up for debate – it became known as the 'Ghost Goal' and has become part of World Cup history.
1st August, 1966

Facing page: Alan Ball of Everton Football Club, who supplied the cross from which Geoff Hurst scored the controversial third goal, in extra time, for England in the World Cup Final. Victory was secured with England's final goal, again scored by Hurst, during a pitch invasion. This made Geoff Hurst the only player ever to have scored three times in a World Cup final.
1st August, 1966

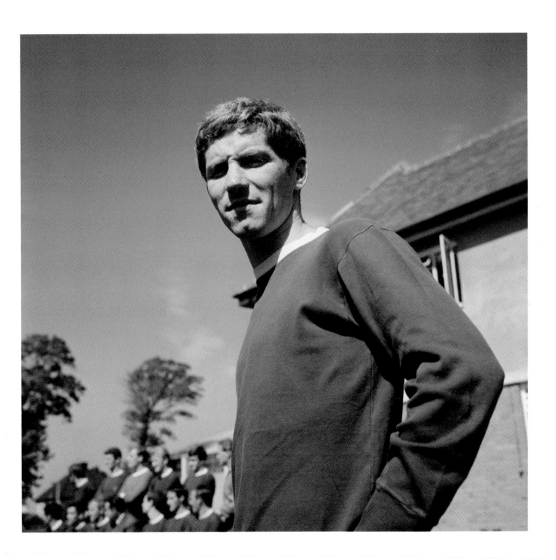

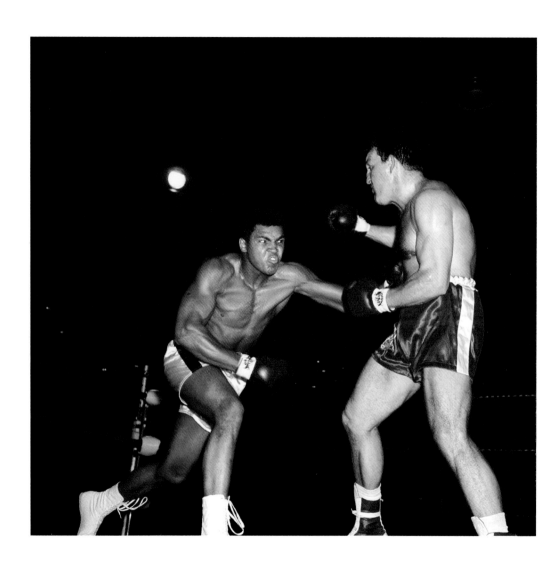

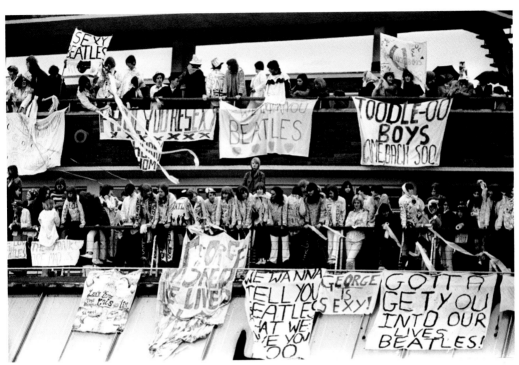

Facing page: Muhammad Ali catches British boxer Brian London with a left to the gut in the World Heavyweight Boxing Championship. Ali demolished London in the third round, once again retaining the World Heavyweight Championship.
6th August, 1966

Huge banners are draped from the rails of the viewing galleries at the Queen's Building in London Airport, as hundreds of fans give a loyal send off to The Beatles as they head off to the United States. The Beatles staged their third concert tour of America in August 1966, and it was the last commercial tour they ever underwent. It lasted a total of 14 shows, with 13 shows in American venues and one in Toronto, Canada.
11th August, 1966

Crammed with their luggage into a car, The Beatles are driven across the runway to their aircraft at London Airport, aboard which they will fly to the United States for their 1966 American tour. Seen through the rain-speckled window are (L–R): Paul McCartney, John Lennon, Ringo Starr and George Harrison. Although the tour was a commercial success, ticket sales had noticeably declined in number. After the tour, The Beatles became a studio band and focused their talents exclusively on record production.

11th August, 1966

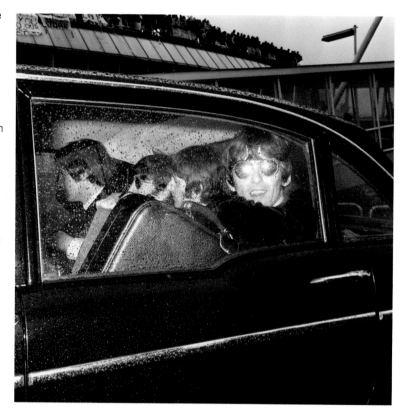

England's Jim Booker rips around the track in the 8th British Commonwealth Games, held in Kingston, Jamaica. Booker won a Silver medal in in the Sprint competition. Roger Gibbon from Trinidad and Tobago won the Gold, while Australian Daryl Perkins took the Bronze medal.
11th August, 1966

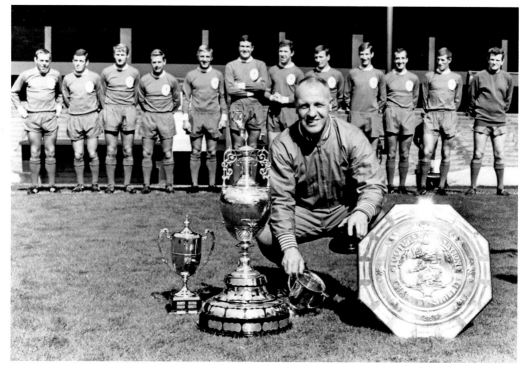

Liverpool manager Bill Shankly crouches by the trophies that his team won the previous season, including the League Championship trophy and the FA Charity Shield, as his players line up in the background (L–R): Ian St John, Ian Callaghan, Roger Hunt, Gordon Milne, Peter Thompson, Ron Yeats, Chris Lawler, Tommy Smith, Geoff Strong, Gerry Byrne, Willie Stevenson, Tommy Lawrence.
15th August, 1966

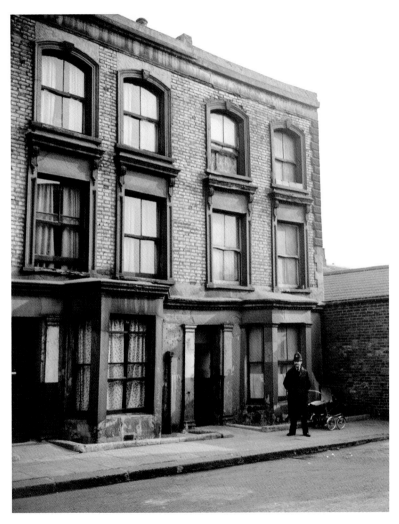

The house at 10 Rillington Place in Notting Hill, London, where a series of murders were committed by notorious serial killer John Christie in the early 1950s. He murdered at least eight women – including his wife Ethel – by strangling them in his flat. Christie's tenant, Timothy Evans, who was wrongly hanged for one of his landlord's murders, received a posthumous pardon in October 1966.

12th October, 1966

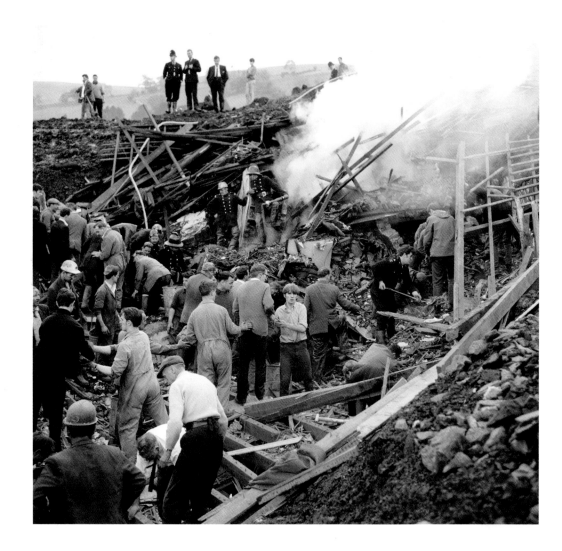

Facing page: Rescue workers tear into the mud and rubble covering the ruins of houses which, together with Pantglas School, were engulfed by a mountain of coal slurry at Aberfan, near Merthyr Tydfil, Glamorganshire, Wales. In total, 144 people, including 116 children, were killed in the disaster. Over 40,000 cubic metres of debris smashed into the village in a slurry that was 12-metres deep.
21st October, 1966

The Queen Mother meets comedy duo Eric Morecambe (R), and Ernie Wise (second R) following the Royal Variety Show. The second feature-length film featuring the pair, *That Riviera Touch* was released in 1966. Eric Morecambe and Ernie Wise, usually referred to as Eric and Ernie, worked in variety, radio, film and most successfully in television. Their partnership lasted from 1941 until Morecambe's death in 1984. The duo are often regarded as the best-loved double act that Britain has ever produced.
15th November, 1966

Top-hatted John Lennon of The Beatles stops at the entrance to a public lavatory to chat with Peter Cook. John was playing the part of a commissionaire, hired to give a running commentary about the celebrities using the facilities, as part of the *Not Only... But Also Yuletide Show*. The programme *Not Only... But Also* was a popular 1960s BBC television comedy sketch series starring Peter Cook and Dudley Moore.

27th November, 1966

The Beverley Sisters at London Airport when they left for Madrid to appear on Spanish television. The Beverley Sisters were a British female vocal trio, popular during the 1950s and 1960s, consisting of eldest sister Joy and the twins, Teddie and Babs. Their style was loosely modelled on that of the Andrews Sisters, a US close-harmony singing act who were popular during the 1940s. Their notable successes include *Sisters*, *I Saw Mommy Kissing Santa Claus* and *Little Drummer Boy*. They were the first UK female group to break into the US Top 10.

1st December, 1966

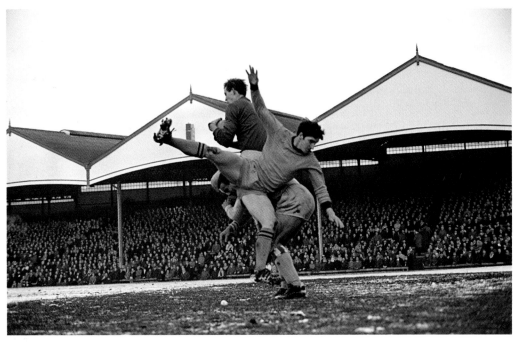

Coventry City goalkeeper Bill Glazier in action at Molyneux, home of opposing team Wolverhampton Wanderers. The clash between the Division Two clubs ended in a 3–1 victory for Coventry City. Glazier played for Coventry from 1964 to 1975, making 346 appearances.
3rd December, 1966

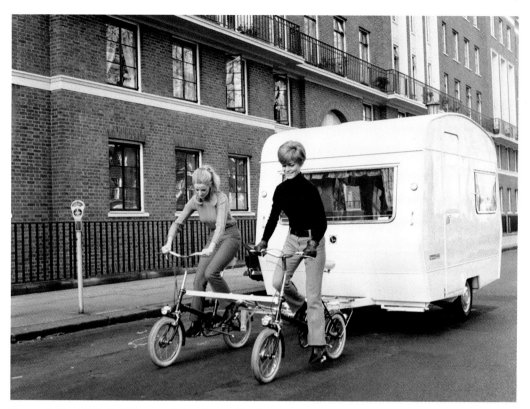

The new lightweight Sprite 400 caravan is towed around London by Margit Saad (R) and Jean Herbert-Smith to promote the 10ft, four-berth vehicle. It was designed by Samuel Alper, a London-born caravan manufacturer. Establishing his business in austere, post-war Britain, Alper's vision was to provide cheap caravanning for the masses, designing his first touring caravan in 1947. He also founded the Little Chef chain of roadside restaurants.

4th December, 1966

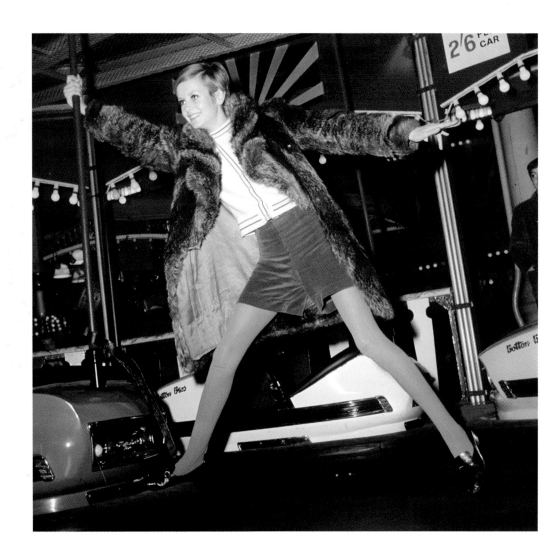

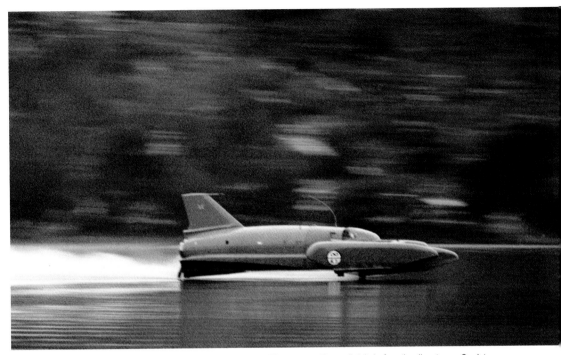

Facing page: Model Twiggy on the dodgem cars at Bertram Mills Circus, Olympia, London. Born Lesley Lawson, with her androgynous looks, thin build and short hair, she became a world-famous British teenage model during the 1960s.

1st January, 1967

The moment immediately before the disaster on Coniston Water, in which Donald Campbell died as *Bluebird* somersaulted at 300mph during a World Speed Record attempt. Campbell's body, and the craft, were not recovered until 36 years later. Analysts believe Campbell unknowingly pushed the craft beyond its limits – he was effectively a test pilot, running at speeds at which no one had previously travelled. On 28th January, 1967, Campbell was posthumously awarded the Queen's Commendation for Brave Conduct for his courage in attacking the water-speed record.

4th January, 1967

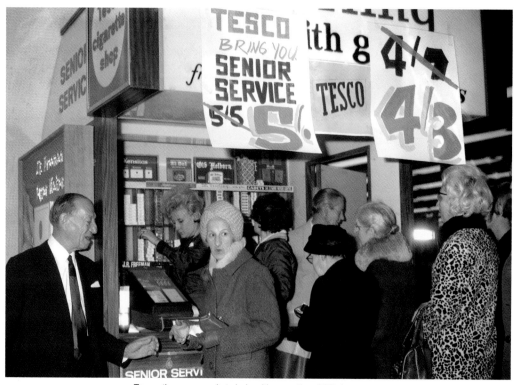

Tesco, the supermarket chain with more than 500 shops, attracted crowds of shoppers when it cut the price of cigarettes. Jack Cohen founded Tesco in 1919 when he sold surplus groceries from a market stall in Hackney, East London. The Tesco brand name came about after Cohen bought a shipment of tea from T.E. Stockwell. He made labels using the first three letters of the supplier's name and the first two letters of his surname. The first Tesco store was opened in 1929 in Burnt Oak, Edgware, Middlesex.
13th January, 1967

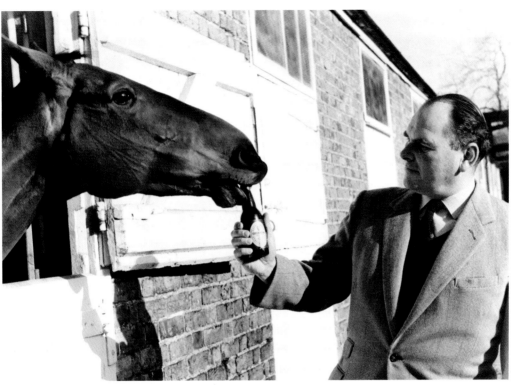

Shown enjoying one of his twice-daily bottles of Guinness, Arkle was considered to be the greatest National Hunt horse of all time. Unbeaten in five races during the 1955–56 season, a fractured pedal bone sustained at Kempton Park in 1966 meant the end of his career. At one point the slogan 'Arkle for President' was written on a wall in Dublin. The government-owned Irish National Stud, at Tully, Kildare, Co. Kildare, Ireland has his skeleton on display in its museum.
20th January, 1967

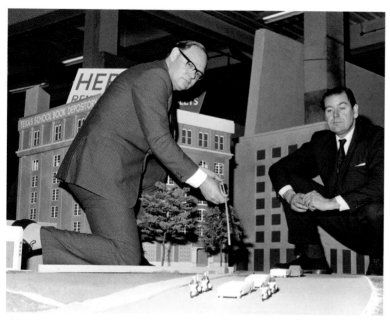

Cliff Michelmore (L) preparing for a BBC2 Television programme, *The Death of Kennedy*, is shown with interviewer Kenneth Harris at the Television Centre, Shepherd's Bush, London, inspecting a scale-model of Dealey Plaza, Dallas, Texas, USA – the scene of President Kennedy's assassination. The documentary discussed issues surrounding the Warren Commission's report of its findings following its investigations into Kennedy's death. The report concluded that Lee Harvey Oswald acted alone in killing Kennedy and that Jack Ruby acted alone in the murder of Oswald. The findings have since proven controversial and been both challenged and supported by later studies.

25th January, 1967

Facing page: Margot Fonteyn and Rudolf Nureyev during a rehearsal of Roland Petit's ballet *Paradise Lost* at Covent Garden in London. Inspired by the poem by John Milton, Petit created *Paradise Lost* in 1967 for Margot Fonteyn and Rudolf Nureyev, and cast the two stars as Adam and Eve.

20th February, 1967

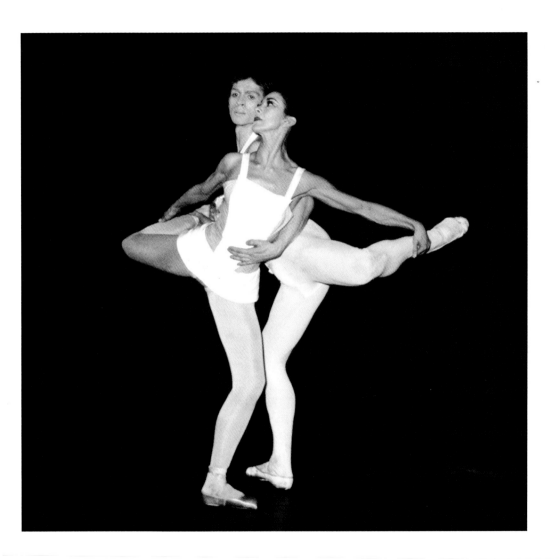

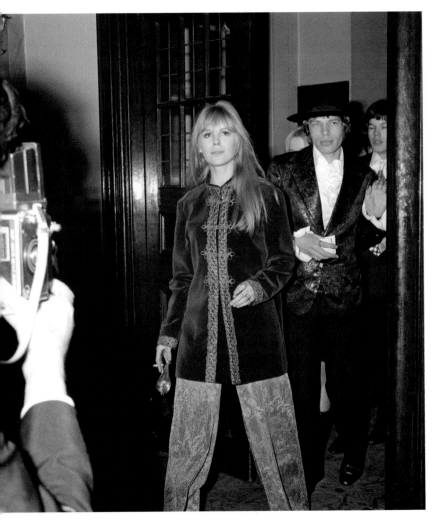

Pop star Mick Jagger of the Rolling Stones and singer Marianne Faithfull arrive at the Royal Opera House in Covent Garden, London, for a Royal Ballet Gala Performance. A few days earlier, on 12th February, the pair had been caught up in a drugs raid when the police descended on Redlands, the Sussex home of the Stones' guitarist Keith Richards. Jagger and Richards were both charged with possessing marijuana. According to legend, Faithfull was found wearing only a fur rug when the police raided the house.

23rd February, 1967

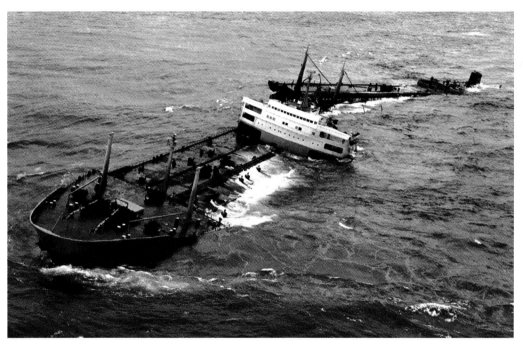

The giant tanker *Torrey Canyon*, already broken in two on
the Seven Stones Reef off Land's End, Cornwall, is battered
relentlessly by waves. Fully laden with a cargo of 120,000
tons of crude oil, the shipwrecked vessel eventually sank,
causing an environmental disaster. An inquiry in Liberia,
where the ship was registered, found Shipmaster Pastrengo
Rugiati was to blame, because he took a shortcut to
save time in getting to Milford Haven. The French singer-
songwriter Serge Gainsbourg wrote and recorded a song
about the incident entitled *Torrey Canyon*.
27th March, 1967

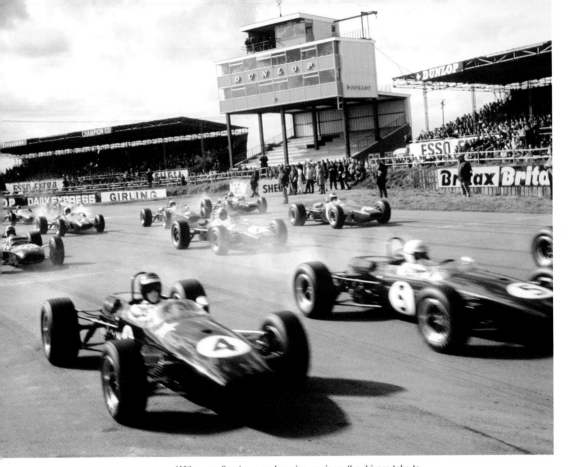

With squealing tyres and roaring engines, the drivers take to the track on the Formula One W.D. & H.O. Wills Trophy race at Silverstone, Northamptonshire. This international sports car race was one of the supporting events at the 1967 British Grand Prix. The race was won by Richard Attwood in a Maranello Concessionaires Ferrari.

27th March, 1967

Cat Stevens, later to be known as Yusef Islam, backstage at the Finsbury Park Astoria, London. Born Steven Georgiou in Marylebone, London, England, Stevens' December 1967 album *New Masters* failed to chart in the United Kingdom. The album is most notable for his song *The First Cut Is The Deepest*, a song he sold for £30 to P.P. Arnold that was to become a massive hit for her. Stevens converted to Islam in December 1977 and adopted his Muslim name, Yusuf Islam, the following year. In 1979, he began to devote himself to educational and philanthropic causes in the Muslim community. He has been given several awards for his work in promoting peace in the world, including 2003's World Award, the 2004 Man for Peace Award, and the 2007 Mediterranean Prize for Peace.
31st March, 1967

Alf Kirvin, aged 74, a resident of Archie Street, Salford
in Lancashire. The street inspired the fictional setting of
Weatherfield in the ITV soap opera *Coronation Street*,
and was reproduced in the television studios. Created by
Tony Warren, *Coronation Street* was first broadcast on 9th
December; 1960. It is produced at the Granada Studios
in Manchester and shown in all ITV regions. On 17th
September 2010, it became the world's longest-running
television soap opera currently in production.
15th May, 1967

Facing page: The Picture Transmission Room of The Press Association in Fleet Street, London. Wirephoto or telephotography is the sending of pictures by telegraph or telephone. Western Union transmitted its first halftone photograph in 1921. In the 1960s, wirephoto machines were large and expensive and required dedicated phone lines. The advent of digital photography in the late 1990s and high-speed internet connections revolutionised the fast transmission of high-resolution photograpic images.
1st June, 1967

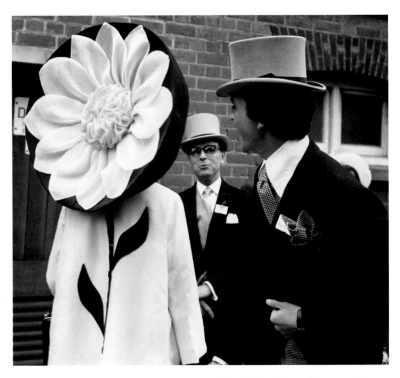

The Chelsea Flower Show came to
Royal Ascot, Berkshire in the shape
of a giant daisy hat worn by Gertrude
Shilling, which was designed for her by
her 18-year-old son, David Shilling. For
30 years after this event – until she was
well into her 80s – Shilling appeared at
showy events in her son's imaginative
creations, forming a wonderfully
eccentric mother-and-son partnership.
20th June, 1967

Lady Diana Spencer (later the Princess of Wales), youngest daughter of Earl Spencer, at Park House, Sandringham, Norfolk with her brother Charles, Viscount Althorp, a former Page of Honour to the Queen. Diana became the first wife of Charles, Prince of Wales, whom she married on 29th July, 1981, and an international charity and fundraising figure, as well as a pre-eminent celebrity of the late 20th century. Her her death in a car crash in Paris on 31th August, 1997 resulted in a nationwide display of public mourning.

1st August, 1967

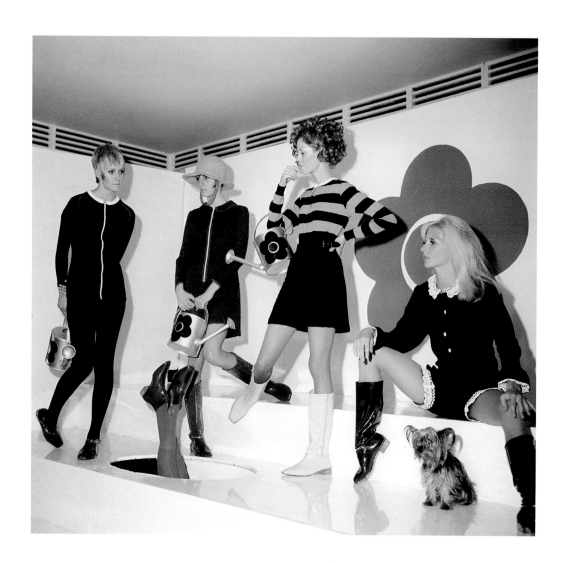

Tottenham Hotspur's Jimmy Greaves plays about with a camera. Greaves enjoyed a legendary career at Tottenham, playing at the club from 1961 to 1970. He scored a club record of 266 goals in 379 matches, including 220 goals in the First Division. He finished as top League goalscorer in four seasons (1963, 1964, 1965 and 1969), an achievement that established him as arguably the most consistent striker in English football history. His record of finishing top goalscorer in six seasons has never been matched. He later became a television pundit – famous for his trademark catchphrase *"It's a funny old game"*.

7th August, 1967

Facing page: Models and a Yorkshire Terrier present creations by the designer Mary Quant in London. The flower motif seen here is a pop-art take on the ethos of the 'flower power' movement of the era. Quant's clothes became part of the 'London Look', synonymous with trendiness and the 'Swinging Sixties'.

1st August, 1967

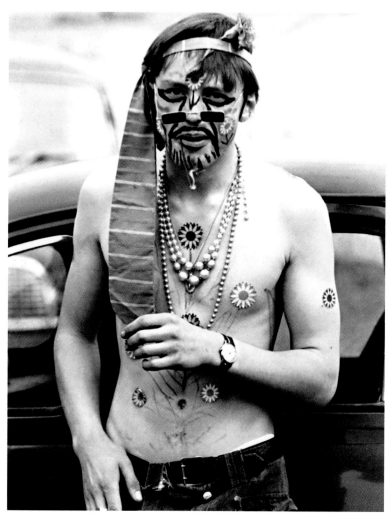

A typical 'flower child' with flowers painted over his body and face, and beads hanging from his neck, at a three day festival held at Woburn Abbey, the stately home of the Duke and Duchess of Bedford. Between 12,000 and 20,000 attended the three-day 'love in'.

27th August, 1967

Laden with parcels, actor Richard Attenborough is seen with his wife, actress Sheila Sim, and daughters Jane, 12, and Charlotte, 8, after flying into Heathrow Airport, London, on their return from a Mediterranean holiday. In 1967 and 1968, he won back-to-back Golden Globe Awards in the category of Best Supporting Actor, the first time for *The Sand Pebbles* starring Steve McQueen and the second time for *Doctor Dolittle* starring Rex Harrison. As a director and producer he later won two Academy Awards for the 1982 film *Gandhi*.

6th September, 1967

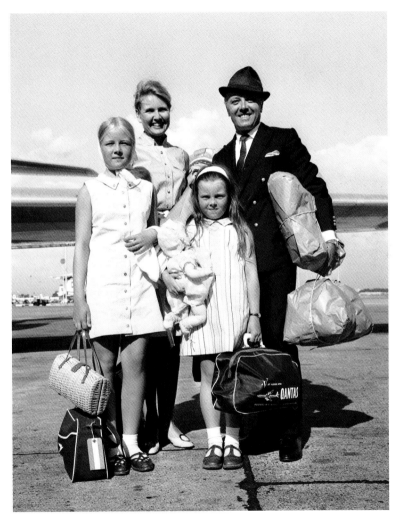

The Test

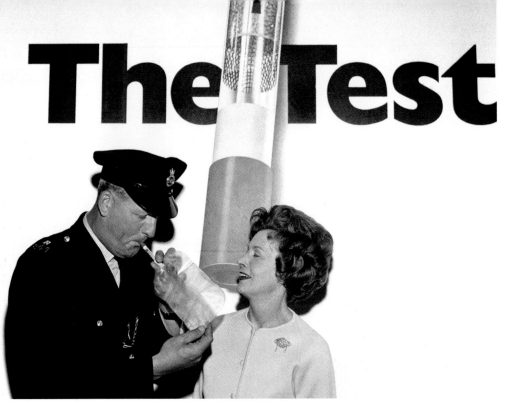

Police Constable Tony Burton of London demonstrating the Alcotest 80 breath-testing device for Mrs Barbara Castle, Minister of Transport, in London where she was launching a drinking and driving publicity campaign to inform the public about the new breathalyser law. The practical and highly portable breathalyser was invented in 1953 by Professor Robert F. Borkenstein. It replaced a more cumbersome contraption, invented in 1938 and known as the 'drunkometer'.
19th September, 1967

The lion Marquess provides a real-life roar for the Troggs pop group, who were recording the song *The Lion* in London. From left; Ronnie Bond, Chris Britton, Reg Presley and Peter Staples. The Troggs had a number of hits in the UK and the US during the 1960s. Their most famous songs include *Wild Thing* and *Love Is All Around*. Originally called The Troglodytes, the group's sound was one of the inspirations for garage rock and punk rock, influencing artists such as Iggy Pop and British pop-punk pioneers Buzzcocks.
10th October, 1967

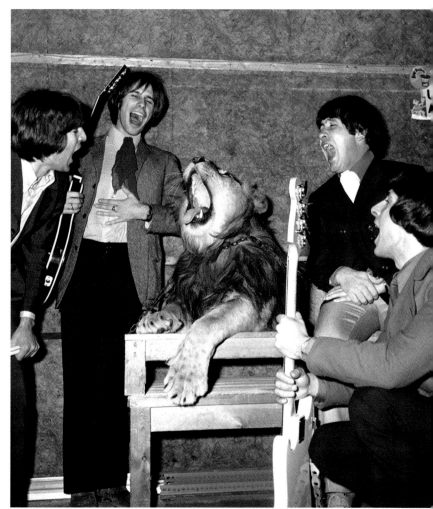

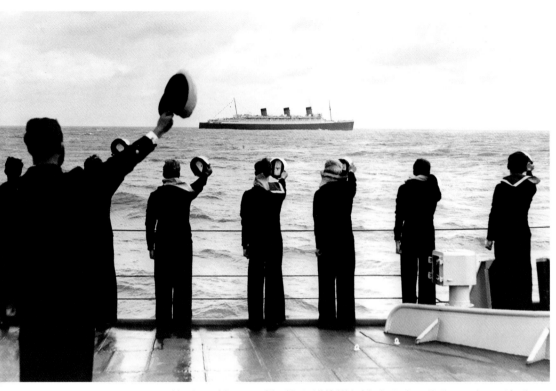

Members of the crew of the frigate HMS *Wakeful*, who took part in the naval escort for the last voyage of the *Queen Mary*, give three cheers as the ship passes by at Southampton. The ship sailed primarily in the North Atlantic from 1936 to 1967 for the Cunard Line. During World War II, she was converted into a troopship. Following the war, the ship was refitted and, along, with her running mate the *Queen Elizabeth*, dominated the transatlantic passenger service market until the dawn of the jet age in the late 1950s. On 31st October 1967, she began her voyage to Long Beach, California, United States. The permanently moored vessel is now a tourist attraction featuring restaurants, a museum and a hotel.
31st October, 1967

Police keep guard at the entrance to Galn-yr-Afon farm, near Oswestry, due to several outbreaks of foot-and-mouth disease in the area. In October 1967, a farmer from Bryn Farm in Shropshire, sought veterinary advice for one of his cows. The animal was found to have contracted foot-and-mouth disease. Bryn Farm was immediately put into quarantine and general animal movement was banned. However, the virus rapidly spread to nearby Ellis Farm. In the following months, over 2,364 outbreaks were detected in the United Kingdom, the majority of which occurred in North-West Midlands and North Wales.

8th November, 1967

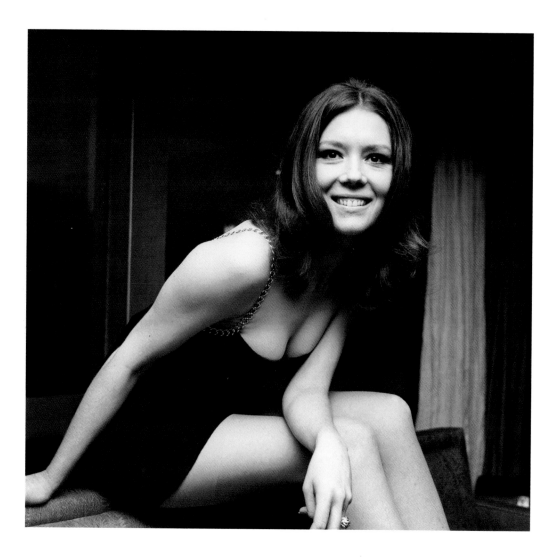

The 19-year-old pop singer Robert Plant (later of Led Zeppelin), from Wolverhampton, visits the office of the Charge d'Affaires of the Republic of China in Portland Place, London, to hand in a letter expressing his interest in the cultural revolution taking place in that country. He also offered the services of his group Band of Joy to perform in China.

15th November, 1967

Facing page: Diana Rigg, star of *The Avengers* television series. Rigg played the secret agent Mrs Emma Peel for 51 episodes between 1965 and 1967. She tried out for the role on a whim, without ever having seen the programme. Rigg later played Countess Teresa di Vicenzo in the 1969 James Bond film *On Her Majesty's Secret Service*. Her career in film, television and the theatre has been wide-ranging, including roles in the Royal Shakespeare Company. She was made a Dame of the British Empire (DBE) in 1994.

8th November, 1967

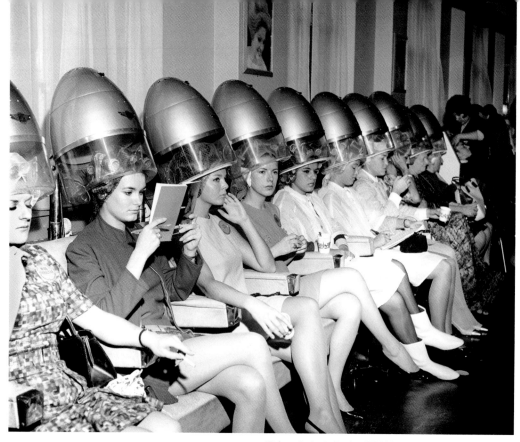

The contestants for the 1967 Miss World beauty title, photographed at a London salon having their final 'hair-do' before the contest. The 17th Miss World pageant, the competition was held on 16th November, 1967 at the Lyceum Theatre, London. A total of 55 contestants competed for the Miss World title. The winner was Madeleine Hartog Bell, who represented Peru.
15th November, 1967

Model Susan Gregg using a new chip vending machine at the Bedford Court Hotel, which serves a fresh portion of chips every 45 seconds at a cost of one shilling. Despite this modern innovation in fast-food vending technology, such machines have never replaced the traditional British fish-and-chip shop.

4th December, 1967

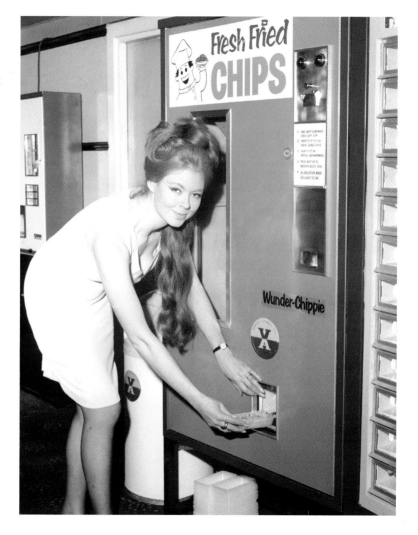

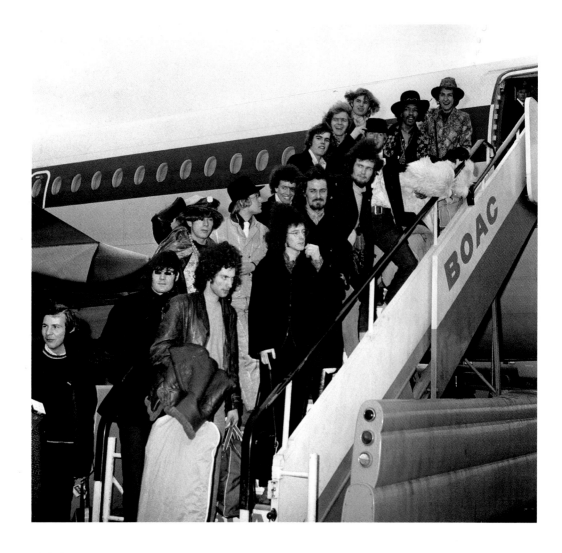

Birmingham City's veteran players George Moore (L) and Tommy Bell prepare to paste up a poster advertising the forthcoming fixtures taking place at St Andrew's fooball ground in the 1967–68 season. In 1968, Birmingham City reached the semi-finals of the FA Cup but were beaten 2–0 by West Bromwich Albion. West Brom went on to defeat Everton 1–0 after extra time in the Cup Final at Wembley.
9th February, 1968

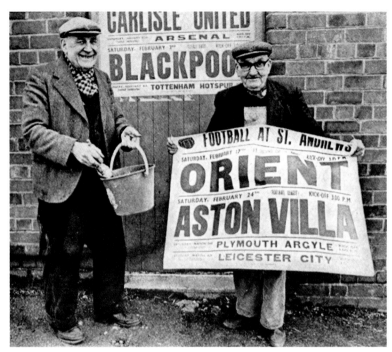

Facing page: British pop groups, bound for the USA on a tour which will yield half a million dollars. They are (from the top of the boarding ladder); the Jimi Hendrix Experience, Eric Burdon and the Animals, the Alan Price Set and Éire Apparent. The Jimi Hendrix Experience were to receive a Gold disc from their US record company for their first LP *Are You Experienced?*, which has passed the million-dollar sales mark.
30th January, 1968

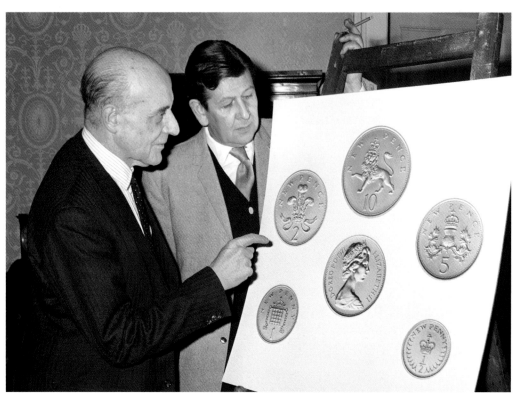

John Hastings, Deputy Master and Controller of the Royal Mint, with the new, decimal coinage and its designer, Christopher Ironside, in 1968. The old system of pound (£), shilling (s) and pence (d) coins were phased out three years later on Decimal Day – 15th February 1971 – in favour of a system dividing the pound into units of ten, including half, one, two, five, ten and 50 pence denominations.
15th February, 1968

Prince Andrew and the famous clown Charlie Cairoli share a joke over a birthday tea party at the Empire Pool, Wembley, on Charlie's 58th birthday, where he is performing in *Cinderella on Ice*. The Prince will celebrate his eighth birthday in a few days. Born in Milan, Italy, to a travelling circus family of French origin, Cairoli began his performing career at the age of seven. Famous for his red nose, bowler hat, eyebrows, moustache and costume, he was the best-known clown on British television in the 1960s and 70s. His career spanned well over 40 years, and he was the subject of ITV's *This is Your Life* programme on 25th February, 1970, where he was introduced as the 'king of clowns'.

15th February, 1968

In her new uniform, Mrs Sislin Fay Allen, who became Britain's first black policewoman after finishing her training. Mrs Allen came to England from Jamaica in 1962. Formerly a nurse at Croydon's Queens Hospital, Allen started work at Croydon's Fell Road Police Station. Sislin faced abuse from the white British community who refused to be policed by a black officer, but her tenacity was a source of courage and inspiration for other black people to join the police.
15th February, 1968

Clint Eastwood, newcomer Ingrid Pitt and British film stars Mary Ure and Richard Burton, during filming of a scene set during World War II for the film *Where Eagles Dare*, at Metro-Goldwyn-Mayer's studios. Now considered a classic, the action-adventure spy film was directed by Brian G. Hutton and shot on location in Upper Austria and Bavaria. Alistair MacLean wrote the novel and the screenplay at the same time. Both film and book became huge commercial successes. Award-winning conductor and composer Ron Goodwin wrote the film score and future Oscar-nominee Arthur Ibbetson worked on its cinematography.

16th February, 1968

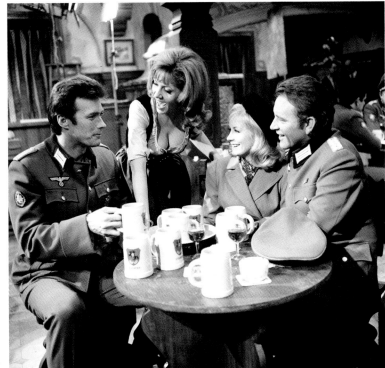

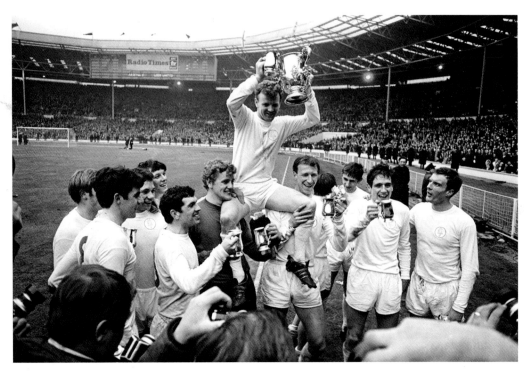

Leeds United captain Billy Bremner holds the League Cup aloft as his teammates carry him on their shoulders after their win against Arsenal. It was the First League Cup Final for both clubs. Leeds had conceded just three goals in six matches in their run-up to the final and their defence were on top again in the battle against Arsenal. Terry Cooper scored the only goal, hammering it home after 20 minutes. After that, Leeds' defensive performance saw them out for the rest of the match.

2nd March, 1968

Legendary Heavyweight boxer Joe Frazier, pictured in London after winning his World Title fight with Buster Mathis in New York. Although the fight was not recognised as a World Championship bout by some, Frazier won by a knockout in the 11th round and staked a claim to the Heavyweight championship. He then defended his claim by beating hard-hitting prospect Manuel Ramos of Mexico in two rounds. Known as 'Smokin' Joe', Frazier's powerful left hook accounted for most of his knockouts.
2nd April, 1968

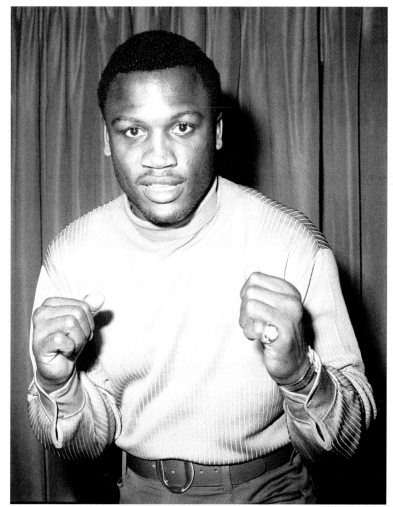

Gerry and Sylvia Anderson seeing off their *Thunderbirds* puppets, bound for Japan, at Heathrow. A science-fiction television show, the series followed the adventures of International Rescue, an organisation created to help those in grave danger using technically advanced equipment and machinery. It focused on the head of the organisation, ex-astronaut Jeff Tracy, and his five sons who piloted the Thunderbird machines. It used a form of marionette puppetry dubbed 'Supermarionation'. The series is still shown today and has inspired a number of television shows and films.

8th April, 1968

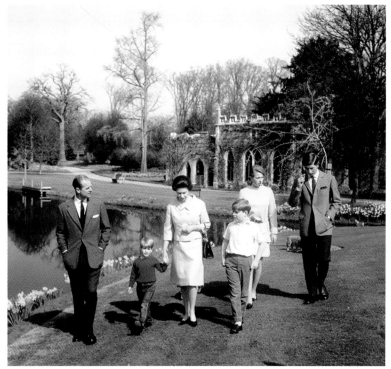

The Royal family, (L–R) the Duke of Edinburgh, Prince Edward, the Queen, Prince Andrew, Princess Anne and Prince Charles, walk by the pond at Frogmore, Windsor. The Frogmore Estate is made up of 33 acres of private gardens within the grounds of the Home Park, adjoining Windsor Castle, in Berkshire. The name derives from the numerous frogs found in this low-lying and marshy area. It is the location of Frogmore House, a Royal retreat. It is also the site of three burial places of the British Royal Family: the Royal Mausoleum containing the tombs of Queen Victoria and Prince Albert; the Duchess of Kent's Mausoleum, burial place of the Queen Victoria's mother; and the Royal Burial Ground.
9th April, 1968

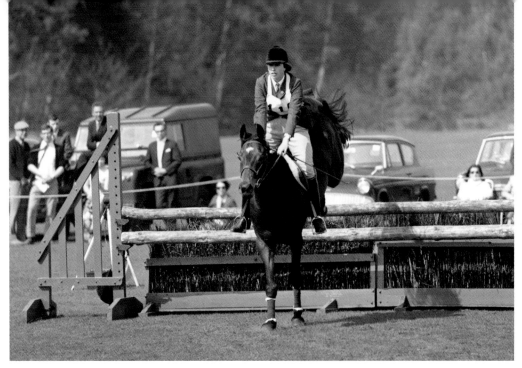

Princess Anne clears the obstacle fence on her pony Purple Star in the Dressage event of the Windsor Horse Trials at Windsor Great Park in 1968. A talented equestrian, the Princess went to won the individual title at the European Eventing Championship in 1971. For more than five years she also competed with the British Eventing team, winning a Silver medal in both individual and team disciplines in the 1975 European Eventing Championship, riding the home-bred Doublet. She also participated in the 1976 Olympic Games in Montreal as a member of the British team, riding the Queen's horse, Goodwill.

26th April, 1968

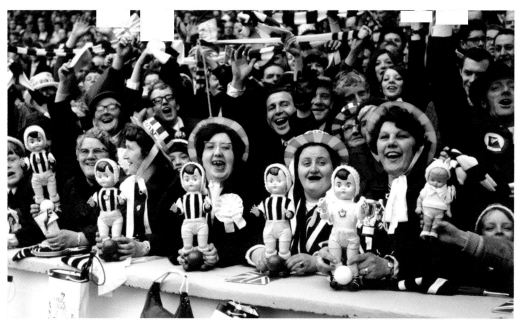

West Bromwich Albion supporters with mascots at the 1968 FA Cup Final with Everton. The match was contested by West Bromwich Albion and Everton at Wembley. West Brom won by a single goal, scored by Jeff Astle three minutes into extra time. The goal meant that Astle had scored in every round of that season's competition. It was the first Cup Final to be televised live in colour. Both teams wore away strips, with Everton wearing bright amber shirts and blue shorts and West Bromwich Albion in white shirts and shorts with red socks. It was the fifth Cup Final win for Albion, qualifying them for the 1968–69 European Cup Winners' Cup.
18th May, 1968

David Sadler with the European Cup after Manchester United beat Benfica of Portugal 4–1 in the Final at Wembley. He is flanked by team mates Brian Kidd (L) and Pat Crerand. The score remained at 1–1 until the end of normal time. George Best put United in the lead again three minutes into extra time. Kidd, who was celebrating his 19th birthday, added United's third a minute later, before Bobby Charlton rounded off the scoring before 100 minutes had been played. United's win meant that they became the first English team to win the European Cup.

29th May, 1968

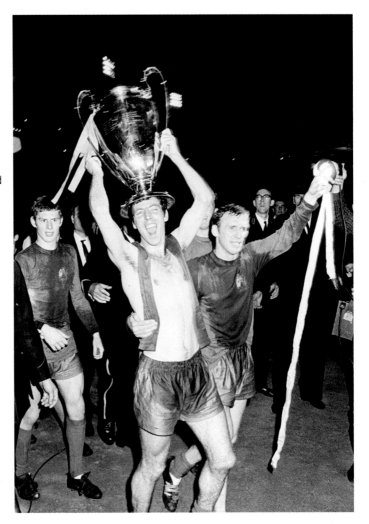

The Queen speaks at the Trade Union Congress (TUC) centenary banquet. The TUC is a federation of trade unions in the United Kingdom. There are 58 affiliated unions with a total of about 6.5 million members.
5th June, 1968

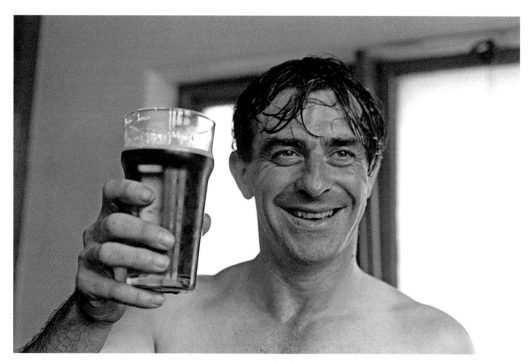

Yorkshire skipper Freddie Trueman takes a well-earned drink after the county's victory over Australia at Bramall Lane, Sheffield. One of the greatest fast bowlers in history, Trueman played first-class cricket for Yorkshire County Cricket Club from 1949 until he retired in 1968. He represented England in 67 Test matches and was the first bowler to take 300 wickets in a Test career. Trueman's talent, skill and popularity were such that British Prime Minister Harold Wilson described him as the 'greatest living Yorkshireman'.

2nd July, 1968

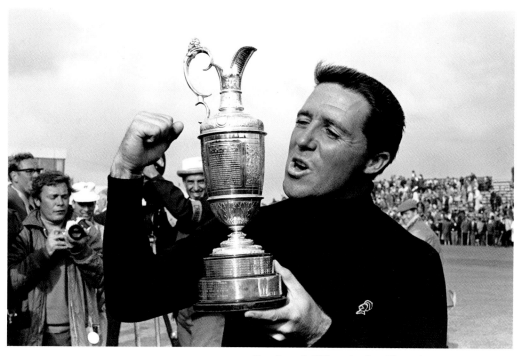

New Open Golf Champion Gary Player shows his trophy to the crowd at Carnoustie, Angus, Scotland. The 32-year-old South African, repeating his 1959 victory, aggregated 289 to win the title. This was two strokes better than the joint runners-up, Jack Nicklaus and Bob Charles. Player went on to achieve nine major championship victories, winning 165 tournaments on six continents over six decades. He is widely regarded as one of the greatest players in the history of golf. He was inducted into the World Golf Hall of Fame in 1974.

13th July, 1968

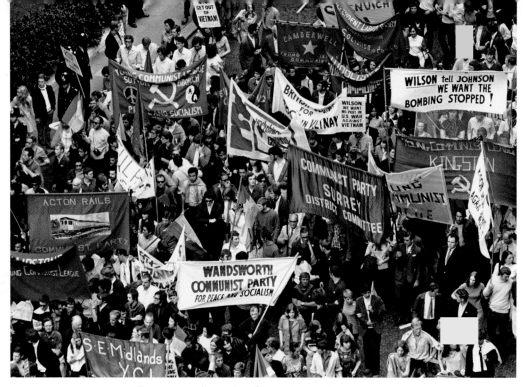

Demonstrators from various Communist groups throughout the United Kingdom march on the US Embassy in Grosvenor Square in a protest against the Vietnam War on 21st July, 1968. It followed a protest march a few months earlier on 17th March, when a rally outside the US Embassy turned into a riot with 86 people injured and over 200 arrested.

21st July, 1968

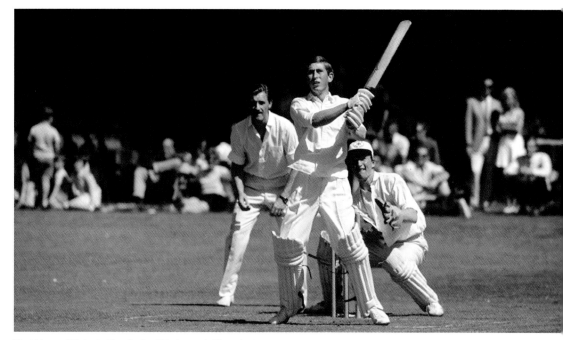

The Prince of Wales batting for Lord Brabourne's XI against
a team of Grand Prix drivers at a charity match. The action
took place at Mersham, near Ashford in Kent. In his years as
heir apparent, Prince Charles has devoted a great deal of his
time to charity work and collaborations with local communities.
He founded The Prince's Trust in 1976, and since then has
established 17 more charitable organisations. Together, these
form a loose alliance called The Prince's Charities, which
claim to raise over £110 million annually.
21st July, 1968

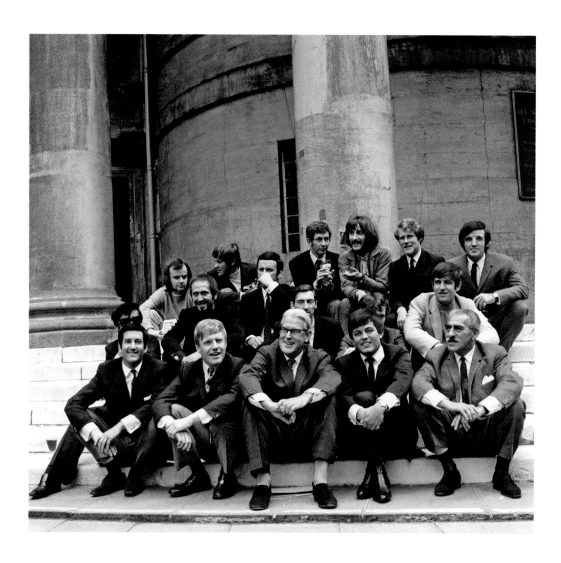

Jimmy Savile, BBC Radio One disc jockey. Savile started his radio career working as a Radio Luxembourg DJ from 1958 to 1967, joining BBC Radio 1 in 1968. Best known for his 1970s' BBC Television show *Jim'll Fix It,* Savile was also the first and last presenter of the long-running BBC chart show *Top of the Pops,* which began in 1964 and ended 2006.
25th July, 1968

Facing page: Radio One DJs: (back row, L–R) John Peel, David Symonds, Dave Cash, Stuart Henry, Johnny Moran, Alan Freeman; (middle row, L–R) Peter Myers, Mike Ravon, Terry Wogan, Keith Skues, Kenny Everett, Ed Stewart; (front row, L–R) Barry Aldis, Chris Denning, Robin Scott, Tony Blackburn, Sam Costa. Radio 1 was launched on 30th September, 1967 as a response to the popularity of offshore 'pirate-radio' stations such as Radio Caroline. The first DJ to broadcast on the new station was Tony Blackburn.
25th July, 1968

Athlete Mary Peters (L) competing in the first heat of the 80m hurdles of the Women's Amateur Athletic Association's (AAA) National Senior Pentathlon, at the Crystal Palace Stadium in London. She represented Northern Ireland at every Commonwealth Games between 1958 and 1974. In these games she won two Gold medals for the Pentathlon, plus a Gold and Silver medal for the Shotput. In the 1972 Summer Olympics Peters won the Gold medal in the Women's Pentathlon. She was appointed CBE in 1990, MBE in 1972, and DBE in 2000.

9th August, 1968

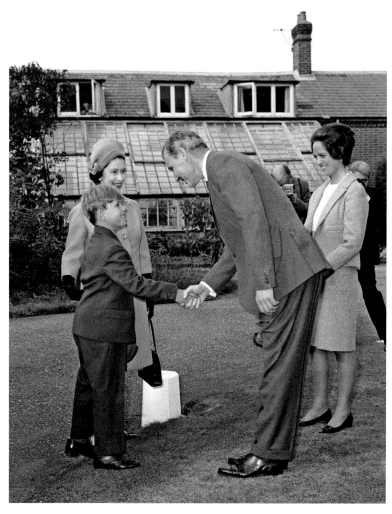

Eight-year-old Prince Andrew, the future Duke of York, and his mother Queen Elizabeth II, are greeted on arrival at Heatherdown Preparatory School, Ascot, Berkshire, by headmaster James Edwards and Elizabeth Keeling. An independent junior school for boys set in 30 acres of grounds, it typically had between 80 and 90 pupils. The school closed in 1982.

13th September, 1968

The new James Bond, Australian actor and former model George Lazenby, in 1969. After Sean Connery quit the role of James Bond, 22-year-old actor Timothy Dalton declined the role in the new film *On Her Majesty's Secret Service* as he considered himself to be too young (he later played the role in the 1980s). Producer Albert R. Broccoli looked for a new Bond and chose Lazenby after seeing him in a commercial. The film was dismissed by critics who cited Lazenby as a disappointing successor to Connery. However, the film has been reassessed over the years and it is now generally ranked as one of the best Bond movies amongst fans of the series.

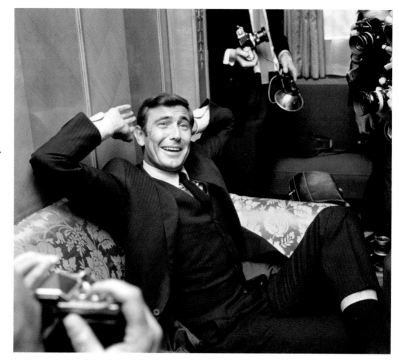

Facing page: Eli, the baby elephant, joins pop group The Who and girls Nicola Austine (L) and Toni Lee (R) on a ride on the 'Magic Bus' from the BBC's Lime Grove studios, to promote their latest single. Members of the group are (L–R), Roger Daltrey (lead singer), Keith Moon (drums), Peter Townsend (lead guitar) and John Entwistle (bass guitar). Together with The Beatles and the Rolling Stones, The Who complete the 'holy trinity' of British rock.
9th October, 1968

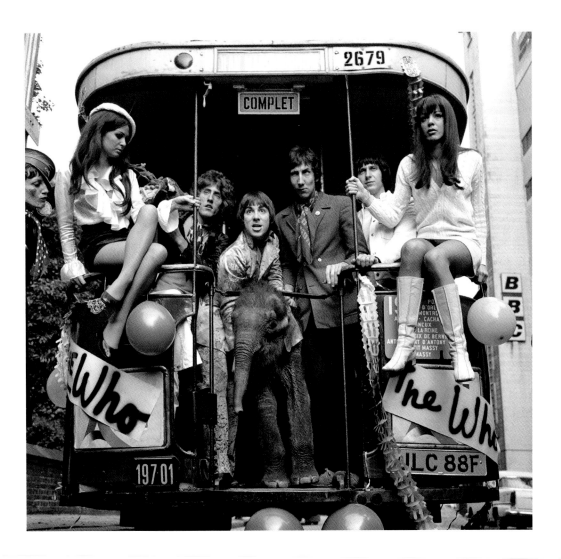

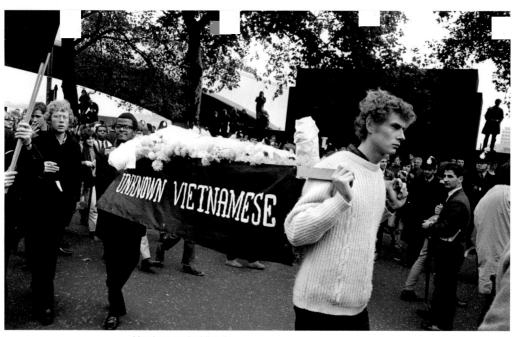

Marchers on the Victoria
Embankment after the start
of the great anti-Vietnam
War march in London. An
estimated 20,000 marchers
set off. At Downing Street,
Tariq Ali of the Vietnam
Solidarity Campaign (VSC),
handed in a petition, signed
by 75,000 people, to ask
the government to stop
supporting the US in its war
against Vietnam.
27th October, 1968

Cliff Richard cuts through the World's Largest Christmas Pudding at the Carlton Tower in London, to be distributed to the Mental Health Trust for patients and hospitals throughout the country. Cliff's involvement with charity causes has continued throughout his career, and he received a Knighthood in 1995. Grants are made by the Sir Cliff Richard Trust every quarter, with about 50 different registered charities benefiting each time. Priority is given to charities working in medical research, with children and the elderly, and those involved with the physically and/or mentally disabled.

4th December, 1968

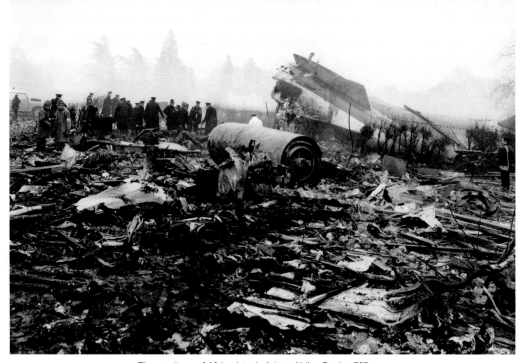

The wreckage of Afghanistan's Ariana Airline Boeing 727, Flight 701, in which 50 people were killed and 15 injured as it crashed into a house on its approach to a fog-bound Gatwick airport. Investigators found the cause of the crash was pilot error by the captain. The decision not to divert to London Heathrow Airport and the failure to extend the flaps to maintain flight at final approach speed led to catastrophe; 48 passengers and crew died, and two people were killed on the ground.

5th January, 1969

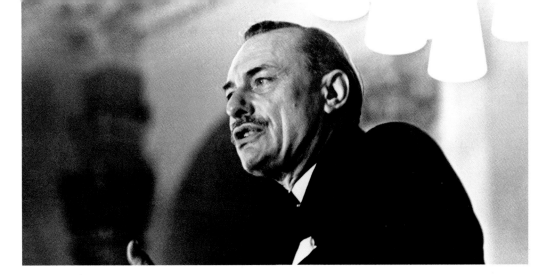

Enoch Powell MP discusses the issues surrounding immigration with the Rector of the Church of St Mary-le-Bow, Cheapside, London, in a public debate. Powell's 'Rivers of Blood' speech on 20th April, 1968, in which he criticised mass immigration from the Commonwealth, led to him being sacked from his position as Shadow Defence Secretary (1965–68) in the shadow cabinet of Edward Heath.
21st January, 1969

Scottish singer Lulu marries Maurice Gibb of the pop group the Bee Gees, at the Parish Church, Gerrard's Cross in Buckinghamshire. Gibb, a musician, singer-songwriter and record producer, was born on the Isle of Man, the twin brother of Robin Gibb, and younger brother to Barry. He formed the singing/songwriting trio the Bee Gees with his brothers. The trio got their start in Australia, and found major success when they returned to England. They became one of the most successful pop groups ever. Gibb was married to Lulu from 1969 to 1973. Their careers and his heavy drinking forced them apart and they divorced in 1973.

18th February, 1969

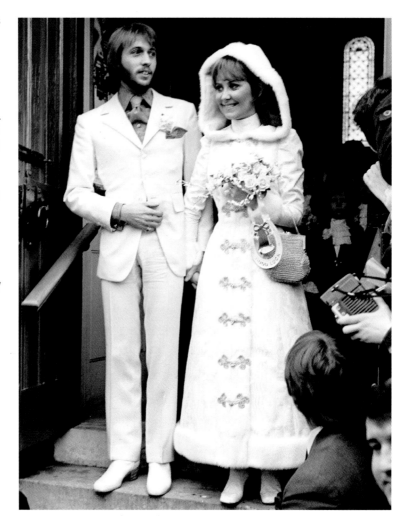

Australian comedian Barry Humphries, backstage as his alter-ego Dame Edna Everage. Originally a drab housewife from Melbourne, Australia, Edna was conceived to satirise the conservatism of Australian suburbia. Since the 1960s, Humphries has continually updated the character, adopting an increasingly bizarre wardrobe and elevating her status to 'Housewife and Superstar', then 'Megastar' and finally 'Gigastar'. Dame Edna's larger-than-life persona and scathing commentary on society and celebrity, as well as her habit of puncturing the inflated egos of her guests on her TV shows, has ensured that the character still retains its satirical edge.

12th March, 1969

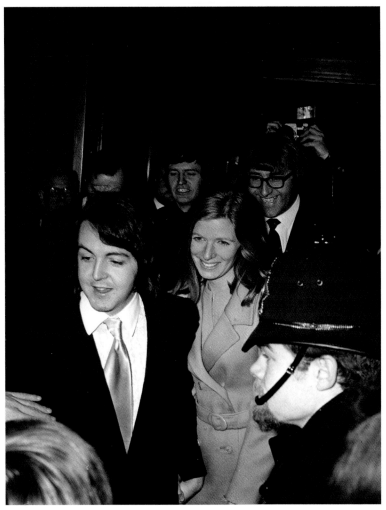

Beatle Paul McCartney broke millions of teenage girls' hearts when he married his girlfriend Linda Eastman in London. The daughter of a wealthy, high-profile New York lawyer, Linda was the house photographer at the Fillmore East concert hall in the East Village, New York. She photographed artists such as Aretha Franklin, Grace Slick, Jimi Hendrix, Bob Dylan, Janis Joplin, Eric Clapton, Simon & Garfunkel, The Who, the Doors, the Animals, John Lennon, and Neil Young. Her marriage to McCartney was a happy, long-lasting union that continued until Linda's untimely death from breast cancer in 1998. They had three children together – Mary, Stella and James. McCartney also adopted Heather, Linda's daughter from her first marriage to Joseph Melville See Jr, an American geologist.
12th March, 1969

Jackie Stewart tries his hand at playing the trombone while sitting in his Matra Ford, watched by racing enthusiast Chris Barber (R) and his jazz band. With wins at Kyalami, Montjuic, Zandvoort, Silverstone, and Monza, Stewart became World Champion in 1969. He competed in Formula One between 1965 and 1973, winning three World Drivers' Championships.

14th March, 1969

John Trollope and Willie Penman celebrate Third Division Swindon Town's victory over First Division Arsenal in the Football League Cup Final. It was Swindon Town's first League Cup Final and also their first match at Wembley. Arsenal began the game by putting Swindon's defence under heavy pressure. However, the first goal came from Swindon in the 35th minute, scored by Roger Smart. Swindon maintained their 1–0 lead until half-time. In the 86th minute, Arsenal's Bobby Gould equalised with a header. This took the game into extra time, during which Don Rogers netted two goals for Swindon, giving the underdog club a 3–1 victory.

15th March, 1969

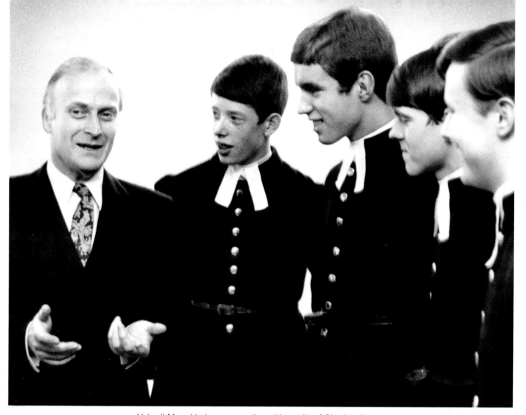

Yehudi Menuhin in conversation with pupils of Chetham's Hospital School, which become a junior school of music in 1969. Menuhin was a Russian-Jewish American violinist and conductor who spent most of his performing career in the United Kingdom. He is considered to be one of the greatest violinists of the 20th century. Today, Chetham's School of Music, familiarly known as 'Chets', is a independent co-educational music school. Situated in Manchester city centre, there are about 290 pupils on its roll, making it the largest music school in the United Kingdom.

31st March, 1969

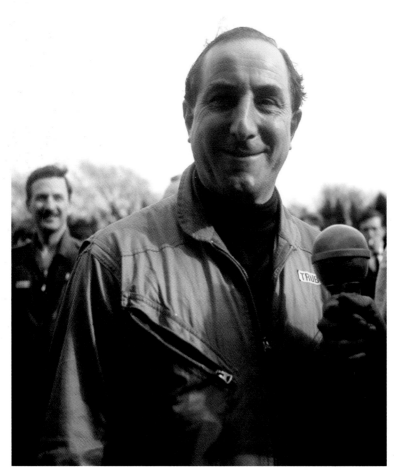

Facing page: Concorde 002, the British prototype of the Anglo-French supersonic passenger aircraft, takes off from Filton, Bristol, on its 22-minute maiden flight on 9th April, 1969. Concorde 001, the French prototype, first took off on 2nd March, 1969 from Toulouse and was in the air for 27 minutes before landing. Concorde entered service in 1976 and continued commercial flights for 27 years before its retirement on 26th November, 2003. It flew regular transatlantic flights from London Heathrow (British Airways) and Paris-Charles de Gaulle Airport (Air France) to New York JFK.
9th April, 1969

A beaming Brian Trubshaw, captain of Concorde 002, at RAF Fairford, Gloucester, where the machine landed after its successful maiden flight from Filton. His comment on emerging from the flight deck: *"It was wizard, a cool, calm and collected operation".*
9th April, 1969

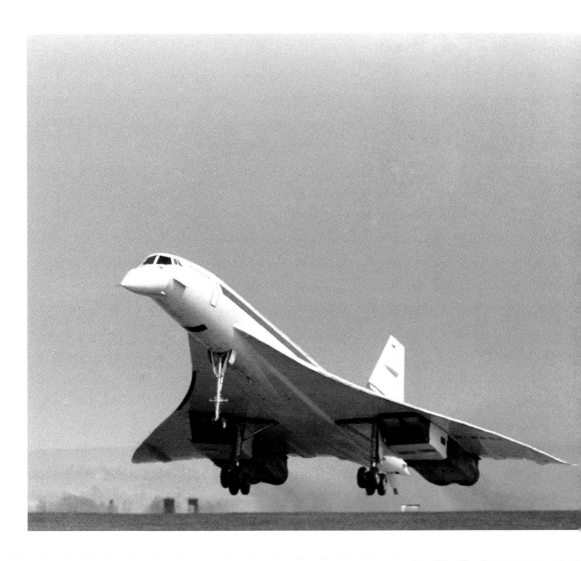

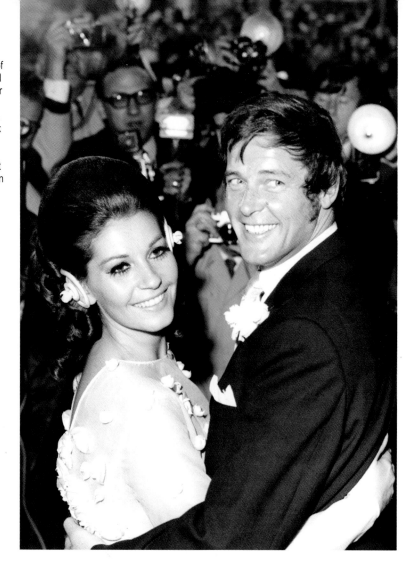

Newlyweds Roger Moore and Luisa Mattioli in front of the press. Moore portrayed the dashing Simon Templar in the long-running British television series *The Saint*. which ran from 1962 for six series and 118 episodes. He is probably best known for portraying British secret agent James Bond in seven films from 1973 to 1985. Moore had a daughter and two sons with Mattioli, but the marriage ultimately ended in divorce. He later married Danish-Swedish multi-millionaire Kristina 'Kiki' Tholstrup in 2002.

11th April, 1969

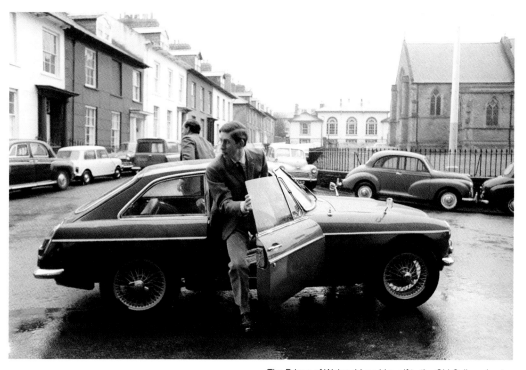

The Prince of Wales drives himself to the Old College (part of the University of Wales, Aberystwyth) in his MGC sports car. Despite only gaining B and C grades in his A-Levels, the Prince was admitted to Trinity College, Cambridge, where he read anthropology, archaeology and history. Charles also attended a nine-week course at the Old College to study the Welsh language and Welsh history. He is the first Prince of Wales born outside of Wales ever to attempt to learn the language of the principality.

21st April, 1969

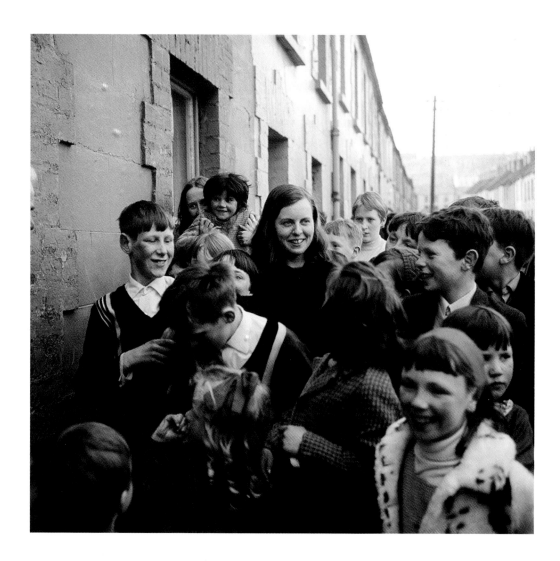

Round-the-world yachtsman Robin Knox-Johnston aboard his ketch, the *Suhaili*, on arrival in London. He was the first man to perform a single-handed non-stop circumnavigation of the globe. He departed from Falmouth on 14th June, 1968 and returned on 22nd April, 1969. In 2006, at the age of 67, he became the oldest yachtsman to complete a round-the-world solo voyage in the VELUX 5 Oceans Race.
1st May, 1969

Facing page: The new MP for Mid-Ulster, Socialist Republican Bernadette Devlin, surrounded by schoolchildren in Londonderry. Elected at the age of 21, she was the youngest woman ever to sit in the British Parliament. Devlin rejected the Irish Republican tactic of abstentionism (being absent from Westminster), standing on her slogan 'I will take my seat and fight for your rights'. Her 1969 book, *The Price of My Soul*, raised awareness of discrimination against Catholics in Northern Ireland.
27th April, 1969

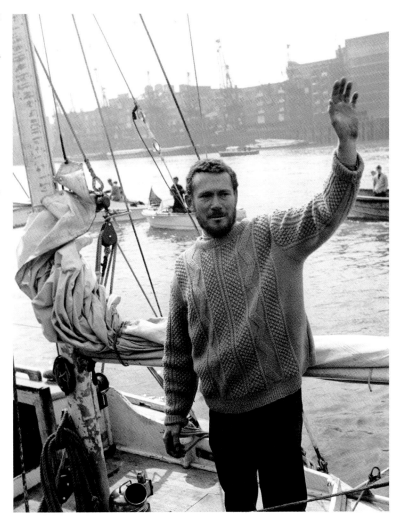

John Lennon holds Kyoko Cox, the six-year-old daughter of his Japanese wife, Yoko Ono, on the child's arrival at Heathrow airport from New York. Ono was awarded full custody of Kyoko afer a bitter legal battle with her ex-husband, jazz musician Anthony Cox. In 1971, violating the legal ruling, Cox disappeared with eight-year-old Kyoko. He raised her in a Christian group known as the 'Church of the Living Word', but left the group in 1977, changing Kyoko's name to Rosemary. Cox and Kyoko sent Ono a sympathy message after Lennon's murder in 1980. Ono later announced publicly that she would no longer seek out Kyoko. In 1994, the now-adult Kyoko made contact with Ono and established a relationship.

8th May, 1969

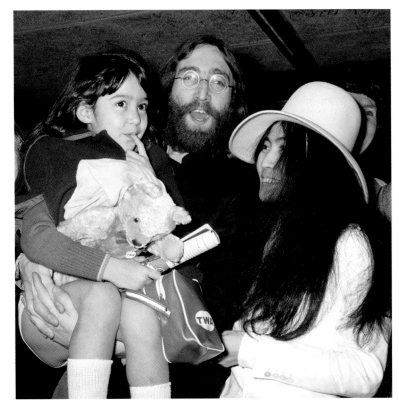

The 24-year-old disc jockey Kenny Everett with his new bride Audrey Middleton, also known as the singer 'Lady Lee', in 1969. Born Maurice James Christopher Cole, Everett is best known for his radio career and television series for ITV and the BBC. His ground-breaking presentation style, featuring zany voices and characters, multi-tracked jingles and trailers was hugely influential and has been much-copied by other DJs. By 1979, Everett had separated from his wife, after his decision to accept his own homosexuality. In 1989, Everett discovered that he had HIV, making a public announcement about his illness in 1993. He died from an AIDS-related illness, in the Royal Borough of Kensington and Chelsea, London, on 4th April, 1995. aged 50.

2nd June, 1969

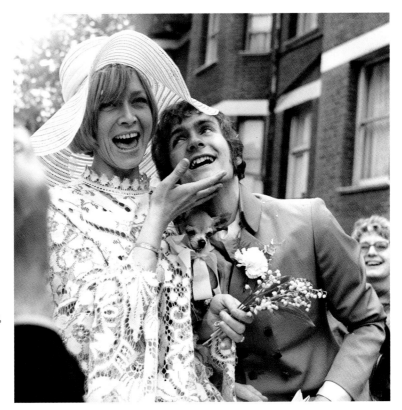

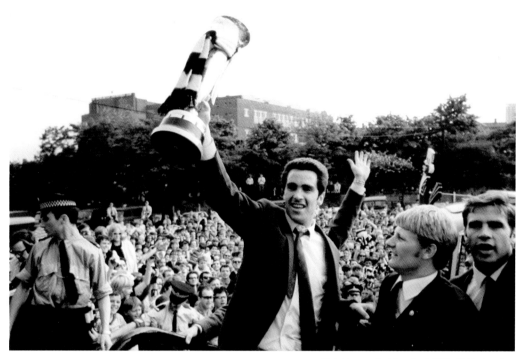

Facing page: Prince Charles during his walk and picnic in Snowdonia after chairing a 'Countryside In 1970' committee meeting at Bangor University. The committee addressed the challenges of trying to conserve the beauty of the Welsh countryside in the forthcoming decade, as well improving the quality of life for people in rural areas and making the most of natural resources.
5th June, 1969

Bob Moncor (holding Cup) Willie McFaul and John McNamee of Newcastle United, back at home with the 1969 European Inter-Cities Fairs Cup. The Final was played in two legs, on 29th May and 11th June, 1969 between Newcastle United FC of England and Újpesti Dózsa of Hungary. Newcastle won the tie 6–2 on aggregate.
12th June, 1969

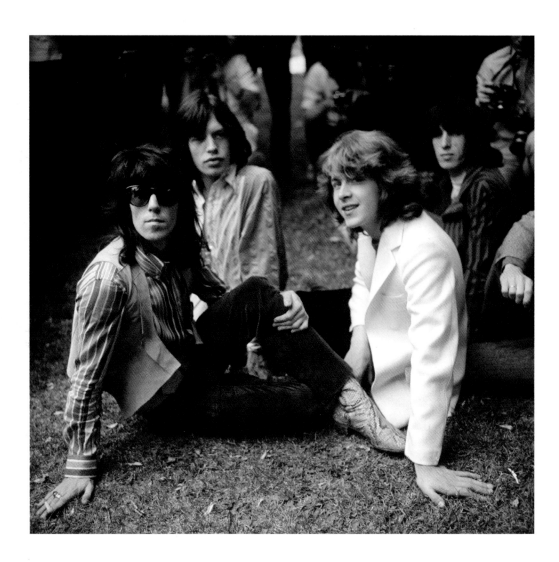

Twisted rails point to a derailed coach from the 14:45 Paignton to Paddington Express after the rear four coaches of the train left the track at Skeel Bridge, near Castle Cary, Somerset. There were no fatalities, but 28 people were injured, 8 seriously. An investigation into this accident and two similar derailments in other parts of the UK concluded that they were directly caused by the buckling of the CWR (Continuous Welded Rail) track ahead of each train.
13th June, 1969

Facing page: Mick Taylor (front R), the new lead guitarist with the Rolling Stones, shown here with band members Keith Richards (front L), Mick Jagger (back L) and Bill Wyman (back R). Taylor replaced the group's founder, Brian Jones, after he left the Stones in June 1969. Jones died less than a month later in his own swimming pool.
13th June, 1969

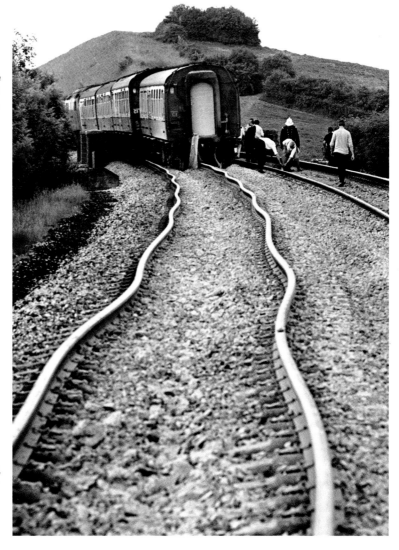

Prince Charles and the Queen Mother walk in procession after the Knights of the Garter ceremony at St George's Chapel, Windsor. The Most Noble Order of the Garter, founded in 1348, is the highest order of knighthood in England. After peerages – and the Victoria Cross and George Cross – it is the pinnacle of the honours system. Membership is limited to the monarch, the Prince of Wales, and no more than 24 members, or 'companions'. Bestowing the honour has been described as one of the British monarch's few remaining truly personal, executive prerogatives.
16th June, 1969

Brian Clough, Derby County manager, at the Baseball Ground in 1969. Under Clough's management, Derby became champions of Division Two in 1969, establishing the club record of 22 matches without defeat in the process. Clough was a hard but fair manager, who insisted on clean play from his players. He insisted on being called 'Mr Clough' and earned great respect from his peers for his ability to turn a game to his team's advantage. Derby's first season back in Division One in 1970, saw them finish fourth, their best league finish for over 20 years. Charismatic, outspoken and often controversial, Clough is widely considered to be one of greatest English managers never to have managed the England national squad.

1st July, 1969

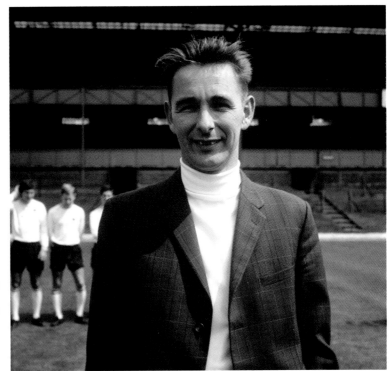

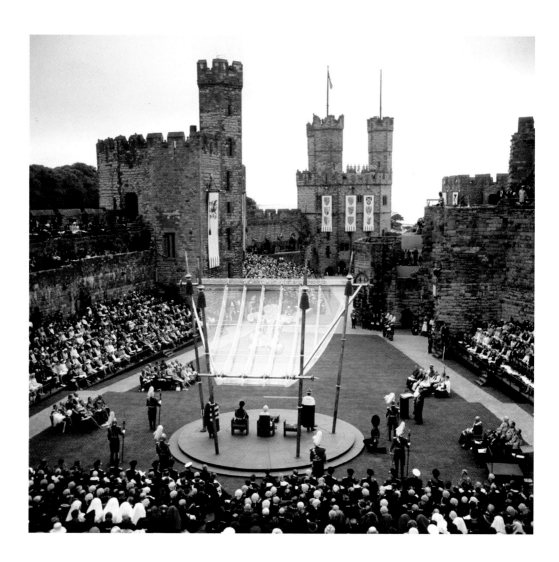

Queen Elizabeth II formally invests her eldest son as the Prince of Wales. Prince Charles spent many weeks leading up to his Investiture learning about Welsh culture and language and during the ceremony he gave his replies in both English and Welsh. The Investiture was watched by millions on TV. It also aroused considerable hostility among Welsh Nationalists. Threats of violence ensued, as well as a short bombing campaign – on the eve of the Investiture, two Nationalist bombers were killed while placing a bomb outside government offices in Abergele.
1st July, 1969

Facing page: The Investiture of Prince Charles as the Prince of Wales at Caernarfon Castle. The tradition of investing the heir of the English, and subsequently British, monarch with the title of 'Prince of Wales' began in 1301, when King Edward I of England, having conquered Wales, gave the title to his heir, Prince Edward (later King Edward II of England).
1st July, 1969

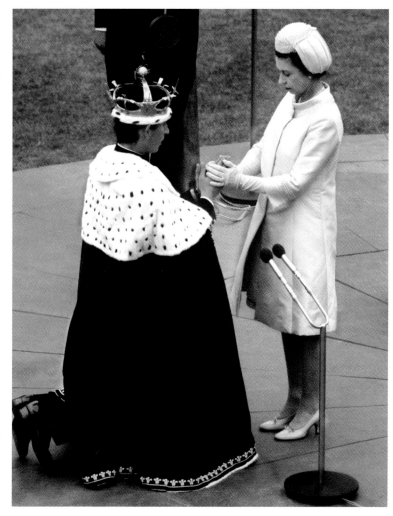

England's Ann Jones stands with her American opponent Billie-Jean King before the start of the Ladies Singles Final match at Wimbledon in 1969. Jones won a total of eight Grand Slam championships during her career: three in Singles, three in Women's Doubles and two in Mixed Doubles. Ann was also a talented table-tennis player, participating in five World Championships in the 1950s. Her best result was losing finalist in the Singles, Doubles and Mixed Doubles, all in 1957. Shortly after this she wrote a table-tennis tuition book entitled *Tackle Table Tennis This Way.*

7th July, 1969

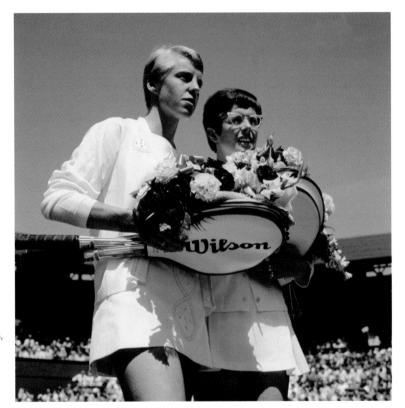

The day after winning the British Open Golf Championship at Royal Lytham St Anne's, Tony Jacklin relaxes with his silver trophy beside him in the back garden of his father, a lorry driver who lives near Scunthorpe, Lincolnshire. The most successful British player of his generation, he was also the most successful European Ryder Cup captain ever. Jacklin won two majors: in 1969, he became the first British player to win The Open Championship for 18 years. The following season he won the US Open. It was the only victory by a European player in an 84-year span, from 1926 to 2009. Northern Ireland's Graeme McDowell ended this streak in 2010.

13th July, 1969

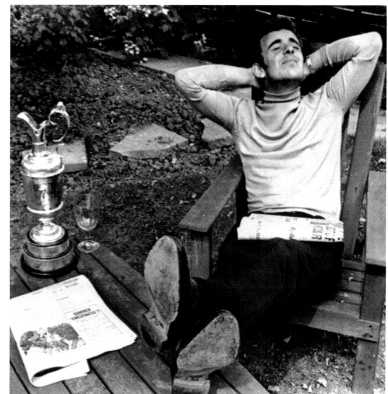

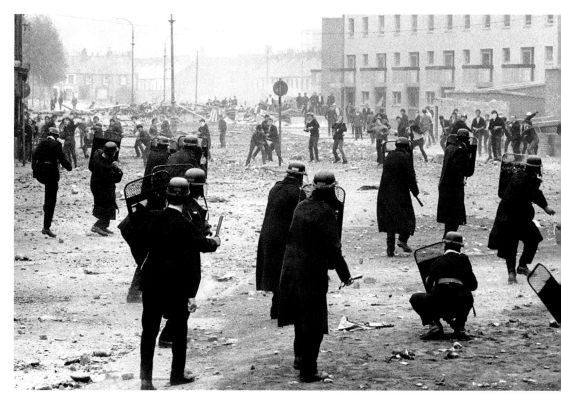

Richard Branson, organiser of the Student Advisory Centre, a service aimed at helping young people. In 1970, he set up an audio record mail-order business. In 1972, he opened a chain of record stores, Virgin Records, later known as Virgin Megastores. During the 1980s, he set up Virgin Atlantic Airways and expanded his Virgin music label. Branson is now one of the richest citizens of the United Kingdom, with an estimated net worth of US$4.2 billion.
31st July, 1969

The Royal Ulster Constabulary (RUC) battle with Irish Nationalists, who are protesting against a Loyalist Apprentice Boys parade along the city walls, in the Bogside area of Londonderry. The British Army was deployed to restore control. The riot was one of the first major confrontations in the 30-year conflict known as the 'Troubles'.
14th August, 1969

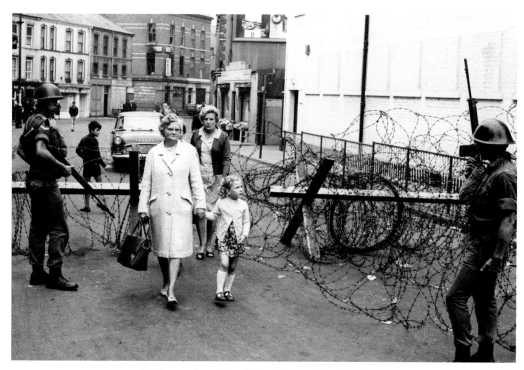

People move to and from the Bogside area of Londonderry, after rioting which led to the British Army being sent in to restore order. The so-called 'Battle of the Bogside' – a three-day riot between the Royal Ulster Constabulary and the Nationalist/ Catholic residents – led to further riots in other areas. The most bloody rioting was in Belfast, where seven people were killed and hundreds more wounded. Many houses and businesses were burned-out, most of them owned by Catholics.
15th August, 1969

Astronomer Patrick Moore wearing a souvenir of his visit to the Astronaut's Centre in Houston, Texas, before his BBC Television programme *The Sky at Night*. Moore presented the first episode of the astronomy programme on 26th April, 1957. A former president of the British Astronomical Association, he is the co-founder of the Society for Popular Astronomy. An author of over 70 books, Moore is credited as having done more than any other person to raise the profile of astronomy mong the British general public. He is also a self-taught musician and accomplished composer.

17th August, 1969

Bob Dylan in the Isle of Wight for the island's pop festival. The 1969 event featured Dylan's first paid performance since his motorcycle accident some three years earlier, and was held at a time when many still wondered if he would ever perform again. Followers from across the world trekked to the Isle of Wight to see the legendary perfomer and his backing group, The Band.

27th August, 1969

Facing page: Some 200,000 fans gathered for the Isle of Wight Festival in 1969. Three festivals were held, from 1968 to 1970, before being discontinued. The event was revived in 2002 at Seaclose Park, a recreation ground near Newport. Many notable artists have performed since its revival including the Rolling Stones, Paul McCartney, Muse, Stereophonics, Donovan, Ray Davies, Robert Plant, David Bowie, Manic Street Preachers, The Who, R.E.M., Coldplay and the Police.

31st August, 1969

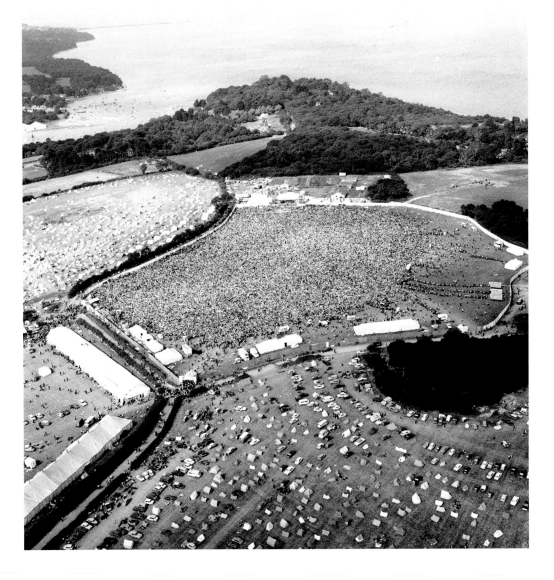

The 1960s • Britain in Pictures

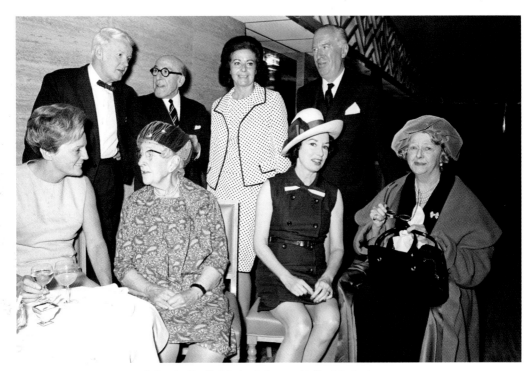

Author Agatha Christie (seated, second left) celebrates her 90th birthday. A British crime-writer who penned novels, short stories and plays, she also wrote romances under the name Mary Westmacott. She is best remembered for her 66 detective novels and 14 short-story collections. According to the *Guinness Book of World Records*, Christie is the best-selling novelist of all time. She has sold roughly four billion copies of her novels.

2nd September, 1969

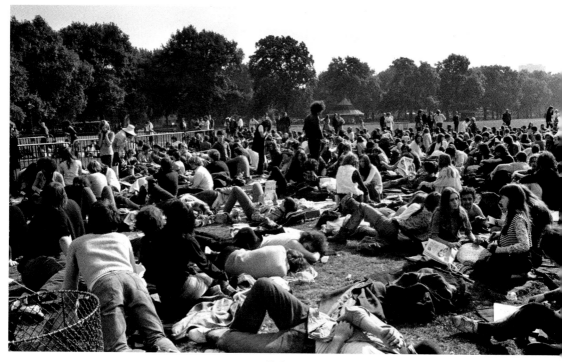

Early arrivals for the last of the year's free open-air concerts in Hyde Park. The featured acts were Soft Machine, the Deviants, Al Stewart, Quintessence and the Edgar Brougton Band. The previous concerts, which were held on 5th July and 6th September, 1969, featured a range of artists including the Rolling Stones, King Crimson, Roy Harper, Crosby, Stills and Nash, Jefferson Airplane and Alexis Korner's New Church.
20th September, 1969

Welsh singer Tom Jones in the pillared entrance of his palatial home at St George's Hill in Weybridge, Surrey, on his return to Britain after almost six months in America. Born Thomas John Woodward, Jones had an internationally successful television variety show titled *This Is Tom Jones* from 1969 to 1971. The show, worth a reported $9m to Jones over three years, was broadcast by ABC in America and ITV in the UK. Since the mid 1960s, Jones has sung pop, rock, R&B, show tunes, country, dance, techno, soul and gospel – and sold over 100 million records worldwide.

27th September, 1969

A convoy of new television detector vans passes over Blackfriars Bridge in London. The first TV detector vans were developed at the Post Office's experimental radio laboratories in the early 1950s. The Postmaster General was determined to identify non-payers of the license fee, who were receiving free entertainment subsidised by those who had paid the fee. The TV detector vans were fitted with three horizontal loop aerials, fixed to the roof. According to the inventors, the loops received signals issuing from television sets and converted them to radio waves, providing both audio and visual information.

17th October, 1969

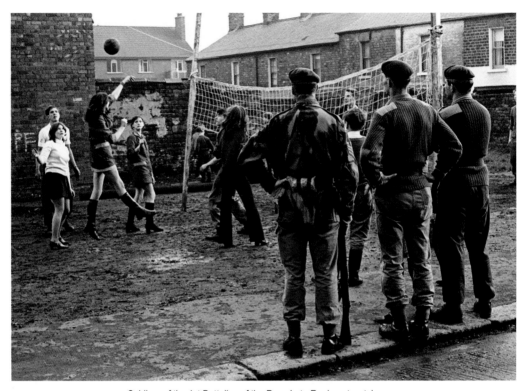

Soldiers of the 1st Battalion of the Parachute Regiment watch
a mixed volleyball game between girls and members of the
Battalion in the Morpeth Street area of Belfast. In the wake of
the riots in August, 1969, the Government of Northern Ireland
requested the presence of the British Army to restore order and
to prevent sectarian attacks on Catholics. Nationalists initially
welcomed the Army, but relations soon soured and the British
forces came to be viewed as a foreign, occupying force.
25th October, 1969

Stephen Taylor, aged seven, from Chertsey in Surrey, dressed as an astronaut, fixing the top section to an Airfix Saturn V *Apollo* rocket model kit. On 20th July, 1969, the Saturn V *Apollo 11* spaceflight made history as the United States landed the first humans, Neil Armstrong and Edwin 'Buzz' Aldrin, Jr, on the Moon. Airfix is a UK manufacturer of plastic scale-model kits of aircraft, military vehicles, spacecraft and other subjects. In Britain, the name Airfix is synonymous with model-making – a plastic model kit is often referred to as 'an Airfix kit' even if it is made by another manufacturer.

4th November, 1969

Disc jockey Alan 'Fluff' Freeman spins a disc in his record shop in Leyton. Born in 1927 and brought up in Melbourne, Australia, he earned his nickname from constantly wearing a favourite jumper until it was so worn out it was covered with fluff balls. Freeman joined the BBC in 1960. His American-style energy and sunny personality led to him becoming one of the UK's leading disc jockeys, and a British radio institution. With his familiar catchphrases *"Not 'arf!"* and *"Greetings, pop pickers"*, he spent more than 40 years in broadcasting, working until he was in his 70s.

6th November, 1969

Facing page: Australian-American businessman Rupert Murdoch looks at one of the first copies of the new *The Sun* newspaper at *The News of the World* building in London. In 1953, Murdoch became Managing Director of News Limited, acquiring various newspapers in Australia and New Zealand, before expanding into the United Kingdom in 1969. He went on to found News Corporation, the world's second-largest media conglomerate, which includes acquisitions such as Twentieth Century Fox, HarperCollins and *The Wall Street Journal*.

7th November, 1969

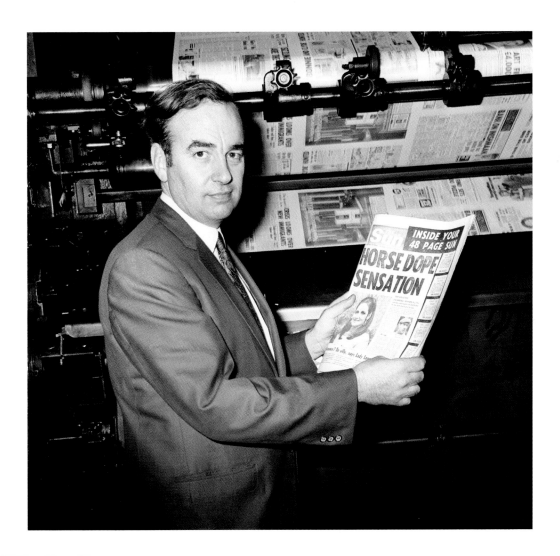

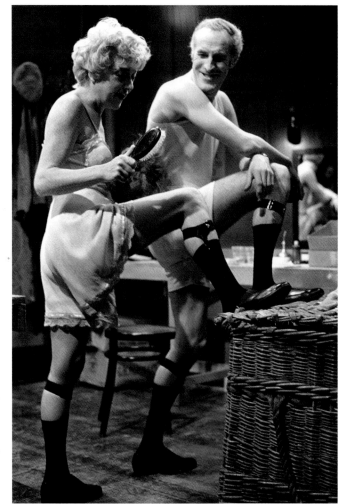

As part of the 70th birthday celebrations for English playwright, composer, director and singer Noël Coward, actress Dora Bryan (L) and entertainer Bruce Forsyth (R) starred in a BBC Television adaptation of Coward's play *Red Peppers*. Best known as the presenter of BBC Television's *The Generation Game* and *Strictly Come Dancing*, Forsyth has made occasional forays into acting. In *Red Peppers*, Bryan and Forsyth play a pair of fading music-hall performers.

23rd November, 1969

George Best, Manchester United and Northern Ireland soccer star, receiving his Daily Express Sportsman of the Year Award from the Prime Minister, Mr Harold Wilson, at a luncheon at a the Savoy Hotel, London. Despite receiving this prestigious award, Best's career was already beginning to be affected by his alcoholism. Successive Manchester United managers had problems controlling him and he increasingly made headlines for drunken binges rather than his footballing skills. Best made 470 appearances for Manchester United in all competitions from 1963 to 1974, scoring 179 goals.

25th November, 1969

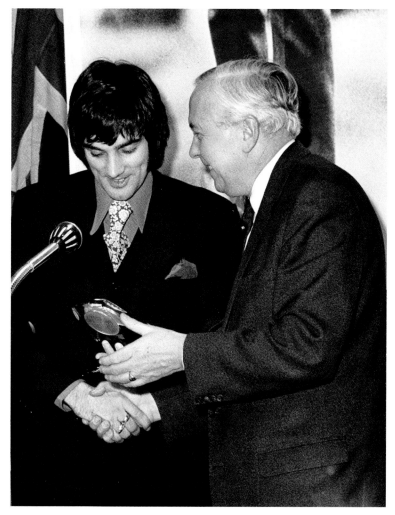

Eton College boys sit on the wall to watch the Wall Game, contested by the Collegers and the Oppidans. It is played on a strip of ground five metres wide and 110 metres long next to a slightly curved brick wall. The first recorded match was in 1766. Each side tries to get the ball down to the far end and then score. Players are not allowed to handle the ball. Each phase of play starts with a 'bully', when about six of the 10 players from each side form up against the wall and against each other. The ball is rolled in, and battle is joined. The player in possession will normally be on all fours, with the ball at his feet or under his knees. His own players will try to get into a position where he can pass the ball to them. Likewise, players on the other side will attempt to obstruct his progress to gain possession themselves.

29th November, 1969

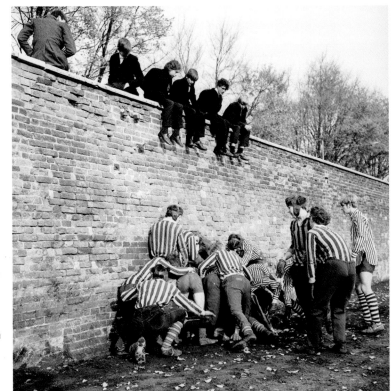

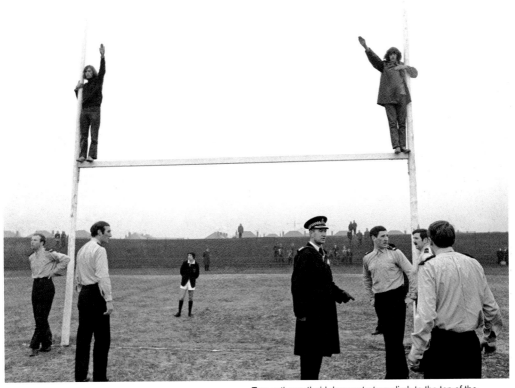

Two anti-apartheid demonstrators climb to the top of the goalposts during the Springboks match at Aberdeen. The Springboks 1969 Rugby Tour was overshadowed by the British public's increasing opposition to apartheid – discrimination against non-whites – by the ruling regime in South Africa. Matches throughout the tour were dogged by protests from anti-apartheid supporters that often descended into violence.
2nd December, 1969

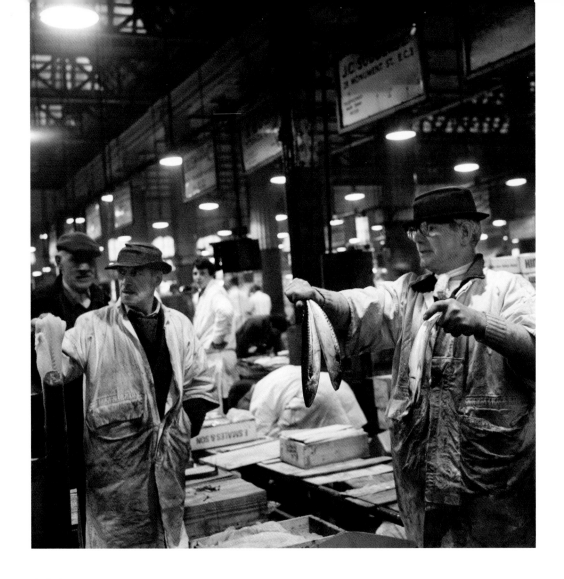

A Christmas message from John Lennon and Yoko Ono is displayed in Piccadilly Circus, reading 'War Is Over! (If You Want It)'. It was one of 2,000 posters on display in London, and the message also appeared in 10 other cities across the world as part of John and Yoko's promotion of world peace. Two years later this slogan became the basis for the song *Happy Xmas (War Is Over)*, when Lennon decided to make a Christmas record with an anti-war message.
15th December, 1969

Facing page: Billingsgate Fish Market in London. Established in the south-east of the City of London in the 19th century, Billingsgate was still a prosperous venue for fishmongers to sell their wares during the 1960s. In 1982, the fish market was relocated to a new 13-acre building complex close to Canary Wharf in London's Docklands.
8th December, 1969

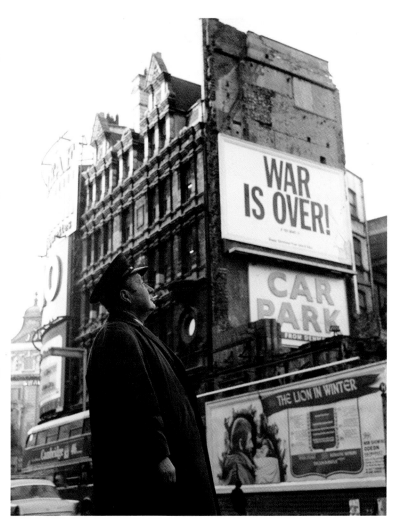

Actor and playwright Noel Coward lights a cigarette during his 70th birthday dinner at the Savoy Hotel, London. Known for his wit, flamboyance, poise and personal style, Coward achieved enduring success as a playwright, publishing more than 50 plays from his teens onwards. Many of his works, such as *Hay Fever*, *Private Lives*, *Design for Living*, *Present Laughter* and *Blithe Spirit* have become classic, regularly performed theatre repertoire. Coward was knighted in 1969 and was elected a fellow of the Royal Society of Literature. He received a Tony Award – an American live theatre award – for lifetime achievement in 1971.

6th December, 1969

Mary Whitehouse, General Secretary of the National Viewers and Listeners Association (NVLA), arriving at Buckingham Palace to deliver letters signed by 20,000 people regretting the Queen's decision not to broadcast a Christmas Day message in 1969. Whitehouse founded the NVLA in 1965 – it is now known as Mediawatch-uk. The organisation was set up to monitor and influence media activity. It campaigned against the publication and broadcast of media content that it considered to be harmful and offensive, such as violence, profanity, sex, homosexuality and blasphemy.

22nd December, 1969

The Publishers gratefully acknowledge Press Association Images, from whose extensive archives the photographs in this book have been selected. Personal copies of the photographs in this book, and many others, may be ordered online at www.prints.paphotos.com

PRESS
ASSOCIATION
Images

AMMONITE
PRESS